HOLD FAST:
An Illustrated History of Sail

by
J. Howard Campbell
© 2024

TABLE OF CONTENTS

DEDICATION ... 3

EPIGRAPH .. 4

FORWARD .. 5

PREFACE ... 6

CHAPTER I: FROM THE OLD TO THE NEW WORLD 7

CHAPTER II: GREAT EXPLOITS AND MASTERS OF THE SEA 42

CHAPTER III: THE SEA HERITAGE OF AMERICA 66

CHAPTER IV: WESTWARD HO ... 99

CHAPTER V: VENTURES OF COMMERCE 109

CHAPTER VI: SAILORS TAKE NOTICE 139

CHAPTER VII: FROM RUM RUNNERS TO THE BARBARY COAST 173

CHAPTER VIII: FROM DEAD RECKONING TO THE DAYS OF STEEL 192

CHAPTER IX: THE LAST DAYS OF THE SAIL 221

ABOUT THE AUTHOR ... 238

GLOSSARY ... 240

SELECT BIBLIOGRAPHY ... 247

SHORT AUTHOR BIOGRAPHY .. 249

ALSO BY J. HOWARD CAMPBELL ... 250

DEDICATION

To shipmates with whom I have weathered many a storm on the sea of life, Paul C. Imschweiler, William J. Brown, Jack J. Danforth, and my wife Joanne for all her patience.

EPIGRAPH

In the tradition of the sea, old time British sailors often had the letters,
"HOLD FAST," tattooed on the knuckles of their left and right hands.
This emphasized an old motto of sailing ship men:
"One hand for the ship and one for yourself
But, in any event, Hold fast! Never give up!"
James H. Campbell

Choose the timbers with greatest care;
Of all that is unsound beware;
For only what is sound and strong
To this vessel shall belong.

Henry Wadsworth Longfellow

FORWARD

Hold Fast is a collection of historical short stories, antidotes, trivia, and brief descriptions of maritime history written in the style of a "coffee table book." It is not intended to be read as a chronological narrative history. The reader can pick up this book and begin reading in any chapter without concern about needing to read previous chapters. As a reader, you are invited to come aboard at any time to read about and enjoy the golden age of sailing.

William J. Brown, editor

Preface

Regardless of the countless hours of research that went into this book and the amount of checking and rechecking that was done, new discoveries may be forthcoming to further refine knowledge of the many sailing adventures chronicled in this book. This work was never intended to be a comprehensive history of the days of the sail. Such a history would require many volumes and many coffee tables. Instead, this book provides a selective history from the vantage point of a professional pen-and-ink artist written over a 50-year period. It is hoped that the selected artwork of great sailing vessels and colorful accounts of sailing history and culture will give you many hours of enjoyment. The author's personal reflections of what became known as *the golden age of sailing* will make you more aware of this remarkable period of history. Exploring sailing over many centuries, from ancient mariners to modern sailors of the sea, we hope these accounts and stories of the great voyages of men and women who have changed the course of our world and forged history in the oceans of our planet will enlighten your understanding of the brave sailors who conquered the world.

James H. Campbell, author
William J. Browm, editor
August 12, 2024

CHAPTER I
FROM THE OLD TO THE NEW WORLD:
Early European Voyages to the New Frontier

They came by ship . . . to the East Coast

Since time immemorial men have been sailing the seas and waterways of the world, always reaching out for new frontiers and new lands to escape from their own bondage. The tribes from the North or Baltic Seas, known to us as Norsemen, are thought to have been the first to sail ships to the shores of the Northeast American coast. They arrived long before Columbus sailed on that August day in 1492. Many artifacts have been found along the East Coast of America telling of colonies and events worthy of historical note.

One such record of interest comes from the Ericson (also Erikson) family of the Icelandic Commonwealth. A story told by Gudrid, the widow of Thorsten Ericson, Leif Ericson's brother, to Snorri, the first white child born in America 575 years before Virginia Dare, is quite fascinating. Many encyclopedias will state Virginia Dare, born on August 18, 1587, was the first white child born in America of English parents in the colony of Virginia (which is now in the state of North Carolina).

However, an alternate story accepted by many is that Leif Ericson's settlement on the Charles River in Massachusetts is the first European settlement in North America. It is unlikely that Columbus knew of the Wineland voyages of Leif Ericson. Like Ericson, men came from every corner of the world to the American continent, some in search of gold, some in search of land to colonize, and some to escape religious persecution. Our Atlantic coast was a land of great promise for all who ventured to its shores.

Ponce de Leon landed in what is now Florida in 1513, claiming that area for his sovereigns, but lost his life to an Indian arrow. The French, in 1562, sailed from Havare for the coast of Florida because of the religious strife in France. The English had visited our shores only six years after Columbus's first voyage. In 1584, Queen Elizabeth sanctioned Raleigh's endeavor to establish a colony in what is now North Carolina, to which area Spain claimed title. In 1606–7, a group of merchants banded together in

the London Company sent out three ships, the DISCOVERY, the GODSPEED, and the SUSAN CONSTANT, with about a hundred-twenty colonists, to establish the first permanent English settlement in America on the banks of the James River in Virginia. Another London company of merchants, the East India Company, funded the voyages of 50 ships from 1603-1616. The company set East Indiaman ships like the DEVONSHIRE to Madras, Bengal, and Ceylon to engage in the lucrative spice trade. In 1621 the Dutch founded the Dutch West India Company, which exploited the huge stretch of land between Maryland and the tip of Maine. The French, the English, and then the Dutch contested Spain's title to the Atlantic coastline. Sweden also focused its attention on the country along the Delaware River about 1637 to 1643. It was the early Swedish families who first constructed the log cabins of selected hemlock tree trunks that we think of

as the pioneer homes of our forefathers.

Men of many nations engaged in another occupation along the East Coast of America. Piracy was the game—defined as robbing on the high seas. When gold cargoes began to move toward Spain from the New World in the 1500s, the Caribbean Sea soon became the rendezvous for cut-throat privateers from everywhere. The rogues of the skull-and-crossbones set were not only tolerated, but even welcomed in ports as far north as New England. They were good spenders, and disposed of goods far below the exorbitant prices demanded by the merchants from England. One among them, known as Blackbeard the Pirate, had long maintained a secure hideout on Ocracoke Island, the sandpit slanting southwest from Cape Hatteras. Blackbeard's origin is shrouded in mystery, but his fate is all too clear. With his sudden demise, piracy met its death soon thereafter, although not completely. Nevertheless, the great among them had now fallen, thus this breed of outlaws became fewer until piracy was cleared from our shores.

The story of the hardships and struggles of the colonists is a great chapter in the history of this nation. From these early settlers came builders of a vast empire. From their coastal ports came ships to sail the world over. Americans built ships by craftsmen from the Old Country, using virgin timbers of oak, chestnut, and pine from America's inland forests.

The schooner was originated in Holland during the late 16th and early 17th century. However, the schooner is essentially American in its later development. The schooner DAVID DOWS was built in 1881 at Toledo on Lake Erie. At the time, this vessel was the largest schooner in the world: 1,418 tons, with a length of 265 feet. The GOVERNOR AMES was the first five-masted schooner built on the Atlantic Coast in 1888, at Waldoboro, Maine. The last large, wooden, square-rigged sailing ships were built in Maine and Massachusetts. They were called "Downeasters." These ships represented the highest development of the American square-rigged vessel, truly a work of art. Over a period of some 20 years, the Downeasters carried more cargo per

registered ton than the American clippers of the 1850s. Downeasters made good profits for their owners, but the advance of steel-hull sailing ships and steam vessels brought about their end. The last Downeaster and deep-sea-square-rigger ship built of wood was the ARYAN, built by Minotts at Phippsburg, near Bath, Maine, and launched in July of 1893. In 1918, this ship was lost by fire in the Pacific.

The cry of "all starbowlines ahoy, lay aloft and furl the royals" will one day be a lost phrase among sailors of the new generation. The day will come when the art of sailing will no longer be spoken from the lips of the old timers who sailed before the mast. Few men living today can relate the hardships of life at sea in ships powered only by the wind of the seven seas. The man who can recall the stories of when a full-rigged ship would carry more than an acre-and-a-half of canvas and make an average of 19 knots on a good passage is a rare breed. Memory of the shouts of sailors have faded, like "Lay aloft there, lad, and furl that main-royal! We are out of the channel and off the point! Sail again, oh Yankee!"

Man has never mastered all the elements of his environment; but for a short period in his history, he learned to harness winds of the Master to sail into new horizons and discover new worlds. One of the first rules of the sea a sailor learns is to take care of himself. "One hand for the ship and one for yourself." A slip and fall from an upper yard

'Haul away lively!'

meant sure death. However, men of the sea never thought of their work as dangerous. Furling and unfurling the sail had to be done over and over again. The amount of canvas a ship could safely carry would change as the wind picked up or slackened off. It was an art in itself to sail a ship in heavy seas and it took a good captain who knew his ship and what it could do in a gale to survive the fierce and unpredictable ocean storms. It would take an experienced sailor no more than two to three minutes to climb to the topmost foreroyal yard. Once a man conquered the terror of climbing the dizzying heights and learned to handle himself against the wind and cold, he could work with the best of sailors.

The fearsome Cape Horn swallowed many a sailing ship and her crew without a trace into the infinite fervor of the southern seas. The woeful bones and broken crosstrees with fractured masts gave mute evidence of the death of many a once proud vessel that sailed by wind power alone. For many a mariner, a tall ship was a living thing with a heart and soul.

Forgotten Voyages

On a cliff above Mount Hope Bay, in Bristol, RI, a discovery was made and recorded in 1780, in which a single line was written in Tartessian Punic: "Voyagers from Tarshish this stone proclaims." Tarshish was a biblical city on the southern coast of Spain, and its men were among the boldest sailors of antiquity, famous also for the size of their ships. In about 533 BC, Tarshish was destroyed by the Carthaginians and its trade was taken over by them. Here was evidence of how the partnership between the Iberian Celts and the Carthaginians began. On Monhegan Island, ten miles off the coast of Maine, another inscription was found, written in Celtic Ogam; it read: "Cargo in platforms for ships from Phoenicia." For at least 400 years before the birth of Christ, a highly developed trade route between America and the Mediterranean was a reality.

Vikings in America

As noted at the beginning of this chapter, there is now substantial evidence that Columbus came to America some 500 years after Leif Ericson and his men landed on the coast of North America. There is also considerable evidence that Ericson came about 466 years after an Irish monk and his seafaring companions first came to America. A Brandeis University professor has discovered even more evidence of still another group of people—the Jews fleeing Romans in the Middle East, who came west and discovered America 1,000 years before Columbus.

If that does not complicate the discovery picture enough, there is also some speculation that Chinese Buddhist monks landed on the North American West Coast around 700 AD and that perhaps some Mediterranean race touched the Western Hemisphere shores possibly as early as the 12th Century BC.

Major evidence pointing to Norse settlements on American soil have come to light in the discovery of some 70 or more artifacts over the past half century. They date back from the 10th to the 14th centuries. Objects found included weapons, implements, ornaments, and runestones with inscribed messages. These artifacts were found along the North American coast from Newfoundland all the way to Virginia. Several major finds were also made in the Red River area of Minnesota. The claim to Viking discovery was made incontrovertible by the evidence found in Minnesota in 1898. The Kensington Runestone tells of a group of Norse explorers who set out to find a lost expedition.

Viking Longships

Vikings terrorized western Europe, crossing the North Sea, and passing through the English Channel and down the coast of France and Spain virtually unopposed, because no other nation could match the speed of their sailing vessels. In response to their threats, England, France and Scottish kings began to build equal or superior ships like the longships, but even bigger and faster than those of the Vikings. The answer to their enemy was to increase the freeboard of the longships. The great voyages of the Vikings started when Eric the Red, in 984, fled to Iceland to escape charges of murder. Viking fleets reached the cities of Barcelona, Pisa, Rome, Venice, and even Constantinople during their maritime supremacy. Longships were not solely a Scandinavian ship even though the design originated there.

Physical courage was one of the highest virtues among Vikings and death in battle was believed to be a sure passport to paradise. For two centuries, the fearless Norsemen devastated the coast of England and Europe and ventured westward

The Norsemen — Campbell

13

to America. Leif Ericson, in 1003, with a crew of 35, sailed south from Greenland along the coast of Newfoundland to an island called Vinland, which many believe to be Martha's Vineyard.

Records found in 1928, in the Royal Archives in Oslo, Norway, dated 1356, tell of a settlement in what is now Minnesota. Considering so much conclusive evidence, it was not surprising that Congress set aside October 9th as "Leif Ericson Day."

Two of the best-preserved 9th century longships are found in Oslo's Viking Ship Hall. The GOKSTAD, excavated in 1880, and the ship OSEBERG, found in 1904, are fine examples of Norse ships. A Viking ship had one square sail and a deep-fastened oar which hung over the right side, and hence the right side of a ship is the starboard to this day. The square-rigged sail was often beautifully decorated by Viking women. An awning in the forepart of the ship sheltered the fighting men on long voyages. Sailors slept in leather sleeping bags and kept their weapons beneath the thwarts from which they rowed. The shields along the sides probably served to keep the crew dry in heavy seas. There was very little freeboard, and only their perfect shape kept the ships from swamping. Scholars say there were longships which reached 100 feet or more. Figureheads were often removed near shore so as not to frighten friendly land spirits. Described below are additional features of Viking ships.

The Crow's Nest. It is said that the ancient Vikings actually carried crows on a little platform on the mast of their ships and when lost at sea, they would release one of the birds and follow it as it flew toward the nearest land. The Viking era began in about AD 800 and lasted for nearly five centuries.

Starboard. Viking ships had reached a high degree of craftsmanship. Their ships were double ended, built of oak and navigated with a steering oar, which was placed on the right-hand side of the hull, near the stern. This side was therefore called "starboard" and soon became "starboard" by combining two Old English words: stéor (meaning "steer") and bord (meaning "the side of a boat"). As such, it is used internationally to this day.

Dragon Heads. The dragons and monsters that graced the bows of the Viking ships were so fierce looking that a law was passed in Iceland ordering all Viking ships to remove the figurehead before entering a landing.

Adventures of Columbus

Long after the Viking explorations of North America, as already noted, came the adventures of Christopher Columbus. Although in recent decades Columbus has been demonized as a plunderer no better than the Viking raiders, his life and accomplishment

were actually much more complex. Columbus suffered greatly during his expeditions. He never returned to Spain with his ship the SANTA MARIA, for she ran aground on the coast of Haiti and became a total loss. The description or plan for this famous ship has been lost in time, but we know that Columbus had to sail with two smaller craft, the PINTA and the NINA, to reach the Spanish port of Palos de la Frontera.

In the year 1892, the Spanish government built what was then accepted as a correct replica of the SANTA MARIA. Research, however, on the part of students of the history of shipbuilding, have proven that the supposed replica was a ship of the early 17th century rather than of the latter half of the 15th century. Accurate drawings of the replica should represent a typical ship of 1492. There were no ratlines on the shrouds; and the crew, in going aloft, mounted a "Jacob's Ladder" alongside the mast. There were no methods of reefing a sail at the time. A "bonnet," which was laced along the foot of the sail, was the only way to reduce the spread of canvas.

Like Ahab in his fanatic pursuit of the great white whale, Columbus held fast to his dream that he could sail west for a mere 2,700 miles and find the Indies. Little did he know that 70 percent of the earth's surface was covered by

oceans and seas. Columbus had been misled by the holy works of the prophet Esdras, who had written that only about one-seventh of the earth's surface was covered with water. In Columbus' day, the newest world map was that of Paolo dal Pozzo Toscanelli Toscannelli of Florence, who vastly miscalculated the expanse of the oceans. The Florentine scholar reasoned that by sailing 3,000 miles from the Canary Islands, the East could be reached by a straight shot. Columbus also had studied the accounts of Marco Polo's adventures to Cathy, Cheambra (India) and Cipangu (Japan). By traversing the 28th parallel, Columbus was of the belief that the distance to Cipangu was only 750 leagues, a quarter of the distance between the two points. The currents of 1492 were unknown, however, although the earth's physiography has changed very little over the past 500 years. If our ancestors had known what the earth was really like, they undoubtedly would have more accurately understood the great oceans of the world.

Columbus and his three caravels reached a small island in the new world on October 12, 1492. This island, which he named San Salvador, is in the Bahamas, located well inside the perimeter of the Bermuda Triangle. Strangely, the landing site of this historic event, despite years of research, has never been known with certainty. Nine islands have been suggested as the original landfall: Cat, Watling, Conception, Samana Cay, Plana Cays, Mayaguana, East Caicos, Grand Turk, and Egg in the northwestern Bahamas. However, most scholars favor Watling Island, which has been renamed San Salvador in 1926 because it best fit Columbus' description.

Columbus was called the greatest dead reckoning navigator of all time. No accurate method of determining longitude at sea was known in 1492, nor would there be for nearly 250 years. Columbus had no way of measuring his speed through the water. On the night before the cry of "Tierra, Tierra!" (land, land!) was shouted by the crew, Columbus experienced several weird incidents. He and his crew saw what appeared to be a greenish, glowing light on the horizon. He also logged that his men were terrified by a baffling disturbance of the ship's compass in these strange waters. Columbus was the first known navigator to speak of the mysteries of this region. There are over 300 islands in this part of the Atlantic. Only a handful of these coral islands are inhabited to this day. The region was called the "Devil's Island" by early seafarers.

Naming America

You may wonder why the American continent is not named after Columbus. A contemporary of Columbus, Amerigo Vespucci, also recorded his sailing adventures. He was an Italian merchant and explorer-navigator who participated in an expedition to

South America in 1499. His account of the voyage was published, in which he told of the wondrous sights he had seen, giving the impression that he was in command of the vessel and that its voyage antedated the third made by Columbus. A geographer named Waldseemuller, having learned of Vespucci's account and not that of Columbus, accepted Vespucci's story, and in 1507 called the new continent America, after the author's first name.

The Nina and the Pinta

Columbus' first voyage was far from a well-financed venture. The very selection of Palos de la Frontera as the point of outfitting was an economic measure; $5,000 was the sum of money put up for the expedition. The five thousand dollars did not furnish the ships. Two of them were furnished by the town of Palos de la Frontera, not from the kindness of its collective populace, but simply because, for some civic misdemeanor, Palos de la Frontera was condemned by the royal authority to yield for one year the tribute of two caravels to the Crown, to be used as the Crown saw fit. In the maritime affairs of Palos de la Frontera, the Pinzon family seemed to have a monopoly on the ships of this port. They owned more than half of the ships that sailed from this port, and they had a considerable finger in every nautical venture. When it came time to manning the ships for this expedition, the Pinzon's influence proved very potent indeed, as far as the two vessels PINTA and NINA were concerned.

The PINTA, commanded by Martin Alonzo Pinzon, was of only half the burden of the SANTA MARIA, but she could sail three leagues to the larger vessel's two; she bore three masts and was decked at bow and stern. The NINA, captained by Vincent Pinzon, was of forty tons burden, and carried a crew of only eighteen men. Columbus' flagship, SANTA MARIA, was the largest vessel of the

three, but she was a slow and unwieldy craft, a vessel of about one hundred tons burden, and perhaps an overall length of 80 to 100 feet and a beam of 20 to 27 feet. The SANTA MARIA drew 6 feet 6 inches of water. The original building plans of the ship have not survived. It is believed she had a caravela redonda rig with the addition of a low-hanging spritsail, which had to be clewed up in rough weather. The SANTA MARIA was rather old and clumsy; she was decked over with a high poop astern and three masts, two of them square-rigged, and a crew of 42 men.

On the first voyage of 1492, Columbus had a crew of between 90 and 120 men. Three voyages followed, establishing proof that other lands could be reached by sailing west. The second voyage in 1493 had 17 ships and 1500 men. Its primary purpose was colonization. The third voyage in 1498 expanded the area of exploration and furthered the search for gold and spices.

South America was discovered on this third voyage. Realizing the New World was not the Indies, Columbus made a last effort to find a way to the Indies by exploring the coast of Central America in 1592. For all of his labors, courage and discoveries, Columbus failed to achieve personal wealth and enduring glory. His moment of fame was short lived, as the land failed to produce for him the great riches he had imagined. The expeditions were rife with mutiny and dissension. As we shall learn after his sailing days have ended, the years of his life were spent in poverty and neglect. If you think of Columbus as a plunderer, you may be assuaged by knowing he actually lived a life of great hardship and suffering.

"I Pray She May Not Have Perished." On the homeward voyage, howling winds and high seas caused the PINTA and the NINA to lose each other, and at one point it was believed that the PINTA was lost at sea. Believing that the two ships might go under, Columbus ordered a stout wine-cask from the hold, in which he placed a brief account of his voyage, discovery, and how he had taken possession of the land in the name of his Sovereigns. Encased in wax, and consigned to the cask, the parchment records were flung into the sea.

Columbus favored the NINA, the smallest of his fleet, and returned on this vessel when the SANTA MARIA went down. The NINA was a caravel of about 60 tons and a crew of 18. She appeared to have been about 67 feet long, with a beam of 21 feet and a draft of just under 7 feet. The NINA was also called the SANTA CLARA. It is believed this ship took part in three of Columbus' four voyages to the New World. Her planking was made of two- and one-half-inch oak fastened with wooden pegs and additional iron bolts at stress points. Because of the arched deck beams, the main deck

had a slight camber, so the crew slept on the flat hatch covers, that is those who could, and as for the rest, they slept below. The morning watch kept the bilge water in check by using two wooden pumps. Stability aboard the ship was maintained by shipping ballast and as the food stocks were used, empty casks were filled with sea water. With the added crew from the SANTA MARIA there was little space for all aboard the NINA.

Columbus's Fourth Voyage

"Land! Land ho!"

Campbell

The fourth and final passage was by far the most harrowing or heroic. His three journeys to the New World were not filled with the glory he had expected. Failure, frustration, and even disgrace, were the price he had to pay. In 1500, Columbus was sent back in chains from Hispaniola for failing to quell civil unrest on the island. At the age of 51, an old and afflicted man racked with arthritis, he pleaded with Ferdinand and Isabella for another chance to find a passage to treasures of India. In order to rid themselves of this desperate dreamer, they authorized four caravels to make up a fleet for one more journey to the New World. Columbus, crippled with arthritis, was losing his eyesight and contracted malaria. The crew also suffered deprivation and despair. Even his ships were riddled by teredo worms, a species of saltwater clams that destroy the timbers of ships. Broken in spirit and body, Columbus sailed for Spain without accomplishing his lifelong goal, only to find a dying Queen Isabella. His adventures were over; barely seven months after his return, Columbus died in Valladolid on May 20, 1506.

If Columbus had lived in the time of the Greeks or the Romans, he would have many statues raised to his great achievement. It is believed that so far as is known, there was never a monument built or a portrait painted of Columbus in his lifetime. It was not until more than half a century after the explorer's death, that an Italian Renaissance painter "discovered" Columbus.

Columbus was an extraordinary man. Having reached the age of 25 illiterate, he set about to propel himself from among the lower middle class into another world. He learned to speak, read, and write in three languages: Portuguese, the tongue of navigation; Castilian, the parlance of the upper class of Spain; and Latin, the language of the scholars. The world of glory for Columbus had denied him. Even today, his reputation is tarnished by his association with the evils of slavery and imperialism and statues of him in the U.S. have been torn down and removed from site in recent years. He never found his route to India, but he had sailed 3,000 miles across an uncharted body of water and back again and gave Spain an empire covering one-third of the Western Hemisphere. Columbus also gave us a few other things not known to most people.

Columbus and the Turkey. The turkey probably owes its name to Christopher Columbus. On landing in the New World, he believed he had reached India and thought the bird was a peacock. He named it Tuka—which means peacock in India. Actually, the turkey is a type of pheasant.

Genoa's Fair-Headed Son. The city of Genoa is Italy's largest seaport, yet it is not a place tourists ordinarily come to visit. Unlike Pisa, it has no leaning tower, and unlike Venice, it has no waterways for streets. But it does have the history of Christopher Columbus. It also has the house in which he was born.

Although everybody seems to be getting into the Discovery-of-America sweepstakes, most people still consider that Columbus was the first because few people know the truth about the great navigator from Genoa. For example, few people know that Columbus discovered popcorn. Few also know the bad news that he brought back something else to Europe, syphilis. The following authoritative quote is to be found in the City Hall archives of Genoa: "The disease syphilis was brought to Europe by those who traveled with Columbus." They contracted it from the women of the mentioned island and when they returned to Spain, they infected some prostitutes with it. "From these it spread further," signed Amerigo Vespucci. Genoa is not particularly proud of that piece of trivia.

As for popcorn, city officials go on record to say that Columbus not only discovered the New World, but also popcorn. According to records, Columbus was the first white man to see natives of the West Indies wear decorations around their necks that had

been made from exploded corn. He also found that you could eat it and that it was delicious. More to add to your bag of trivia, in the City Hall of Genoa are kept the priceless and historical mementos of Columbus' life and travels, including his ashes in a gold urn mounted on a marble base. The ashes are there "temporarily" because in his will, Columbus did indeed request burial on the Island of Hispaniola (Haiti and the Dominican Republic).

Curiously enough, Columbus never sailed on the PINTA, which was the first ship to sight America and the first to reach Hispaniola. On his return voyage, Columbus stopped over in the Canary Islands, where he fell in love with the governor's wife, with whom he had an affair. Columbus had two sons, one by his legal wife and one by his mistress. One strange aspect about Columbus is that he never wrote in Italian, not even to his brothers. He wrote nearly everything in Spanish and sometimes in Latin, signing his last name in different ways, Colombo, Colom, or Colon, but never Columbus. He also called himself both Cristoforo and Cristobal.

The Wreck of the PINTA. Treasure hunters have found the PINTA, one of three ships that sailed with Columbus in 1492. The PINTA returned to the New World and was shipwrecked off the Turks and Caicos Islands in the Bahamas. Olin Frick, John Gasque, and a crew of 23 divers and archaeologists say they plan to retrieve the artifacts from a coral-covered wreck they believe is the PINTA. Using records in the Spanish archives and a 500-year-old tax report, Eugene Lyon, a Florida historian, has concluded that one of the PINTA's owners, Vincenta Pinzon, made a return trip to the New World in about 1499 or 1500. An iron cannon and a lead cannonball from the wreck, which have been determined to date from that period, were found by divers several years ago. It was known that Pinzon island-hopped for six months in search of slaves and riches before a hurricane sank two of his four vessels. Mendel Peterson, former director of underwater archaeology for the Smithsonian Institute and now a shipwreck artifact appraiser, says he has found nothing which would contradict the treasure hunters' claim that their wreck is the PINTA. Even if the wreck is not the PINTA, it is established that the vessel sank around 1500, so it still would be the oldest shipwreck ever found in the New World. Underwater archaeologists believe it is possible for a ship to survive nearly 500 years in the waters of the Atlantic.

A newspaper story dated March 6, 1982, from the *San Jose Mercury News*, brought new light on the sunken ship believed to be the PINTA. Treasure hunters appear to have dynamited and damaged the wreck which lies on a shallow bottom under turquoise-clear water in an atoll off the British Turks and Caicos Islands, a British colony 600

miles southeast of Miami. An aborted salvage operation left a gaping 5-foot hole in the pile of ballast stones marking the grave of what may be one of the oldest known shipwrecks in the New World. The ship's coral encrusted anchor and a well-preserved cannon were found to have been damaged from the blast. Both the anchor and cannon are believed to date from the first half of the 1500s.

In an effort to halt further destruction, the British government authorized the Institute of Nautical Archaeology in Texas to recover and preserve everything of historic value at the site. The PINTA is believed by some scholars to be one of the two ships which sank in a hurricane in July 1500 as part of Vincente Yanez Pinzon's fleet of four treasure ships.

While generations of dedicated archaeologists and shipwreck hunters have searched for the wrecks of the NINA, the PINTA, and the SANTA MARIA, the remains of Columbus' history-making first fleet have proven elusive as they remain undiscovered.

Sixty Dollars a Year. Queen Isabella, before the first voyage of Christopher Columbus, had offered a lifetime pension of 60 dollars a year to the first man to sight land. A sailor by the name of Rodrigo was the first to sight land; however, Columbus himself stepped up and claimed the title. Rodrigo went to North Africa and became a Muslim.

Columbus and His Legacy

In his letter to the Queen, after completing his third voyage, Columbus wrote: "I have come to the conclusion...that the world is not round, but of the form of a pear where the stalk grows is the highest and nearest the sky." The cost of discovering America covering entire expenses, including salaries, was $6,951.62. For all of his work Columbus received $59.28. He died on May 20, 1506, having the ill fortune to die at a moment when his discoveries were little valued and his personal fortunes and expectations were at their lowest ebb.

On his four voyages, from epic landfall on San Salvador to shipwreck and humiliation on Jamaica 11 years later, Columbus led the way along the southerly Tradewinds route to the New World, discovering the North Atlantic's generally clockwise airflow. The years to follow were to be the convoy system for merchant ships to the land of gold and silver.

Not all treasure fleets were lucky to take their prize home, disaster by terrible hurricanes in the early 1700s destroyed many Spanish fleets. In 1715, ten ships broke up off Florida's east coast; about twenty more came to grief off the Florida Keys in 1733.

Other Notable Ships Following Columbus

The Nuestra Senora de Atocha

This ship, crammed to the gunwales with South American gold and silver, went to her death in a raging hurricane in 1622. Salvagers have raised treasure estimated at six million dollars, perhaps only less than a tenth of the total. The coastal waters of North and South America hold a wealth that cannot be known; modern diving equipment is less than 75 years old and millions of square miles have taken toll of ships and the cargos they held.

The Spanish Galleon

We usually associate the word *galleon* with the Spanish ships of old. However, England, France, and Italy alike had ships of this type by the mid-16th century. The pen and ink drawing for this picture was drawn from an old oil painting found in an antique shop in B.C., Canada. Galleons usually carried four masts. On the early galleons there was a "beak-head" or projection resembling the ram of the Roman galleys of an earlier period. Some historians gave rise to the idea that the word galleon may have come from the galley.

Spain was intent upon building a new empire from the rich resources discovered in the New World. Not only gold, silver, and precious gems, but equally profitable was the slave trade. The Spanish slave trade rose in importance until it was second only to her fleets of galleons and caravels that carried the treasures of Mexico and South America back to Spain. On July 4, 1502, the EL DORADO and twenty-six other ships set sail for the long return voyage to the homeland. The EL DORADO was carrying a table of solid gold in addition to two million dollars in gold and silver. It was to be the richest ship ever to return to Spain. The entire fleet sailed off into oblivion. This was the first

known disappearance in what is now known as the Bermuda Triangle. The Spanish admirals of the day did their best to sail their ships through the western boundaries of the Bermuda Triangle which were the lifeline of Spanish trade. Their galleons were top heavy and not stout enough for the storms off the coast. There were many instances recorded in the 16th century of entire fleets that vanished without a trace. In 1750, a fleet of five Spanish galleons, carrying precious metals and gems, set forth for Spain. The armada vanished with a fortune in treasures without a clue to their destiny.

The Manila Galleons

For 250 years, Manila in the Pacific became the center of commerce interchange between Europe and Asia, by way of the Americas. Spanish galleons sailed from Acapulco to Manila, the first leg of an 18,000-mile round-trip. Goods from India, Southeast Asia, Japan, and China were the rage in Europe. When the ships were loaded with their treasures, they set sail on a voyage that would take them perhaps seven months and 9,000 nautical miles back to Acapulco. From there the ship's cargo was loaded on mules and carried to Vera Cruz for reloading on ships bound for Spain. A typical galleon returning from Manila might be loaded with clove, cayenne, curry, cinnamon, black pepper, silk, China ware, and mercury for refining Mexican silver ores. Spaniards living in Manila lived well on the profits. A shipwreck or lost at sea spelled disaster; fortunes were made and lost, and sunken galleons were scattered all along the route. In 1530, King Charles I ruled that none but Spanish ships might sail the Pacific.

San Salvador in 1542

Jaun Cabrillo sailed up the coast of what is now California from Mexico in 1542, 78 years before the Pilgrims landed on the Massachusetts shores. In two small ships, the VICTORIA and the SAN SALVADOR, of which very little is known, manned by inexperienced crews, and poorly provisioned, Cabrillo sailed in search of the mythical Strait of Anián, the great river linking the Atlantic with the Pacific. Juan Cabrillo was a Portuguese hired by the Spanish viceroy Antonio de Mendoza to find the much-desired strait believed to provide a direct route from Spain to the East Indies. Although he was the first European to land on the shores of California, he did not find the Seven Cities of Cibola or the great river link, but he did name many of the bays and islands and points of land along the coast. The expedition sailed from a tiny port on the coast west of Mexico City, on June 27, 1542. The ships did not reach the "good closed port"

of San Diego (which Cabrillo christened San Miguel) until September 28, 1542.

The SAN SALVADOR was a caravel, this much is known, but there are no records of this ship as to where or when this ship was launched. The log of Cabrillo's exploration told of how the death rate was very high. Scurvy and other illnesses plagued the crew and even resulted in the death of Cabrillo.

In the Santa Barbara channel, the ships several times took refuge in a snug port on San Miguel Island, now known as Cuyler's Harbor, where they traded with the Indians and took on water and repaired their ships. While exploring the island, Cabrillo fell and broke his arm near the shoulder. Despite the intense pain, Cabrillo ordered the ships to continue the voyage. Sailing past Point Conception was difficult because of the almost continuous storms. The ships passed Monterey and San Francisco bay without seeing them as a result of fog and rains. Forced to return to the refuge on San Miguel Island on November 23, the storms kept them there for nearly three months, and here Cabrillo died on January 3, 1543, probably of gangrene. He was buried in a yet undiscovered grave. Many have searched for Cabrillo's grave, but like that of Moses, "no man knoweth the place thereof unto this day." Under the command of Bartolome Ferrelo, the frail little ships set sail again on February 18, 1543 and are believed to have succeeded in reaching a point opposite the Oregon border before a terrible storm and the threat of starvation forced them to give up and head for home.

One of the islands which Cabrillo discovered and named was San Salvador (Santa Catalina). In the years to follow, this island became a smuggler's paradise. Sebastian Vizcino, 60 years later, renamed the island Santa Catalina.

Magellan Found a Way

It was Vasco Nunez de Balboa who was the first European to see the Pacific when in 1513 he struggled across the Isthmus of Panama. However, it was Ferdinand Magellan, who although born Portuguese, he became a Spanish citizen, sailed for Spain on a voyage that led the way to the first expedition in 1519–1522 to circumnavigate the world. This voyage has been described as the greatest sea voyage of all time, though he lost his life in the Moluccas in Indonesia. In 1521, Magellan found a way to the Pacific around the southernmost tip of South America.

The GOLDEN HINDE

In 1577, Spain and England were in a state of turmoil and anticipation. Antagonism between the two great powers was growing. On December 13, 1577, five ships left Plymouth Harbor, presumably bound for Egypt. The convoy consisted of Francis Drake's flagship, the PELICAN, ELISABETH, the bark MARIGOLD, the supply ship SWAN, and the BENEDICT. Drake himself selected the crewmen, who were not only the finest seamen England could offer, but

were experts in sail-making, rigging, carpentering, block-making and, most important, map and chart-making. Sailing under the guise of a merchant trade voyage to Alexandria, Egypt, Drake and his crew of 164 seamen carried the English ensign into water over which it had never flown before. A voyage around the world— truly a remarkable feat in 1580.

The true nature of the voyage was to sail around the southernmost tip of South America and into the Pacific Ocean to plunder Spanish shipping and settlements. When Drake reached the Strait of Magellan and passed into the Pacific, the PELICAN was sailing alone. The ELISABETH returned to England and the other three ships were either sunk or lost. Drake selected the PELICAN for its similarity to a Spanish vessel. Approaching the Strait of Magellan, the ship was repainted and its general appearance changed to look like a Spanish ship. The camouflaged ship took on a new name, the GOLDEN HINDE.

Attacks against the Spanish were completely successful and almost without loss for Drake and his crew. The GOLDEN HINDE grew fat with jewels, gold, cannons, and other valuables taken from unfortunate captives. Drake was able to replenish his food, clothing, gunpowder and other necessities, as needed, from the booty of captured Spanish galleons. The greatest prize of all for Drake was the Spanish ship CACAFUEGO, sometimes spelled CASAFUGO. This ship was heavily loaded with gold and jewels, and other treasures were considered of great value. The secret sea charts and maps of the Pacific coastal areas were the real prizes. Drake had captured a Portuguese pilot, Nuno da Silva, who was forced to translate the charts with information which proved priceless for future voyages.

The crew of the GOLDEN HINDE did not restrict raiding to the high seas. Many of the coastal towns and villages were plundered for the wealth they possessed. A price was placed on Drake's head by the Spanish government for his capture or death. The character of Francis Drake was the subject of bitter controversy, variously described as a rank pirate and a glorious patriot. It is impossible to judge him by modern standards; however, he did wonders for England at sea.

Realizing his situation, Drake could not risk returning to England by his same route. He elected to head north and perhaps discover a northeast passage. Sailing as far north as what is now Vancouver, the GOLDEN HINDE turned south and into a cove which bears Drake's name just north of San Francisco. Resembling the White Cliffs of Dover, Drake was prompted to name the cove Nova Avion. In 1933, a brass

plate was found on the shore, showing the date of their arrival as 1579. The plate was later authenticated and reads as follows:

> BE IT KNOWNE TO ALL MEN THESE PRESENTED: JUNE 17 1579 BY THE GRACE OF GOD AND IN THE NAME OF HERR MAJESTY QUEEN ELIZABETH OF ENGLAND AND HERR SUCCESSORS FOREVER IT TAKE POSSESSION OF THIS KINGDOM WHOSE KING AND PEOPLE FREELY RESIGNE THEIR RIGHT AND TITLE IN THE WHOLE LAND UNDER HERR MAJESTIES KEEPING. NOW NAMED BY ME AND TO KNOWNE UNTO ALL MEN AS NOVA AVION.
>
> <div align="right">G. FRANCIS DRAKE</div>

It was here that the ship was completely overhauled and refinished for her voyage home to England. Deciding not to return via the northern passage, Drake made one of the most famous decisions in history, to return by way of East India. In 1580, the GOLDEN HINDE sailed from the coast of California across the Pacific non-stop around the Cape of Good Hope and up the coast of Africa on toward England.

Nearly three years after Drake's departure from Plymouth Harbor, the PELICAN, renamed the GOLDEN HINDE, returned with great jubilance. Drake and his crew had long been given up as lost. The voyage reaped a return of 4,700% on the investment for Queen Elizabeth and the nobility who had shares in the venture. The money gained from the GOLDEN HINDE voyage was sufficient to finance a larger British navy which, under the command of Drake, defeated the Spanish Armada some eight years later.

Pleased with the success of the journey of the GOLDEN HINDE, Queen Elizabeth knighted Drake on board his ship in Plymouth Harbor. The original GOLDEN HINDE for almost a century lay berthed as a visible memorial to Drake's voyage. Time took its toll on the historic vessel, and it fell into disrepair, eventually collapsing in 1662. All that survives as an odd memento is a chair which was constructed from some of the timbers and presented by Charles II to the University of Oxford.

The Drake's Plate of Brass— A Forgery? The brass plate thought to have been left at the spot where Drake landed in 1579 has been found to be a modern forgery. This news was brought to light through new techniques of testing metal. The plate caused a furor in the historical community when it was discovered near what is now Greenbrae in Marin County in 1933. Detailed studies of the plate, conducted by the Lawrence Berkeley Laboratory and the Oxford University Research Laboratory show the brass plate contains too much zinc and too little copper or lead to be 16th century brass. The plate was given a detailed microscopic examination and "found no evidence that the plate was made by hammering, the 16th century process, rather than by the modern method of rolling." However, the investigators involved in the tests did not flatly state the plate is a forgery, the new tests cast serious doubts on its authenticity. The crudely- lettered brass plate was found in the summer of 1933 by Beryle Shinn, a department store clerk, while on a picnic in the hills of San Francisco. At that time, it was declared to be authentic "beyond all reasonable doubt." Not everyone was sold on the little 5-inch by 8-inch rectangular slab; it was thought to be a hoax perpetrated by some collegiate joker.

Debate over exactly where Drake landed has been a favorite controversy of local historians for generations. The edges of the slab had not been chiseled as would be expected in the 16th century, but instead looked as if it had been shaved and then hammered to obscure the straight-cut marks. The famous brass plate of Drake's has never been completely free of suspicion since its discovery, even though metallurgical tests soon after seemed to support its authenticity. There have always been dissenting opinions even when both the age and the wording of the test have given room to some skeptics. Now that you have a two-sided story you take a choice, if the plate is a hoax, it is, in the words of Harvard historian Samuel Eliot Morison, "as successful a hoax as the Piltdown Man or the Kensington Rune Stone."

New England to California. When Drake landed on California's shores, he named the area New England or Nova Albion. The Romans had named England Albion, the white land, because of the famed White Cliffs of Dover coast. Drake now added the

Latin Nova to Albion, and California became New England. The precise location of his "Port of New England" is still subject to controversy, only Drake and the Miwok Indians knew the exact location for certain.

Francis Drake at Monterey Bay— MAY 1, 1579. There is an interesting story told around Monterey, California about some evidence found in 1934, which would put Francis Drake on the Monterey Peninsula more than 23 years before Sebastian Vizcaino claimed it for Spain. A Pebble Beach couple found what later turned out to be a lead scroll on Fan Shell Beach in 1934. The message on the scroll claimed the land for Queen Elizabeth I and was signed by Drake and his chronicler, Francis Fletcher, on May 1, 1579. During the first 15 years after it was found, the hand-blown bottle in which the scroll was placed served as a bookend. The real significance of the discovery was not realized until 1948. As the story goes, one day the bottle fell, dislodging the contents of sand, an Elizabethan six-pence and a small round object. The rolled cylinder was made of lead. It measured 8 and 5/8ths inches in length, 5 and 7/16ths in width, and was about 1/32nd of an inch thick. A photograph of the plate was taken and the message read as follows:

> IN NOMINEE ELIZABETH HIBET BRITANNA RIARUN REGINA, I DO CLAIM THIS GREAT LAND AND THE SEAS THEREOF, THERE BEING NO INHABITANTS IN POSSESSION TO WITNESS THERETO THIS BOTTLE AT GREAT TREE BY SMALL RIVER AT LAT. 36D. 30M. BEYOND HISP. FOUR OUR MOST FAIR PUISSANT QUEENE AND HERRE HEIRS AND SUCCESSORS FOREVER UNTIL THEIR KEEPING. BY GOD'S GRACE THIS FIRST DAY OF MAY 1579.

The wording and spelling engraved on the scroll was of the type common to the English of the 1500's and compared favorably to the wording found on the Drake plate of brass found in the San Francisco Bay area. The latitude given on the plate was only eight minutes off or eight miles south of Point Pinos Lighthouse. Navigators of that day had no means of determining longitude. The bottle was analyzed and found that the glass was more than 400 years old. The scroll was sent to England where it was studied by historians. Their report doubted the authenticity of the scroll because they did not believe it had been rolled into a cylinder.

In 1965, the home of the finder was burglarized while he was abroad. The plate, bottle and coin were reportedly stolen. The date on the scroll is significant and helps to add to the story. Francisco Drake is known to have left the Mexican port of Huatulco on April 16th and landed somewhere in the San Francisco Bay area on June 3, 1579. It is conceivable that Drake could have stopped briefly at the tiny fan shell cove sometime between the two dates. However, there is no record in any of Francis Fletcher's chronicles about such a landing. Before the scroll was lost, historians at two universities in California examined the lead plate but refused to let their names or their conclusions be disclosed.

England's Claim

England's early claims to America had little to do with any exploration by her own countrymen. John Cabot, born in Genoa and a citizen of Venice, induced Henry VII to outfit an expedition. It is believed that Cabot and his son Sebastian, in 1497–98, explored the coast from Newfoundland to South Carolina. It was not until a century later that the work done by the Cabots was remembered. England was now ready and only too anxious to recall their discoveries.

Another country was heard from when a Portuguese navigator succeeded where Columbus had failed. In 1497, Vasco de Gama set sail to discover the mysterious empire to the east. Heading into the waters of the South Atlantic, and then turning east, he sighted the African coast near the Cape of Good Hope. Rounding the Cape, he continued east and found the water route to India. He claimed the country and returned home in triumph.

The French Connection

Giovanni da Verrazano, the Florentine navigator, was the first to establish any French claim to the New World. He was sent out by Francis I in 1524 to find a route to China by way of a western waterway. Touching at about Cape Fear on the present coast of North Carolina, he sailed north. He discovered the Hudson River, and may have found the present Narragansett Bay, Newport Harbor, and even the Gulf of St. Lawrence. The voyages of Jacques Cartier were the real basis of the French claims to Canada. In 1534, he set out to find the passage to China that had evaded so many others. That year and the next, Cartier explored the St. Lawrence River as far as Montreal, where he visited the Indian village of Hochelaga. No serious effort at colonization was made

until the coming of Samuel de Champlain. Champlain established Quebec in 1608, appreciating that this site was the key to the St. Lawrence River Valley. He explored much of the land and made frequent voyages to France to advance Quebec's interests. In 1629, he was forced to surrender his beloved city to the English, but when Canada was restored to French hands he came back to his post. His wife, whom he had married when she was but twelve, became a nun on his death in 1635.

Jamestown—1607

On December 19, 1606, 105 colonists and 39 mariners sailed from England on a voyage that took them five months to reach a wilderness island in the New World, which they named Jamestown, after the King, James I. The first permanent English settlers arrived May 13, 1607. There is little data on the three ships used by the English settlers; even the names of the two larger vessels are not known for certain. The largest of the three ships, the SARAH or SUSAN CONSTANT, was a 100-ton vessel. GODSPEED, the smallest of the three, was a four-ton ship. The DISCOVERY was a 20-ton vessel.

Drawn here is a 17th century merchant ship that may have been fairly typical of the size of the SUSAN CONSTANT. Meals were cooked by the passengers in good weather at an open fire on deck. The small ships were overcrowded and rat-infested, and the bilge water reeked. When the first supply ship arrived eight months later from England, only 38 were alive of the 105 settlers.

Henry Hudson's HALF MOON

The story of Henry Hudson and his ship "DE HALBE MOEN" or HALF MOON, which played a great part in the history of our country and the river bearing his name, needs no repetition. There is something to be said about the ship that never seems to come out in the tales of the Hudson voyage. HALF MOON was a small merchant ship with lines of the 16th century ships. The ship had a steep sheer fore and aft, a narrow high stern transom, whereon appeared the crescent moon, from which the HALF MOON took her name.

She also carried two shields displaying the lion of the United Province and the arms of the Dutch West Indies Company under whose ownership she sailed. HALF MOON's decks consisted of a short and rather steep forecastle, and a low half-deck above which appeared the round hood of the steerage or helmsman's position. Above that, up the

steep ascent of the half-deck, was the poop deck. This ship was common for this type of vessel found in all north European countries. Rigging for HALF MOON was simple but adequate: chains were used to secure the lower deadeyes to the ship sides, and the chain wales were set rather low. The bowsprit was rigged with a jack staff, the precursor of the spritsail topmast. The fore and main masts bore courses with bonnets and the high narrow topsails of the day, without reef points.

Hendry Hudson sailed for the Dutch to find a westward route through the heart of the New World to the Indies. He sailed his ship, HALF MOON, into the harbor and up the river in 1609. After seventeen days he was convinced that this was not the route or direct passage he was seeking, and he set sail for home. He was sailing north on the river and discovered the great bay that now bears his name. In the winter his ship became frozen in the ice. When spring came, he tried to sail north, but his crew mutinied and set him adrift with some of his men in a small boat. Hudson disappeared among the ice floes of the Arctic and was never seen again. The crew returned to England and was tried and punished for mutiny.

The Word "Hulk"

During the early years of the 16th century, the word "hulk" was applied to a type of large-size ship. The vessel was round sterned, square tucked, high pooped and covered with teak clench work or skids. The rigging of a hulk was substantially that of the ships of a corresponding period in time. The appearance of the Dutch flute in the course of the century seemed to have marked the hulk's extinction. Hulks were recorded in great fleets and ranged in size from one hundred to eight hundred tons.

The Mediterranean counterpart of the hulk was a type of vessel called a Marsillian. The word "hulk" today means a ship reduced to its purest state, the death of a vessel, or the remains of a once proud vessel. In its day, the hulk was considered as a cargo carrier of the first class. In the 16th century, maritime trade was expanding rapidly and with the increase in size of the ships themselves, the conditions and comfort of the sailors improved also, but slowly.

The SEA VENTURE

On July 23, 1609, the SEA VENTURE, the flagship of nine vessels sailing from England to Virginia, became separated from the rest of the fleet by a terrible storm. Bailing water and miraculously still afloat, they sighted Bermuda and launched the

ship's boats, finding to their surprise an abundance of wild pigs (left by the Spanish who discovered the island in 1503), fish, birds, turtles, prickly pears, palmetto, and tall cedar trees. Bermuda is often confused with the Caribbean, or Caribbean Islands.

It is hundreds of miles north, about 508 miles off Cape Hatteras, N. C. During the time the survivors were on the island, two children were born, a boy and a girl, named Bermuda and Bermudas. Their father was John Rolfe, who later married for the second time the famous Indian princess Pocahontas of Virginia. Almost a year later, the crew set sail for Virginia, aboard two ships built from cedar and the remains of the SEA VENTURE. The names of the ships were the DELIVERANCE and the PATIENCE. The wreck of the SEA VENTURE is immortalized in Shakespeare's "The Tempest," and a replica of the DELIVERANCE can be toured on Ordinance Island in downtown St. George where the ocean liners tie up. The English called Bermuda the "Isle of Devils," after coral reefs and hurricanes had caused numerous shipwrecks. Navigators learned to avoid the islands; however, it was a shipwreck that gave Bermuda its first permanent settlement. The first official settlers arrived in Bermuda in 1612, and the town of St. George was founded. Named after the patron saint of England, St. George was the capital until 1815, when the government decreed that Hamilton, more centrally located, be the new capital.

The MAYFLOWER

The Pilgrims sailed their ship to Cape Cod in 1620, landing first at Provincetown, but settled in Plymouth. A national monument commemorates the Pilgrims' first landing site in America. The MAYFLOWER was not a new ship when she sailed to America. It has never been known for sure where or when this ship was built, she was definitely afloat in 1606, and was maybe even older. There had been two ships called

MAYFLOWER in the English fleet fighting the Spanish Armada in 1588. It is believed that one of these ships was used by the Pilgrims when they sailed from England. Old records dated 1606 refer to the MAYFLOWER and her captain, also the dates from 1609 until 1620 show the MAYFLOWER sailed with master, Christopher Jones, the same Jones who in 1620 sailed the Pilgrims on their historic voyage to America. This ship may also have engaged in seasonal Greenland whaling. History tells us that the Pilgrims had left England for Holland because of religious intolerance.

The Pilgrims bought the SPEEDWELL, a sixty one ton vessel, and chartered the MAYFLOWER for one year. On August 5, 1620, the two ships sailed from Southampton, England. The SPEEDWELL, a smaller and older ship, developed leaks, and soon proved to be unseaworthy. Twice the two ships had to return to England. The MAYFLOWER finally sailed alone from Plymouth, England in September of 1620. The voyage was plagued by storms and the MAYFLOWER was nearly lost on several occasions.

The Speedwell 1620 — Campbell

The storms blew her well to the north of her intended destination making her landfall at Cape Cod in November of 1620. The first site where the Pilgrims landed (where Provincetown is now built), was not a suitable site and after a reconnaissance of the area, the Pilgrims decided to land on the opposite side of Cape Cod Bay at a spot they had named Plymouth. It was here they decided to establish the first permanent settlement in New England. The hardships had barely begun and half the colonists were to die within a year of arrival. Since the Pilgrims had decided to land in New England instead of in Virginia as planned, the patent given to them by the Virginia Company of London before they left England did not apply. In order to prevent disorder and separation after landing, they drew up a historic measure, known as the Mayflower

Compact, and signed by the male passengers. This compact was one of the earliest examples of self-government in America.

The MAYFLOWER had been used during the winter as a support vessel, and in April 1621, she left the struggling colony for England. Records show that Captain Jones died at Rotherhithe in 1622, and his ship MAYFLOWER may have been laid up after his death and allowed to become ruined. According to historians, some of the MAYFLOWER's timbers are part of a barn in Buckinghamshire and two of her masts are used as pillars in a chapel at Abingdon by the Thames.

The Mayflower Voyage

Mayflower II Plymouth, Mass.

No contemporary drawing or plan of the MAYFLOWER has survived, except that she was believed to be 90 feet in length and a ship of 180 tons burden and that she hailed from Port Varmouth on the east coast of England. The MAYFLOWER had three masts, the fore and main were square-rigged in the simplest manner, while the short mizzenmast behind the poop was rigged to fly a lateen sail. Across the foredeck was a forecastle built like a small house. Her stepped-up poop deck suggested the appearance of folds of a winged gull at rest. Between the forecastle and the poop deck

was a low waist deck; this was where most of the settlers would gather. The chimney from the galley stuck up out of the MAYFLOWER'S forecastle.

Meals were a community affair and each day new orderlies were picked to serve. Food that had to be cooked was done all at one time and had to do for several days, dishes were served cold and sparingly. In the hole the crew's cook would check his stores by testing the soundness of the barrels with a tap from the side of his boot, then he would lift the lid where he could sniff the contents. There was salted pork, a little bacon, peas, oats, dried salt cod, onions, turnips, smoked herring, flour, unmilled wheat, and biscuit bread. There were also several barrels of watery light beer, perhaps a provision against the drinking water of the New World. Enough food was stored on the MAYFLOWER for almost a hundred men, women, and children for not less than two months on the open sea, and three months after landing.

While the crewmen went about their tasks, the settlers crowded about the narrow limits of the middle deck. During good weather this was where the women would dry their clothing. The middle deck was a constant beehive of activity. The children of the families were quite at home onboard the ship, running about from morning to light. Women orderlies were kept busy seeing to it that no one fell overboard or climbed into the rigging. There were four tiny cabins in the poop allotted for a special few. The MAYFLOWER had two holds, the first was free of gear except for the fishing boat carried in sections, a twenty-five-foot boat which was to be used when they landed in the New World. With a hundred and two settlers and a crew of twenty-five, space was at a premium, each family or single person had their own square feet of deck to call home till the end of the voyage. The passengers below in the second hold were not so comfortable; their space was shared with spars, rigging, cables and some of the lighter cargo, the only ventilation being by way of the hatchway to the first hold. Most of the gear below was made fast in preparation for rough seas ahead. Rats on board the ship caused a fearsome feeling knowing as you lay on the floor you were sharing your quarters with them.

The passengers were constantly seasick from the endless motion and never ceasing creaking and rustling of the rigging. In both holds the settlers were constantly awakened during the night by those who were seasick or the wailing children. These agonizing groans became familiar sounds day and night. The passengers could not wash daily; the ship's drinking water had to be used sparingly. It had to sustain them for two to three months at sea. They were also advised to forget about soap and water till they reached land; in the salt winds one's skin kept best with a dry wipe now and then, when in a

sweat. Dirty clothing hung on the waist deck to be freshened in the winds. This was a source of entertainment in more ways than one for the ship's crew. It was said that if you try and wash in the sea water you would begin to look like raw meat. Your skin would crack open and the wind would dry it out even more. Cleansing was only one of the many problems for the settlers, as cockroaches were a constant complaint.

The Battle Royal for The New World

Columbus opened the door to the New World, and Spain claimed it all. For three centuries Spain fought to keep her wealth and land from other European competitors, the English, French, and the Dutch. The New World was not to be a monopoly for one empire, and so it was that a parade of sea wolves from around the world came to the gates of Spain's new empire for their cut of the pie. John Hawkins in 1563 began selling African slaves to Spanish colonists in the Caribbean. Another Englishman, Francis Drake, would soon become a thorn in the flesh with his harassment in the New World. A century later, Henry Morgan, a bloodthirsty buccaneer, took a lion's share of Port Royal and from here he ran over Spain's Caribbean strongholds, torturing women and children, slaughtering prisoners, and generally raising hell. Port Royal became known as the "world's wickedest town" when it became a pirates' den after England seized Spanish Jamaica in 1655.

Port Royal — The Sunken City

Port Royal became the "hub of the Caribbean" and one of the most cosmopolitan cities in the West Indies. There was money to be made in the sugar, slaves, and raw material markets. Port Royal became the home of pirates the world over and a wealthy maritime center with a reputation as a city of cutthroats, taverns, and brothels. At the height of Port Royal's prosperity, she had an estimated population of 6,500 people and as many as 2,000 buildings. There were many buildings built of brick and some were even several stories high. However, the world came to an end for Port Royal on June 7, 1692, when a severe earthquake shook two-thirds of the city to her knees and it slid into the ocean. In less than two minutes, 2,000 people would die instantly by the earthquake and tidal wave that followed. In the days to come, another 3,000 people would die of injuries and disease. This 17th century disaster by earthquakes and floods can be compared to the Pompeii story, a prosperous city which suddenly became buried by volcanic ash, and became a time capsule entombed as if by a giant hand of fate. Published in a London

newspaper was the following account: "Port Royal in Jamaica sank in the ocean after an earthquake and tidal wave that hit the island giving terrible warning from God that man should mend his ways." Survivors combed through the devastated remains trying to recover whatever they could from the sunken city. Port Royal was virtually a forgotten city until 1859, when a Royal Navy helmet diver identified the remains of Fort James, marking the northwestern edge of the original city.

Post-Mill

French corsairs wreaked their share of havoc on ships of the Spanish fleet. The French worked their way from Guadeloupe and Martinique to Hispaniola. Ships from other great powers came with cannons ablaze, warships stood beam to beam and, in a maze of smoke, ripped one another to matchwood as raiders tore into the Spanish fleets. It seemed as if all the world was up for grabs. The sea ran red in the struggle for the treasures of the New World. The Dutch were in on the action as well. In 1628, Pieter Heyn hijacked virtually an entire Spanish treasure fleet off the coast of Cuba. The Dutch holdings were minor, but her role as a trader and naval power was major. The Dutch opened up for business in 1624 with a trading post on the Hudson. Manhattan, site of New Amsterdam, was quickly purchased for 24 dollars' worth of gewgaws. In 1664, the island became New York when the Dutch surrendered to an English fleet. The Swedes

had their hand in the pie, some 200 lived at Fort Christina, built in 1638. The Dutch in 1655 took control of the fort, and later this site became known as Wilmington, Delaware. Other nations were not content to plunder Spanish held colonies but to seek their own land holdings. England and France thrust their flags into the soil north, a land later to be called Canada. The Hollanders and Swedes dogged English footsteps along the Atlantic coast. The French made their mark by exploring and annexing a vast swath of the Mississippi. The apex of Spain's New World in the mid-1700s began its decline with Florida being ceded to the U.S. in 1750.

The Royal Navy from The King's Broad Arrow

For nearly a century and a half, the coast of Maine was the easterly border of the vast tract of forest land which was to furnish the Royal Navy with great masts. The great forest which was to be known as the white pine belt bordered the sea from Nova Scotia to New Hampshire and reached back into the country west of the Connecticut and Hudson rivers. Henry Hudson's first voyage in 1609 was logged as the earliest record of taking a mast on the coast of Maine. A mast was cut and stepped for a foremast aboard the HALF MOON, Henry Hudson's ship, which he sailed for the Dutch to find a westward route through the heart of the New World to the Indies. England received her first cargo of masts in the summer of 1634 from New England. The approaching depletion of England's native forests necessitated her shipbuilders to turn to the Baltic region for naval timber and masts. The Dutch wars of the 17th century all but cut off this supply of lumber for ships of the Royal Navy. In desperate straits, England turned to the colonies, and in 1652 there began a regular supply line of timber and masts for the great ships of the Royal Navy for a century and a quarter. The first step taken to control the forests in the interest of the British Crown was to appoint Edward Randolph, in 1685, as Surveyor of Pine and Timber. Randolph began at the Penobscot and reported large fir trees from 20 to 34 inches in diameter on the Mount Desert Island and the Sheepscot.

He reported that on the Kennebec there was an almost untouched tract where forty or fifty ships might load with pine or fir and masts, boards, and blanks. In 1691, England appointed a surveyor for the forest of the coast. White pine with a diameter of 24 inches at the base or one foot from the ground were suitable for masts or bowsprits. With his marking hatchet, the surveyor made three cuts through the bark, resembling the barbed head of an arrow or the track of a crow, the ancient sign of naval property. The very existence of the North American forests played a vital part of the struggles

for Continental supremacy in the eighteenth century. England and France needed the forests of Maine to supply the vast timber to build their ships. Many a famous man-of-war, both English and French, crossed Maine spars slow and aloft...The VICTORY, Nelson's flagship at Trafalgar, had masts cut from the forests of Maine. The frigate CONSTITUTION, was built with a keel of white oak from New Jersey, timbers of live oak and red cedar from Georgia, and masts of white pine from Maine.

The American Revolution rendered King George's broad arrow meaningless. France became a good market for American masts. In the latter days of wooden man-of-war ships all the navies of the world flew their pennants at the peak of a Maine mast. As early as 1820, the great white pine became more and more difficult to find. The demise of ships made of wood may well be a direct result of the inferiority of the wood used in ships today.

In summary, this chapter has featured some of the most discussed historical voyages across the Atlantic Ocean from the European continent to the New World. In the next chapter, we will continue to look west and consider more exploits across the great Pacific Ocean.

CHAPTER II
GREAT EXPLOITS AND MASTERS OF THE SEA:
Pacific Explorers, Sea Rovers, and the Ocean Conquest

Ships from the old world may have had silver dishes and other signs of comfort, as we know from salvaged sunken vessels, but life aboard was not all that fascinating. The constant fear of the unknown, the perils of pirates, and the ever-changing weather were a constant threat. There was the problem of never having dry clothing or bedding. Water was everywhere, but there was little chance for bathing. Quarters were exceedingly cramped; meals were old with little variety. Long voyages were likely and were not rarely mutinous in the face of the unknown.

Despite the dangers and hardships, there were those who had the stomach for such a life. Sailors and explorers born within the circle of Europe in the 15th century saw the world and themselves as the center of all life. However, there were a few willing to venture into the uncharted waters. The world seemed to be opening to the new horizons in the 16th century as English galleons confronted Spanish treasure ships and as the Dutch East India Company and the English East India Company were incorporated. The scene was now set. The race for trade in the 17th and 18th century was on. It was as if the whole world was up for grabs.

The Pacific Ocean saw its share of explorers. In his Pacific discovery voyages in the 18th century, Captain Cook was surprised to see Polynesians sailing twin-hulled dugouts with crab sails and crews of two to three hundred men on board. Some of these island craft were 130 feet long.

Variations of this type of ship were found in the Caroline Islands in the west, in the Hawaiian Islands in the north, and in Tahiti in the south.

Polynesian Navigators

Ancient Polynesian sailors were skilled master navigators. Without compass or charts, these islanders were able to find and colonize a constellation of islands scattered over 15 million square miles of ocean. Sailing without instruments, these great navigators could steer by star horizon courses, find latitudes of islands by knowing their zenith stars, bird zones, and wave patterns broken by islands. The wind, waves, stars, and birds were all signs known to these early sailors. The mysterious "te lapa" lights flashing far under the Pacific waters were another phenomenon known to these early men of the sea. The "te lapa" are streaks, flashes, and momentary glowing plaques of light that keep appearing well below the surface. They dart out from the direction of an island. The phenomenon is best seen 80 to 100 miles out and disappears by the time a low atoll is well in sight. "Te lapa" lights are quite different than ordinary surface luminescence. On overcast nights it was customary to steer by the strange lights. There are still a few of the old men of the sea who sail much as their early Polynesian ancestors.

Magellan and His World

The first voyage around the world can be traced to Ferdinand Magellan, who sailed from Spain in September, 1519. Magellan's fleet of five ships and a crew of about 275 men set out to search for a western spice route and to find the shortest route back to Europe. Magellan's goal was to reach the Moluccas or Spice Islands, where cloves and other cooking spices, a source of great riches, awaited him.

Magellan believed sailing around the New World would be a shorter route than around the coast of Africa. His small fleet of ships were very small. In fact, the largest ship was not as big as a modern harbor tug. His largest ship, the SAN ANTONIO, was only 120 tons; the CONCEPTION was 110 tons; the VICTORIA, 85 tons, and the SANTIAGO, 75 tons.

The passage Christopher Columbus pioneered was mainly a sunny trade-wind route to the West Indies. By comparison, Magellan's voyage took an unwilling fleet nearly to Antarctica in order to find a way around South America. Magellan was a man of great drive. He resolved to sail as far as the Antarctic latitudes to find the open passage he only had known by rumor or conjecture. Sailing south to the entrance of the strait,

now named after him, he journeyed a tortuous 38 days on his 360-mile journey to the Pacific Ocean. There was a mutiny among his captains. The crew were caught in the doldrums and were wild-eyed from their suffering. Provisions were so meager that the crew was forced to chew leather and to eat rats to prevent starvation. Their water was dirty. Their biscuits were infested with worms, smelled of rat urine, and turned to powder.

Finding the Pacific was Magellan's greatest discovery. Though the Spanish explorer, Vasco Nunez de Balboa, had sighted the Pacific Ocean in the year 1513, Magellan was the first European to put it under his keel. Little did he know that on that day, November 28, 1520, he had discovered the largest ocean in the world. The Pacific is 66 million square miles including adjacent seas and covers an area roughly 20 times larger than the United States of America.

Once in the Pacific, Magellan's crew finally reached Guam, then the Philippines, where Magellan and several of his crew were tragically killed by natives on April 27, 1521. With only two ships left, the fleet finally reached Moluccas on November 8, 1521, where they filled their ships with precious cloves. The expedition continued west around Africa far out to sea to avoid capture from Portuguese ships along the coast.

Only one ship, the VICTORIA, with a remnant crew of 31 men, survived and achieved the distinction of being the first to circumnavigate the globe. Although Magellan had not completed the voyage, his expedition had discovered the Strait of Magellan, Guam, and the Philippine Islands. He had given a name to the world's largest ocean and proved to all that the world was round. Magellan's wife and only surviving son died while Magellan was on his expedition. His remaining heirs remained unawarded for Magellan's sacrifice from King Charles of Spain.

No one knows where the body of Magellan lies. Juan Sebastian Elcano became captain, and continued the voyage that took three years from the time Magellan sailed from Seville. They finally reached Spain in 1522, but the greatest importance of this voyage was the discovery of the Magellan Strait, which opened up a new route to China and India. From the log of the VICTORIA, geographers realized for the first time the true size of the earth. This opened the way for Spain and Portugal to lay claim to a monopoly of these ocean routes. However, England and Holland did not buy this plan. France was the first non-Hispanic nation to mount a search for an alternative westward passage to China. With a ship provided by King Francois I of France, two Florentine brothers, Giovanni and Girolamo da Verrazzano, sailed to America reaching the coast near the present Cape Fear in North Carolina and sailed north. Reaching Pamlico

Sound, they thought they had reached the Pacific. When they realized their mistake they sailed northward again. They were the first Europeans to enter New York Bay and Narragansett Bay, the site of Newport in Rhode Island. They may even have reached Newfoundland after rounding Cape Cod. Returning home with little value, Francois I would not finance a second voyage. England would have to fight for new markets to the east and west. She was not in a position to do so until near the end of the 16th century, when the new galleon design was introduced. Magellan's great round-the-world voyage was followed 58 years later by Francis Drake, this was more of a privateering voyage directed against Spain.

Pirate, Privateer, and Buccaneer

Around the year 1550, piracy became big business when the great European nations such as England, France, Spain, Portugal and Holland all began shipping great wealth home from their overseas colonies. Many of these ships were laden with gold and silver from the far-off lands. The Age of Piracy lasted through the 1700s and finally trickled away in the 1800s with the advent of steam and the telegraph.

Some of these pirates were a grubby lot, and wild stories always followed them. One such was "Blackbeard." He would board a ship with slow-burning matches crackling in his greasy hair. Blackbeard's real name was Edward Teach, an Englishman who turned pirate after being a legitimate privateer. He sailed the QUEEN ANN'S REVENGE, a 40-gun warship. During a vicious fight, Blackbeard was shot dead by Lt. Robert Maynard of the British Navy.

The fight was devastating for Maynard and his men, as 21 of his crew of 35 were wounded by Blackbeard and his pirates. Blackbeard, seeing victory within his grasp, said, "let's finish them lads, jump on board and cut them to pieces." The two crews met head on in hand-to-hand combat on the British vessel, with pistols firing, cutlasses

clanging, and men shouting as they fought with knives and swords. When Blackbeard went under Maynard's guns, the remaining pirates still fighting cast down their weapons and surrendered. Blackbeard's corpse had 25 wounds, five from pistol shots. Maynard ordered Blackbeard's head cut off and tied from the bowsprit, and with that grisly trophy, he sailed home to Virginia. Blackbeard's death marked the end of piracy in America and for his cohorts, the end was near. There were only a few pirates remaining to annoy shipping in the Atlantic in the late 1820s. However, Benito de Soto, a Portuguese diehard, and his ship the BLACK JOKE, were feared by all who crossed his path. Homeward bound on February 21, 1828 in the South Pacific, the barque MORNING STAR met with de Soto and his pirates as they blasted the unarmed MORNING STAR with cannon shot. The captain of the unarmed ship was summoned to the pirate's ship; he was slow to answer the sea wolf and as he stood before de Soto. The pirate roared, "thus does Benito de Soto reward those who disobey him!" With that, he raised his cutlass and offed the captain's head. The women passengers were brutally raped and thrown into the hold while the men had been clubbed and cut down. The pirates next riddled the ship's hull with holes and left her to sink. The crew of the MORNING STAR managed to force open the hatch, man the pumps, and keep the ship afloat. De Soto sailed into Gibraltar where he was later recognized by some of the crew of the MORNING STAR. Benito de Soto was tried, convicted, and hanged in short order.

One of the last instances of piracy in the Atlantic took place September 20, 1832, when the American brig MEXICAN, bound from Salem to Rio de Janeiro, was overtaken by Pedro Gibert aboard the pirate schooner PANDA. The pirates looted the ship, then slashed the rigging, and set fire to the galley while the crew was locked. Eventually, the crew freed itself and gradually doused the fire. After six weeks at sea, the crew managed to return to Salem. Pedro Gibert was caught and hanged in 1834.

The one name that stands out among the last and most lethal of the pirates was Captain Bartholomew Roberts. He was an outstanding master mariner, but as a ship's officer of working-class origin, he could not have commanded his own ship in a legitimate service at sea. As a pirate, Roberts' expertise and experience made him a match for any ship. Even his style of dress had a ring of class; his damask waistcoat and breeches were a rich crimson red, his tricorn hat had a red feather, and around his neck was a gold chain with a diamond cross hanging from it. He carried two pistols on the end of a silk sling over his shoulders and a sword at his side. Roberts feared no one and if crossed, he would kill a man on the spot.

Captain Bartholomew Roberts set sail in July of 1719 with his ship the ROYAL ROVER and a crew of cutthroats that made history in the Golden Age of piracy, a period in marine history that lasted barely 30 years from the close of the 17th century to the first part of the 18th century. No one has achieved the nearly impossible task of calculating the amount of plunder that was taken by pirates during this time when great prize ships were up for grabs.

Roberts had an incredible career. In less than four years, he and his men had captured a staggering total of over 400 ships. He made the entire Atlantic his hunting ground, from West Africa to North and South American seaboards. Captain Chaloner Ogle, of the H.M.S. Swallow, finally brought Roberts to justice in February of 1722.

Roberts and his ship the ROYAL FORTUNE set a course to take on the H.M.S. SWALLOW, a daring unexpected maneuver. Wearing his crimson waistcoat and breeches, his silk sling with its two pairs of pistols, and his sword waving at the war ship, Captain Roberts took a shot that had struck and tore open his throat. As he had always requested, his body with all his finery was thrown overboard. Captain Roberts' rampage along the Gulf of Guinea was his last great act of his extraordinary saga on the high seas. His unexpected death before age 40 ended his days of bravado, unnerved his crew, and ended the four-year reign of plunder in the Atlantic.

Sir Francis Drake was called a pirate in his day. He took a fortune in loot from the Spanish. Before starting to cross the Pacific for England, he had to dump 45 tons of silver into the bay off Plate Island. Of the hundreds of pirates that sailed, only a very few actually had enough treasure to bury. Most of them squandered their loot and lived fast and died young.

Not all pirates were an illiterate sleazy lot. A Frenchman named de Lusan was one of the more polished, highly educated of the notorious pirates and a devout churchgoer. His piracy took in many Spanish ships, but when he returned to France and set up his new lifestyle, it was one of a gentleman. He was one of the society set, fought several duels, and wrote a book about his adventurous life as a pirate.

The richest and most loathsome pirate of them all was Henry Morgan. He was a man of rich desire. During the peak of his career, he commanded a fleet of 37 ships and 2,000 men. Morgan was eventually captured and brought to England where he was to be hanged, but after several million pounds had changed hands, Morgan was spared. He was given a title Sir Henry and made the Lieutenant Governor of Jamaica. Morgan's greatest success was his raid on Panama, the richest town of the Spanish-American empire. Henry Morgan regarded himself as a buccaneer and not as a pirate. There was

always a fine line between being a privateer, buccaneer, and pirate. In his new post as Lieutenant Governor of Jamaica, he secretly financed his brother as a pirate. Morgan was recalled to account for his double-dealings and suffer accordingly. The fate of this shrewd pirate is one of great mystery; there is no record of him from this point on and his manner of death has never come to light. Henry Morgan simply disappeared without a trace.

Piracy is said to be man's third oldest profession, after prostitution and medicine. Piracy flourished widely among the early civilizations from the time man first went down to the sea in ships. There was no monopoly among nations or nationality for piracy, as they all had a hand in the pie.

Privateer

The word "privateer" was given to privately owned and privately armed ships. Privateers were not really considered to be pirates, although they engaged in many similar activities. At this time most nations had very small navies and privateers were commissioned by nations to rob, sink, or attack the enemy. However, the crews of many of these ships lived much like the crews of pirate ships. Like pirate ships, many of these vessels attacked any and all ships that chanced to sail their way. Privateering was a term applied to crews who were commissioned by government letters of marque licensing them to raid and loot the shipping of the enemy. The problem was almost every ship became an enemy.

Buccaneers

The term "buccaneers" stems from a French word meaning "a place for curing meat." The French word "boucan" is a grill for smoke drying meat. Because of the warm climate, many pirates lived on the islands of the West Indies. These islands made good retreats for the pirates or buccaneers, for here they could take their stolen cattle, smoke the flesh, and sell it to passing ships.

Although piracy was practiced by many nations, some of the misconceptions about pirates were commonly held beliefs. The idea that pirates were cruel and other seaman were honorable was one such misperception. The act of "walking the plank," for example, was not a true part of pirate culture. The reason why many seamen turned to piracy was to avoid the violent culture and the extreme punishment on board the merchant and Navy ships they were on. Men were victims of sadistic officers who ruled their ships

with harsh discipline. Common sailors were flogged and beaten, and for talking back, a man could be keel-hauled (being scraped across the barnacles on a ships' bottom). Other common punishments included running the gauntlet, being hanged from the yardarms, or being ducked from the yardarms or towed from the stem. It was said that life was brutal in those days. We have changed very little in our gross and economic injustices of today. Tortures at seas were many, and like those of all ages, unspeakable.

A privateer turned buccaneer, who was given an evil reputation which he did not really earn, was Captain Kidd. He was ordered by the King to catch and destroy enemy pirates. During his encounters he picked up some treasures in the process. When he heard that he was wanted for piracy, Captain Kidd returned to England at once. At this point in his life, he made his greatest mistake. All of the treasures that he had gathered he gave to a friend to hold until the trial was over. When he returned for his treasures, his good friend, Lord Bellomont, knew nothing of such treasure or even having kept it for him while he was being charged with piracy. Kidd spent nearly two years in prison awaiting trial. At his trial, Kidd could not go into the witness box to testify in his own defense nor could any of his crew testify on his behalf during the piracy trial.

Captain Kidd was hanged, then later cut down, only to be taped and bound in chains and his head set in a metal harness so that his bones and skull would stay in place when the body tissues rotted. His body dangled in the sun along the Thames River for many years as a warning to those lads who were cut from the same cloth . . . BEWARE. BEWARE.

As for good friend Lord Bellomont, he died nearly three months before Kidd's execution. A building that now houses the National Maritime Museum at Greenwich was bought with part of the money for Captain Kidd's treasure, most of which was never found. Whatever happened to the full treasure of Captain William Kidd is still a mystery. It was believed to be buried close to Cherry Harbor beach on Gardiner's Island.

Captain Cook

Next to Lord Nelson, Captain James Cook remains as one of the most famous seamen of British history. He died knowing that his ventures and achievements in three historic voyages made between 1768–1779 would be the basis for geographical knowledge in the generations to come. James Cook discovered much of the Pacific on his three voyages that is known today from the west coast of Canada and the Hawaiian Islands to New Caledonia. He also sailed around New Zealand, proving that it was not a mythical continent but two large islands. He reached more corners of the earth via the seven

seas than any other man of his time. Captain Cook pioneered the use of the chronometer to determine longitude, a great advancement in navigation. He also helped to control and conquer scurvy, the scourge of seafaring men the world over. Cook made giant steps in navigation and became the father of modem marine surveying.

Cook's first voyage was made on the bark ENDEAVOUR, a Whitby-built bark of 368 tons, round-bowed and deep-waisted, and a reliable but slow sailing ship. With vivid memories of the near loss of the ENDEAVOUR on his first voyage, Cook insisted that on his second voyage there should be two ships. It was agreed, and so it was that Drake and the Raleigh were commissioned for his second voyage. However, it was felt this might offend the Spanish who still claimed the Pacific as their own, so they were again rechristened RESOLUTION and ADVENTURE.

On Captain Cook's third voyage to the Pacific, while captain of the RESOLUTION, he was killed at Kealakekua Bay, Hawaii, on February 14, 1779. The Priests of Hawaii had mistaken him for the god Lona who one day was supposed to return to earth. It became apparent to the Priest that Cook and his men were mere mortals. A fight ensued and

50

Cook and 17 natives were killed. There is a monument marking the spot where the fight took place on the Big Island of Hawaii where Captain Cook was killed.

In Hawaii, Cook's memory was held in the greatest veneration until about 1850. Then an American missionary, the Rev. Sheldon Dibble, decided to revile Cook's memory. He taught his distortions as history; they were accepted until Cook was detested by all Hawaiians and many Americans as well. It was not until this century that the truth was revealed and Captain James Cook's good name was rehabilitated.

In 1978, British Columbia dedicated the entire year to celebrate its own unique bicentennial—the 200th anniversary of the arrival of Captain James Cook. More famous for his discovery of Hawaii and New Zealand, Cook was the first European to record setting foot on what was to become known as British Columbia, Canada's western-most province. In March, 1778, after two storm-tossed months on the Pacific, Captain Cook's expedition found safe anchorage in Nootka Sound on Vancouver Island at a spot still known as Friendly Cove.

Captain James Cook. Highlights of the bicentennial celebrations included sail-ins by the Tall Ships of the World, and visits from several modern navies.

The BOUNTY

The story and history of the BOUNTY has become one of the classic sea legends of all times. In 1787, King George III sent Lt. William Bligh, Commander of the BOUNTY, to Othaheite Tahiti in the South Seas to load breadfruit plants for transport to the British colonies in the West Indies. The voyage of the BOUNTY left England on Christmas Eve, 1787, intending to

round Cape Horn, and after a month against heavy seas, Captain Bligh reversed course and bore away for the Cape of Good Hope and an eastward passage to Tahiti. His voyage took nearly 11 months in all. Bligh averaged 4 1/2 knots for the whole voyage of nearly 11 long months, which was not a bad record when you remember his 30 days' beating about off Cape Horn and the frequent calms found in these latitudes. The BOUNTY carried a crew of 46 men.

After a stay of more than five or six months at one of the finest islands in the world, part of the crew, under the leadership of acting mate, Fletcher Christian, mutinied shortly after the start of the homeward voyage. On April 28, 1789, the mutiny of the BOUNTY took place off Tofua, on the way to the Friendly Islands. Captain Bligh and 18 others were set adrift in an open boat while the mutineers returned to Otaheite (Tahiti), expecting a life of ease for the rest of their days. Bligh was able to return to England. Remarkably, he had navigated an open boat 3,618 nautical miles in 41 days to the island of Timor.

When Captain Bligh returned safely after the mutiny, he was the talk of England. He was hailed as a hero and a martyr. Then public opinion changed. It seems Bligh, in all his brilliant career, was always having trouble with the men under his command. He was a strict disciplinarian who knew little about handling his officers and crew. Bligh never got the best out of his crews because he was a driver rather than a leader of men, although he must be given the due credit for keeping his crew in far better health than was usual in long voyages at this period. In Captain Bligh's own words, "The mutiny can be attributed to the charms of the handsome, mild and cheerful women of Tahiti. My men wanted to return to the island paradise where they need not labor."

After stories emerged about Bligh's ill treatment of his men, Bligh became a sadist and caustic in the eyes of the public. Even to this day, this fanatic disciplinarian has taken second place to the irascible nature depicted in the film of *Mutiny on the BOUNTY*.

Christian knew the Admiralty would someday sooner or later send a ship from the Royal Navy to look for him and his mutineers. He sailed back to Tahiti, where 16 mutineers elected to stay on this island of paradise. Fearing that someday they would be taken back and brought to justice before a court in England, Christian and eight others, six native men, twelve women, and a little girl sailed from Tahiti and disappeared. Not until 18 years later was the mystery solved as to where Christian landed. Looking for seals, the ship TOPAZ touched at lonely Pitcairn Island, 1,300 miles southeast of Tahiti. This little island, believed to be uninhabited, astonished the crew of the TOPAZ when they found a flock of women and children and a lone aging Englishman,

the sole survivor of the Pitcairn mutineers. From him they heard the story of violence and tragedy and how, ten years after the BOUNTY landed, all the Tahitian men were dead and of the mutineers, he was the only survivor.

The Character of Bligh and Christian

The real Fletcher Christian, the legendary man who led the mutiny on the BOUNTY in April, 1789, was not in the tradition of Clark Gable and Marlon Brando, according to details from Captain Bligh's logbook. Mr. Christian, according to Bligh's account, was a 24-year-old, swarthy, 5'-9" robust fellow. Bligh writes he has a "star tattoo on his breast and tattooing on the lower back. His knees project slightly to the sides and you could call him somewhat bowlegged. He suffered violent sweating, especially on his hands, which is why he contaminated everything he touches."

Bligh returned to Tahiti and he succeeded in transplanting breadfruit to the West Indies. The final irony is that when the breadfruit reached the West Indies at last, at the cost of mutiny, piracy, shipwreck, murder and exile, the slaves there found it tasteless and would not eat it. Bounty Bay conceals the bones of the ill-starred ship BOUNTY beneath 20 to 40 feet of turbulent water. Her iron ballast bars lie in the surf. Her rudder was found years ago. It is believed that the rudder had snapped off when mutineers ran the ship into the bay to ground her and set her afire.

The Three Mutinies of Captain Bligh

Captain William Bligh has been infamous, known as a sadist who provoked a mutiny on the H.M.S. BOUNTY. The mutiny probably was the most notorious in history. Reaching out for little known facts reveals that Bligh actually was involved in three mutinies. In 1789, Master's Mate Fletcher Christian led the revolt against Bligh and took command of the BOUNTY and set him adrift in an open boat with 18 others.

In 1797, Bligh was in command of the H.M.S. DIRECTOR and became caught up in a chain-reaction mutiny involving the entire fleet at Nore, England. The men were demanding more pay, stronger grog (which had been watered down to reduce drunkenness), and the dismissal of abusive captains. Ironically, William Bligh was not on that hit list. However, he was none the less relieved of his command and put ashore.

In 1808, as Governor of New South Wales, Australia, Bligh came down hard on insobriety and curtailed the sale of alcohol. His stem disciplinary actions set off the Rum Rebellion, and he was removed from his office and held in custody. Afterward,

Bligh returned to England, and in time worked his way up to the office of Vice Admiral William Bligh. Until the day he died, Bligh never was able to live down his reputation as "That Bounty Bastard."

The China Connection

In the year 1784, an American sailing vessel named the EMPRESS OF CHINA, a 360-ton ex-Revolutionary War privateer, worked her way up the Pearl River and dropped anchor in the port of Canton. This was the first ship flying the American flag to reach a Chinese port. This American vessel from New York arriving at Canton caused little excitement in China. However, the event meant a great deal to the struggling young nation called the United States of America.

The American Revolutionary War was over, and victory was ours; however, this newly won independence had brought new problems. The war had disrupted trade with other countries. Great Britain closed the profitable British West Indies trade to all American shipping. American farm and forest products were exchanged for West Indian sugar and molasses. Unless new markets were found for American products, this young nation faced the possibility of financial ruin.

Yankee seafaring men sailed off to distant ports of the world, sometimes without even maps and charts to guide them in search of new trade. America's China trade picked up rapidly by 1789, for as many as 15 American flagships could be seen crowed into Canton harbor. These ships came from all up and down the East Coast along the Atlantic. The main cargo for which American shipmasters sailed halfway around the world was tea. Large profit was the key to the China connection. Other items from the China trade included silk, paintings, fans, silver dishes, and porcelain tableware (which came to be known as "chinaware" or "china"). Other goods that were brought home were nankeen cloth, art, and furniture objects made by skilled Chinese artists and craftsman from ivory, jade, bronze, copper, and lacquered wood. The trade was so brisk by 1850 that in Salem, Massachusetts, as much as one fifth of all household goods were imported from China. Ladies' silk and paper fans were brought in by the tens of thousands.

As the pressure of western markets demanded more handcrafted oriental wares, the Chinese craftsmen started to produce cheap, gaudy items during the 1860s. Ivory objects carved from elephant tusks that were imported to China from southern Africa, Siam, and Burma were among the most highly prized items of the China trade.

American shipmasters knew what they wanted from China, but what could they offer to trade with the Chinese? It was discovered that after trying one thing after another, the Chinese were found to be interested in furs (especially of seals and sea otters), sandalwood (a sweet-smelling wood sometimes burned as an incense in Chinese temples and homes), and "sea cucumbers," an ugly sea animal that Chinese considered delicious when cooked in soups and other dishes.

Complicated trade routes were created by early Americans to deliver this unusual cargo. New England merchants loaded their ships with metal tools, mirrors, and various other knickknacks, and sailed down the Atlantic coast, around the Cape and back up the Pacific coast, eventually sailing to Nootka Sound in the Pacific Northwest. From the Indians of Vancouver Island, they received their cargo of sea otter furs. Sails set for across the sea, they would call at the Hawaiian Islands to pick up a load of sandalwood and perhaps stop at the East Indies for "sea cucumbers" before heading for China. On arriving in Canton, the cargoes picked up along the way were traded for Chinese goods. The homeward voyage usually took them by way of the Indian Ocean, around the tip of Africa, and across the Atlantic to make one complete trip around the world.

The China trade voyage meant more than a year spent on the high seas. It was not unusual to be at sea for three years on the China trade. Profits made it all worth the

time and risks for American merchants and ship owners. The China trade also had an important side effect. Americans received their first good look at the Pacific side of the north American continent. Americans were actually latecomers to the China trade scene. The Portuguese had reached Canton as early as 1516. The Dutch had put into port off the South China Sea in 1624, and were followed by the English in 1637.

When the Americans began to take part in the China trade in earnest, the Canton system was already firmly established. All foreign ships entering the mouth of the Canton River had to stop first at Macao, a Portuguese settlement on the south China coast some 85 miles downstream from Canton. Foreign ships were issued a "chop," a permit with an official seal, at Macao. Then the vessel was permitted to sail up the Pearl River to Whampoa Island where they dropped anchor and moved its cargo to a smaller river boat for the last twelve miles to Canton.

Foreign trading in Canton had little contact with the Chinese people. All business was carried on with a small group known as the Hong merchants. Foreigners were made to observe very strict rules of behavior while in China. Such tight rules irritated the foreign traders. Thus, it was only a matter of time before the resentment between the foreigners and Chinese boiled over. When the true conflict came to light, it was centered on an argument over bringing opium into China. Opium trade was largely controlled by British merchants who had easy access to opium poppies grown in Bengal in

British-controlled India. Shipments of opium were outlawed by the Chinese government, but not very successfully. The opium trade brought enormous profits to the enterprising foreign merchants. The Chinese government began to take strong steps to stamp out the opium trade when serious penalties were decreed for all (including foreigners) who grew, sold, or smoked opium. Bad feelings between the British and the Chinese resulted in the 1839 Anglo-Chinese war, often called the Opium War. The war ended in 1842 with the Nanking Treaty. The island of Hong Kong off the China coast was given to the British. Four other ports in addition to Canton were agreed to be open to foreign trade. These ports were Amoy, Foochow, Ningbo, and Shanghai.

Evolution of the Clippers

In 1844, the Americans gained similar trade and residence rights in China. The way was now open for the trade boom, and the speed on the high seas was soon realized by the China traders who wanted the tea business. This demand resulted in the building of the swiftest sailing ships ever built, the famous China tea clippers. China clippers wrote the last exciting chapter to the days of sailing vessels. Long after the clippers had disappeared from the high seas, there were men who would keep the memories alive of these tall-masted, full-fledged beauties.

Before the design of the clipper, the accepted principle of ship designs was, as one old time ship builder once said, "cod's as the ship moved through the water, riding up and over the crest, while the narrow stern hull left a clean wake with little turbulence." Merchant ships were built along these lines for two centuries; they were safe and dependable but not fast. The perishability of tea inevitably led to the American clipper ships. Old salts could scarcely believe their eyes when they saw the speed of the new clippers.

The original clipper ships built for the New York to China tea trade made investment in these new vessels a very profitable venture. American customers were willing to pay a premium for fresh tea from China. The clipper-ship era started in America and ended in England a generation later. The term "clipper" was derived from the word "clip" as "to go a good clip." With the discovery of gold in California, the clippers were just what was needed for passage to the gold fields.

In the past, the average speed was six knots for oceangoing vessels; thus, 150 nautical miles were regarded as an excellent day's run. With the speed of the clippers of 1850, 250 miles a day was a routine voyage. Then came ships like the CHAMPION OF THE SEAS which sailed 465 nautical miles downwind in a single 24-hour period in 1854. This ship averaged 20 knots, a record that would never be beaten by a sailing ship.

It was the speed of American sailing ships that outsailed the Royal Navy in the War of 1812. A by-product of the second war with England was a vessel later to be known as the Baltimore clipper, small two-masted Chesapeake Bay privateers. Baltimore clippers were not called ships by seamen of the 19th Century. Only three-masted, square-rigged ships qualified for the appellation. It was Yankee obsession for speed that changed the world and produced some of the fastest ships ever to sail.

New York to Melbourne

The RAINBOW. The first ship designed along the lines of a clipper was the RAINBOW. Even the tail masts would go by the boards with the first puff of a gale. Oldtimers saw this radical design as a death ship if ever there was one.

On the first voyage of the RAINBOW, she had set a new record for the passage from New York to Hong Kong and home. In just one voyage, she had earned profits equal to twice the cost to build the ship. She even sailed in the wrong season, leaving New York in the winter and entering the China Sea at monsoon season.

She was an American clipper-ship built in 1844–45 and was considered to be one of the best clipper designs of the day. This ship was built for the China trade, which meant speed at the expense of cargo capacity and low operating costs. The profits from

the tremendous boom-trade during the first leg of the return voyage to California made it necessary to build ships designed for speed.

Newspaper writers of the day wrote more "romantic" literature about clipper ships than any other type or design of sailing ship in the history of sailing. Overly enthusiastic writers singled out this ship to be the culmination of sailing ship designs. However, the clipper was not the highest development of the shipbuilder's art. The remarkably short career (1846 to 1859) of the clipper ship as a distinct type can be traced to the fact this type of design was not economically sound in the long run. Because of the drive for speed, it required large crews and heavy losses of spars, sails, and gear, as well as straining the weakly built wooden hulls, all of which increased operating costs. American clippers were well-built in the sense that they were beautifully finished and constructed with exceedingly fine workmanship. However, they were weak in structural design. But, from the knowledge gained from this type of vessel, many fine ships later developed.

The RAINBOW was built at a cost of $22,500. She was launched in 1845. She was 1,043 tons and measured 159 feet in length and 31 feet in the beam. In 1848, on her fifth voyage, she was lost in route from New York to Valparaiso.

The Chinese Junk. The 2,000-year-old Chinese junk is considered the queen of the world's sailing ships. The word "junk" simply means boat. It was a word to describe all types of Chinese vessels. The traditional fishing junks did not have scale drawings or plans; they were made by veteran craftsman by rule of the thumb and experience.

The ancestors of the early Chinese junks may very well have discovered the Cape of Good Hope 1,500 years before the first Portuguese ships

made their way down and around the Cape. Early Chinese literature gave accounts of junks reaching the Cape of Good Hope hundreds of years before the birth of Christ. Marco Polo, who spent 17 years in Kublai Khan's China (1275–1292), wrote of these split-bamboo vessels with watertight compartments and bat wing sails. It was several centuries before bulkhead-built hulls were adopted into the designs of ships of the west. Another Chinese development was multiple masts and the use of a rudder. It is believed that the true rudder was used in China at least 900 years before it found its way to Europe.

Technically, the Chinese junks were superior to western vessels in size and tonnage. They were floating monsters compared with the ships of the early Spanish and English explorers. The junk was built to follow the example of the "duck" that floats gracefully on the water. With a flat or rounded bottom and abrupt squared stem, raked masts and lugged bat-wing sails, the junk was unique in design. The Chinese "duck" design may have reached back as early as 200 BC.

The Golden age of the Ming dynasty was a period when China's shipbuilding yards were working to full capacity. Junks were needed for a series of seven imperial expeditions, conducted between 1403 and 1433. Admiral Cheng Ho, the Captain Cook of China, sailed the waters of southeastern Asia and the Indian Ocean. This brief 30-year exhibition of power and pomp was the closest China ever came to mastery of the world. The Chinese had invented gun power and introduced it to the west; the day would come that this legacy would backfire with deadly consequences.

It was during the 17th century that the British East India Company was establishing a lucrative trade in tea and silks. The Manchu of China were not interested in any of the British products as pay, only silver bullion. This drain of Britain's silver had to be turned around. Thus, one of the most odious and nefarious trading practices in history took place. Opium from India was traded to China which in time created a national addiction. The British received silver from the Chinese with which to pay for the tea.

English and Yankee clippers became victims of pirates camouflaged as fishermen. The Chinese pirate junks would swarm in around the becalmed ships and overpower them, stripping the ships of everything moveable. Bias Bay, east of Hong Kong, was the most notorious pirate lane on the South China coast. British naval ships were rushed to Canton to stop the pirates. The war-junks were no match for the long-range guns of the British. The pirates were armed with antique muzzle-loading cannons.

The Great Tea Clipper Race of 1866

Foochow Race

On May 30, 1866, four vessels left Foochow loaded with tea within a few hours of each other. This was one of the most famous incidents of the China tea trade. The race was well documented. In London, a bonus was waiting for the first ship to arrive. There was a keen rivalry between the captains who made every effort to get the upmost speed from their ships. Clipper ships were very sensitive to the way they were trimmed, the cargo was leaded so that the ship was not too much "by the head" or too much "by the stern." It was common practice to balance a ship by moving varying lengths of chain cable from the chain locker in the forecastle to the stem for balance. There is a story that Captain Keay of the ARIEL had his cabin, which was right aft, filled with tea chests to give the ship an extra inch or two by the stern, while he moved his quarters to a passenger cabin.

With their cargoes stowed and hatches battened down, the ships were towed to the mouth of the Min River. Their course lay through the islands of the South China Sea, past Anjer Point at the tip of Java, across the Indian Ocean to the Cape of Good Hope, and then a straight run north of 6,000 miles.

For the first part of the voyage the FIERY CROSS led, with ARIEL and TAEPING close behind, and the SERICA in sight. From day to day the ships changed positions and seldom saw each other; they hailed other passing ships for news. At St. Helena, the TAEPING was the leader, with the FIERY CROSS, SERICA, and ARIEL following

in that order. The ARIEL and TAEPING sighted the Bishop Rock Lighthouse within hours of each other on the 5th of September, and the two ships sailed up the Channel together. Their speed was over 15 knots. On the evening of September 7th, both ships docked at London, with the SERICA arriving later the same night, and the FIERY CROSS the next day. The two winners consequently divided the prize after a race that took 99 days and a voyage of 16,000 miles, and only twenty minutes separated the TAEPING, the leader, from the ARIEL. Of the four ships which took part in the race of 1866, only the FIERY CROSS had a long life. In 1889, she sank in the Meday. The SERICA was wrecked near Montevideo in 1872; the TAEPING was lost in the China Seas in 1871; and in 1872, the ARIEL disappeared on a voyage from London to Sydney.

The TAEPING was built in 1863. This vessel was 767 tons, 184 feet long, and could load over a million pounds of tea. The ARIEL was launched in 1865 and she was one of the most beautiful clipper ships built by Robert Steele and Co. The ARIEL, 886 tons, had a length 195 feet constructed with iron frames, planked with teak and elm, and her lower masts were made of iron. The SERICA was built in 1863, and the FIERY CROSS (the second clipper of that name) was built of wood at Liverpool in 1860. In the race from Foochow to London, there were five ships, three of them arrived three hours from each other after 99 days and a voyage halfway around the world. The FIERY CROSS and the TAITSIN arrived in 101 days, this was an astonishingly close finish to this 16,000-nautical mile race.

Far East Trade and the Northwest Fur Trade

Following the hostilities of the Revolutionary War, American shipping was devastated. English ports were closed to Yankee ships. The technological development of fast privateers helped to rebuild American commerce. The ship, EMPRESS OF CHINA, left New York to begin a lucrative trade in the Far East. The GRAND TURK, sailed to Macao in 1785, was one of the first New England vessels to reach the Orient. This ship also made history as a profitable privateer in the war of 1812. The GRAND TURK today is seen in outline on a famous line of men's toilet articles, featured under the trade name of "Old Spice."

The Americans entered the Northwest fur trade in 1787, with Captain Robert Gray who sailed aboard the LADY WASHINGTON in company with the ship COLUMBIA. Gray returned in 1790 aboard the COLUMBIA after completing the first American circumnavigation. American ships had sailed to every corner of the globe seeking

trade by the early 1800s. In some of the islands of the Pacific, the Massachusetts towns of Salem and Boston were believed to be powerful countries like England, because so many ships came from these two ports.

The Russians might have had a stronger hold on the ship NEVA, but it was lost January 9, 1813, on Kruzof Island. This ship had taken part in the first Russian circumnavigation under Lisianskii and Krusenstem in 1803–1806. Some people believe the NEVA bore a rich cargo. With the loss of the NEVA, many legends grew around this ship and its whereabouts. The NEVA was believed to have been wrecked off Cape Edgecumbe near Sitka, Alaska.

Lady Washington

The Northwest Passage

The Northwest passage, the Arctic Sea route across the New World to Asia, had been the dream of European explorers for centuries. Throughout the 4,000-mile-long passage there are more than 18,000 islands. A navigable channel which connected the North Atlantic and the Pacific Oceans, the passage lured many a mariner to one of the world's most forbidding and fascinating regions on the earth. One of the early explorers described what he saw of the Arctic as "a world unfinished by the hand of its Creator."

Sebastain Cabot claimed the discovery of what he called the "hidden secret of nature," the Northwest Passage, during a voyage with his father, John Cabot, when he attempted to find Cathay. Sebastian, like his father before him, had searched in vain for the wealth of the Grand Khan. He was probably the first person to propose the idea of a northwest passage through the New World.

The Northwest Passage holds some interesting treasures. Many of the explorers brought along artists to record their polar experiences. The earliest such record was made by John White, who sailed with Martin Frobisher in 1577. White's artwork was the first rendering of the ice lands north of the American continent by a European.

John Ross, who led three expeditions into the Arctic, was an untrained artist, but his sketches are fascinating.

There were many explorers in the early 19th century. One notable explorer was John Ross, whose first exploration with two ships was in 1818 and second one in 1829–1833. William Parry also made two attempts, the first in 1819–1820, and the second in 1821–1823. Sir John Franklin was lost with two ships and 129 men challenging the hazardous Polar Passage in 1854.

Finally in 1903, Roald Amundsen became the first to navigate the entire passage from east to west after a three-year voyage. As a boy, Amundsen was inspired by the heroism of Captain Franklin. At the age of 21, he gave up his medical studies to go to sea. After serving with a Belgian expedition to the Antarctic, he returned and began his own preparations for a voyage to the Northwest Passage.

Roald Amundsen, the Norwegian adventurer and explorer, bought the GJOA, a small herring sloop of 47 tons, in 1901 for his voyage to tackle the unsolved link of the great Arctic. There had been 50 or 60 expeditions before and all had failed. After repairs, the GJOA was ready to be put to the test. She had a clumsy gaff-and-boom rig, an old-fashioned bowsprit and jib boom, a bit of a cabin aft, a minute forecastle, and little else. Built in Norway in 1872, the GJOA was a very strong ship.

Amundsen packed enough food and equipment into her to last his party of seven, all Arctic veterans, for five years. They left Norway in June of 1903. By late August, the GJOA was through Baffin Bay and among Canada's eastern Arctic islands. Slowly the little sloop drove the ice pack toward the Pacific. GJOA wintered on King William Island for two years, for the ice never opened in 1904. The time spent waiting for the ice to flow was used to survey and make scientific observations and sledging to the vicinity of the north magnetic pole. At last, in August of 1905, the ice parted. Working her way westward and through the chain of ice-jammed straits and gulfs along the northwest coast of the continent, GJOA navigated the "unsolved link in the Northwest Passage." It was 1906 before the little sloop passed Boring Strait and came down the coast into the waters of the blue Pacific. The voyage took such a toll on the 33-year-old Amundsen that those who met him after the voyage reported that he looked like a man in his sixties.

To report the news that the Northwest Passage finally was conquered, Amundsen, with an American and 10 dogs, journeyed more than 400 miles through uninhabited territory and across 10,000-foot mountains to reach Eagle City, the nearest telegraph station. The journey had taken two long months but now the world would know of his achievements. Amundsen had proven the position of the magnetic North Pole and

gathered meteorological observations which were to take scientists 20 years to process. His discoveries showed that Eskimo culture was 600 to 800 years older than previous estimates had indicated. Many of the hills and islands were given Norwegian names as they found and charted their way to the Pacific.

Amundsen began making plans for his next great adventure. He sailed onboard the FRAM this time southward to the Ross Sea and to the Bay of Whales. This expedition made Roald Amundsen's name known the world over and assured him a place in the history books. On October 19, 1910 Amundsen and four other men set off to beat Robert Scott and his men to the South Pole. On December 17th, the Amundsen group had reached the pole and erected a small tent, which Scott found when he arrived on January 18, 1912, just a month after Amundsen had completed his measurements to determine the position of the pole point.

The world did not know of the South Pole conquest until the year after they left. It was fifty years later when the first Norwegian journalist arrived at the South Pole that the journey from the Bay of Whales to King Haakon VII's Plateau took just three hours by aircraft. Today, a dispatch would arrive in minutes.

The Return of The GJOA

Norway gave the GJOA to the United States after its arrival in San Francisco in 1909. In 1949, the GJOA was restored and placed on display in Golden Gate Park in San Francisco, California. The ship became a historic monument there, but by the early 1970s it had become the victim of neglect and vandals. In 1972, the GJOA was put aboard the STAR BILLABONG and shipped home. Arne Borgersen was given the St. Olav Medal of Norway in 1972 for his work in returning the GJOA to Norway, where it is now on display in the Oslo Maritime Museum.

CHAPTER III
THE SEA HERITAGE OF AMERICA:
Yankee Ingenuity and the Founding of a Nation

Yankee ingenuity was the key to building a new nation. From this fledgling young country, ship builders found virgin forest. If the world was to know of America, ships would have to be built to sail the seven seas. Early Americans needed to establish control its coastal waters and great rivers to guard a land that attracted pioneers filled with enthusiasm, young spirit and a willing to fight for what they believed was right. American shipbuilders produced some of the fastest, most beautiful wooden sailing ships the world has ever known.

The year of 1812 found America desperately engaged in a struggle with the most fearsome maritime machine of the age, the Royal British Navy, which numbered some 900 ships and knew only victory in all its action on the high seas. As America met the challenge, it found within its ranks some of the most gallant sea warriors of all time. Dueling like knights in ship-to-ship action, these young Americans were among some of the most brilliant naval men in the annals of fighting ships. The men alone were only a part of the story. The Yankee frigates were smaller than the great ships of other nations, substituting the speed of a greyhound for heavy gun power. American shipbuilders and designers advanced the state of their art to a point where United States frigates would be the envy of the naval architects the world over. The term frigate was first used to describe a kind of galley that appeared in the Mediterranean in the late 1300s. By the early 1800s, most navies had designed some sort of vessel along the lines of a frigate. Admiral Horatio Nelson once said, "Frigates! Were I to die this moment, want of frigates would be found engraved upon my heart."

The Pinnace VIRGINIA of 1607

Bath, Maine, once the world's leading shipbuilding centers, built the first ship by English speaking people in North America, the pinnace VIRGINIA in 1607. A pinnace was a small, two-masted sailing ship of about 20 tons that was often used on

board a larger vessel as a tender or scout. Occasionally it carried a single mast and sail square-rigged.

Bath itself is a beautiful exhibit of the shipbuilding city of yesterday and today. Ships have been built on these shores at the mouth of the Kennebec River from 1607 to the present day. In the days of the sail, Bath was one of the great centers of the world. Between 1820 and 1920 more than 1,000 oceangoing vessels were launched from Bath. In the decades after 1870, more than half the wooden ships built in the United States were Maine-built. Not only did Maine men build sailing vessels, but they also sailed them to all corners of the globe. Ropewalks, chandleries, foundries, and sail lofts flourished on the Maine coast and particularly in the Bath area, which by 1855 was ranked as the fifth largest port in the United States. Today, at the Bath Iron Works is the largest ship-building crane of its type in the Western Hemisphere.

The Birth of a Navy

The British frigates were so successful in stopping Rhode Islanders from smuggling, the General Assembly voted to create the Rhode Island Navy on June 12, 1775. It was the first American Navy of the Revolution. Three days later, the sloop KATY fired the first naval cannon shots to capture the British sloop, DIANA. The KATY was one of the two ships actually written into the bill that created the Navy on October 13, 1775. This 12-gun sloop was renamed PROVIDENCE. On March 3, 1776 she was the first to land the U.S. Marines at the capture of Nassau, Bahamas. This ship was the first command of John Paul Jones. There were three ships in the Continental service at the same time with the name PROVIDENCE.

Some historians believe the first naval battle of the Revolution was the capture of the 70-ton sloop GEORGE by Benedict Arnold on May 18, 1775. However, it should be pointed out that the personnel involved were soldiers under the command of Army officers, not the Continental Navy. The captured 10-gun British sloop GEORGE was renamed by the Americans the ENTERPRISE. The first ship in the Continental Navy was the merchant ship BLACK PRINCE, renamed ALFRED, after the English King who is said to have founded the Royal Navy. This ship was also commanded by John Paul Jones. The British captured this ship in 1780; two years later this vessel was sold out of the Royal Navy. The 24-gun frigate, DELAWARE, was the last survivor of the Continental Navy's original 13 frigates.

In 1775, Congress put together its first fleet at Philadelphia; one of the smaller ships to be included was the Chesapeake Bay sloop HORNET. This ship was mounted with

ten four-pounders. She was burned in 1777 to avoid capture by the British when they took control of the Delaware River.

One of the last survivors of the original 13 frigates authorized by Congress was the 32-gun frigate HANDCOCK, built at Newburyport, Massachusetts, in 1777. This ship was captured by the Royal Navy and renamed IRIS. It was recognized by both the Americans and the British as the finest and fastest frigate in the world.

The largest frigate used in the Revolution was the 40-gun SOUTH CAROLINA. It has never been known for sure if this ship was a frigate or an East Indiaman. This vessel probably had an influence on the design of the frigate CONSTITUTION, which was built about 20 years later and was the largest frigate of her day.

When the Revolutionary War began, the Governor of Connecticut decided that they needed a navy. The ship OLIVER CROMWELL was launched in Essex, Connecticut in June of 1776. There were many American ships in the Revolutionary War named OLIVER CROMWELL, presumably because it was thought that the name would strike terror into the hearts of the Tory.

The Truck Gun

The 32-pound *truck gun* was given its name because of the way it was mounted on wheels. The guns could shoot iron balls a distance of about 1200 yards. The length of the cannon was referred to as the chance, sometimes spelled chase. A 32-pounder received its name from the size of the round shot which fitted the muzzle. A good crew could load and be ready to fire in less than a minute.

The ALLIANCE

The 36-gun frigate ALLIANCE was built in 1776 on the Merrimack River at Salisburg, Massachusetts. Her exact measurements and details are not known. The ALLIANCE and her sister ship the CONFEDERACY were the largest frigates of the Continental

Navy. This ship was the only frigate to go all the way through the war and be afloat when the peace treaty was signed in Paris in 1783. The ALLIANCE was "sold out" of the navy in 1785 and was made into a packet, remaining in the service for several years. She sunk in the Delaware at Philadelphia about 1800.

ANDREA DORIA

The Alliance and the Andrea Doria 1776

The name of the ship ANDREA DORIA before she was purchased for the Continental Navy is not clearly known, nor is it known where she was built or when. This ship was fitted out for naval service with 14 guns and a crew of 130. She was named for the George Washington of another country, the Prince of Melfi, Knight of the order of the Golden Fleece, Admiral Andrea Doria of Genoa, Italy. At the time he was commander of 500 ships. "ANDREA DORIA" meant power of the sea. This ship sunk in the Delaware at Philadelphia in about 1777.

The PHILADELPHIA

Another important early American vessel was the gunboat PHILADELPHIA. Under the command of Benedict Arnold, the PHILADEPHIA was used to help fight the British on Lake Champlain in New York in October 1776. The Americans met a line of advancing British ships with a ragtag collection of newly built boats and fought

the British to a standstill. The PHILADEPHIA was sunk by the British during the battle and rested on the bottom of the lake until 1935, when it was recovered. The ship, with much of its equipment intact, was restored for the Smithsonian Institute in Washington D.C. and came to the Museum in 1964, complete with the 24-pound ball that sent the gunboat to the bottom of Lake Champlain.

BON HOMME RICHARD

The BON HOMME RICHARD was a converted French East Indiaman built in 1765. It was aboard this 42-gun ship in 1779 that John Paul Jones became America's first naval hero. With a small fleet, Jones met a British convoy off Yorkshire. The 44-gun SERAPIS and the BON HOMME RICHARD fought one of history's greatest sea duels. In a bloody battle that lasted well into the night, the SERAPIS surrendered to the American ship and John Paul Jones. Although Jones and his crew were victorious, the BON HOMME RICHARD sank several hours after they boarded the SERAPIS. It was during this battle that the commander of the SERAPIS, Richard Pearson, demanded Jones' surrender to which Jones shouted his immortal words in reply, "I have not yet begun to fight." Jones later commented that he had never seen such a bloody battle. The loss of life was so great on both sides that neither Jones nor Pearson ever issued a full list of casualties. The two ships fought muzzle to muzzle in the moonlight for three hours. When the fire aboard the SERAPIS forced Pearson to surrender, there were only two guns still in operation on the BON HOMME RICHARD. This famous sea battle took place on September 23, 1779.

Shipwreck Found. Searchers found the 1779 wreck of the Revolutionary War ship the BON HOMME RICHARD 150 feet under the sea off Flambrough Head on England's northeast coast. Jones sailed the SERAPIS to Holland to become the hero of

Europe and America. The ship was found with the help of electronic equipment on a survey ship.

The Lost Years of John Paul Jones

John Paul Jones was perhaps the most conspicuous personage on two continents and one of the most paradoxical figures in American history. He rose from the station of humble apprentice boy to the command of conquering squadrons, standing at times at the pinnacle of fame and at other times lost in obscurity. His career fascinates all who make a study of his life. John Paul, the son of an unlettered gardener in Scotland, went to sea at the age of 13 and became captain of his first merchant ship at age 21.

Most of John Paul's life is fairly well documented except for the period 1773–1775. Here is one of the more interesting stories about this man. The story originates with Willie Jones, a patriotic gentleman planter, large landholder, and wealthy benefactor of the needy. It was in Halifax, North Carolina when he observed a young man who appeared to be lonely and despondent walking aimlessly about town. The man was Captain John Paul of the ship BETSY, nearly destitute and traveling incognito on the advice of counsel after having been forced to kill a mutinous sailor in Tobago in self-defense. Willie Jones took John Paul to his home, where he found a haven for rest while he recovered in body and spirit. Tradition has it that towards the end of his stay, he expressed his thanks for the many courtesies extended to him by the Jones family. Willie Jones commented that if he could help in any further service to let him know, whereon John Paul declared that there was one favor he would like to ask and that was that he be allowed to add Jones to his name. He promised to wear it with dignity. Willie, in granting the request, was so moved that he presented John Paul with his sword, which is believed to be the one now on display at the U.S. Naval Academy.

Newport Rhode Island

The 1976 Bicentennial Tall Ships race finished in the historic waterfront city of Newport, Rhode Island. The birthplace of the protected harbor at the mouth of Narragansett Bay together with the favorable climate enabled the small seaport settlement in 1639 to develop into one of the leading colonial trade centers of this country.

In the fifty years preceding the Revolution, Newport became not only a leading whaling and shipbuilding center, but also a port renown for her privateers, smugglers, and lucrative triangle trade, which kept 21 island distilleries busy making West Indian

molasses into rum for the purchase of African slaves sold in the South and West Indies. The American Revolution marked the beginning of Rhode Island's decline as a trade center. Rhode Island was the first colony to declare her independence and as a result, she soon found herself resembling a waterfront ghost land.

In July 1769, the men of Newport had the distinction of making the first overt American move against England when they destroyed the British sloop LIBERTY. Newport had begun to recover from the devastating effects of the Revolution when the War of 1812 and the Great Storm of 1815 decimated the waterfront and tolled the end of the city's prominence in shipping and trade. Over a century later, her distinction in the heritage of American sail was to return with the J-boats of the 1930s. These stately ships or vessels successfully defended America's Cup three times in Newport waters. With the revival of the Cup races in the 12-meter yachts, Newport came to be known as the "Yachting Capital of the World.'" For sixty years or so the Cup had been contested off Newport, Rhode Island, far out where local wind shifts and currents are minimal. A best four-out-seven events, the series can, with its provision for lay-days and the possibility of bad weather, stretch on for nearly three weeks. Since 1958, each race is a "match race" involving only two boats that are exclusively 12-meter sloops designed specifically for the contest.

Ironically, the race that has become so identified with American yachting, but it did not originate on U.S. shores. It was the inspiration of a London trade fair of 1851 that sparked the idea. Ever since the Cup was brought to the United States in 1851, it has been symbolic of America's long-term superiority in yacht racing.

The HANNA – 1775

The first United States warship was the HANNA. George Washington, as commander of the American Army, commissioned Nicholas Broughton to arm and outfit his schooner HANNA as a fighting vessel on September 2, 1775. One of the articles of the commission instructed the captain to not waste any of the ammunition in salutes or for any purpose but what was absolutely necessary. The HANNA went out to sea on September 5, 1775. Her first prize was the ship UNITY, a cargo of naval stores. This was the first ship captured by the Continental Navy.

In October of 1775, General George Washington instructed Colonel Glover of the Marblehead Marines to procure two more ships from Newbury or Salem and prepare them at once for armed sea duty. The mutinous crew of the HANNA had been a source of embarrassment for General Washington. Delays had put great pressure

on Washington, and because of the pressing need of gunpower for the army camped before Boston, four more ships were commissioned in addition to the two new ones, the LYNCH and the FRANKLIN. By October 29, a small navy was ready for action. Washington's Cruisers consisted of the LYNCH, FRANKLIN, LEE WARREN, WASHINGTON, and the HARRISON.

Although these early vessels cruised with some success, they were far from a model navy. General Washington wrote to the Congress: "The plague, trouble and vexation I have had with the crews of all the armed vessels is inexpressible. I believe there is not on earth a more disorderly set."

On December 7, 1779, a letter was received by the President of the Continental Congress, John Hancock. The letter read as follows: "I hoisted with my own hands the Flag of Freedom the first time it was displayed on the ALFRED on the Delaware," signed John Paul Jones. This flag, respected as the first flag of the United States, flew over General Washington's headquarters at New York when the Declaration of Independence was read to the troops. For the first years of the American Revolution, on land and sea, the Grand Union was the nation's flag.

The ensign on the LEE was a flag with a white background, a tree in the middle, and the motto, "An Appeal to Heaven." It was the fashion of the day to display very large ensigns at the stem of centuries of naval warfare that a great banner signified the might of the nation behind it.

Men-of-War Built in America

Men-of-war have been built in Maine for over 250 years. The frigate FALKLAND, of 637 tons, was the first ship of war to be built on this side of the Atlantic and launched in 1690. In 1782 the AMERICA, a gift to the French government, was the first line-of-battleship to be built in this country.

Whatever the causes were for the American Revolution, one of its major effects was the devastation of American shipping. The war had done much to broaden our horizons and a rebuilding program with ideas gained through wartime experience

helped the rapid growth of American ships. Courage and resourcefulness carried our merchant flag to the world's harbors and our nation on to world prominence.

Privateers— All for One and One for All

At the beginning of 1776, the Continental Navy had four ships to put to sea and was far too small to damage the Royal Navy. The task of carrying the war to the British merchant marine fell to American merchant seamen sailing on private ships, the States' navies, and the Continental Navy. Letters of marquee and reprisal were issued to individuals authorizing privately owned and operated ships to capture enemy shipping for profit. Early in the war, privateers started to take their toll. The first privateers were mostly small sloops and schooners, well-armed and carrying large crews so they could man any prize that came their way. Realizing the prize money from the sale of captured goods, many owners outfitted their small ships with six or nine-pound cannons and sailed up and down the coast. Privateering became big business as the hostilities of war grew. A privateer's officers and crew, as well as her owners, stood to gain from capture of British vessels, for each received a percentage of the total prize money.

Sailors preferred to serve aboard privateers throughout the war because their percentage of the prize lot as well as their wages were higher than on Navy ships. Seamen on board a privateer were paid $12 to $16 per month plus a cut of the pie. From the log of one ship, a 14-year-old cabin boy's share of a month's prize was said to total $700 in cash, a ton of sugar, 35 gallons of rum, and 20 pounds each of cotton, ginger, logwood, and allspice. That was a good wage for a lad of 14 in 1777. The prize was great, but the price was also high. The most successful of New England's Revolutionary War Privateersmen was Jonathan Haraden of Salem, a 35-year-old commander who was a cool, easy-going, courageous sailor who endeared

himself to his crew by showing a readiness to take advantage of any luck brought his way. Haraden and his crew captured more than 60 ships, mounting 1,000 guns.

In May of 1780, Haraden set sail with his ship, the 180-ton GENERAL PICKERING, built in Salem, and granted a letter of marque. She carried 16 six-pounder guns and a crew of 45 men and boys. Bound for Bilboa, Spain, with a cargo of T sugar, she planned to hunt enemy shipping on her return voyage to America. In the Bay of Biscay, under the cover of night, she closed unobserved alongside a British vessel and bluffed her identity as an American frigate of the largest class. Taken by surprise and unable to verify the statement in the dark, the Captain of the 22-gun British privateer GOLDEN EAGLE struck her colors. When he came aboard Haraden's ship as a prisoner of war and learned that his ship carried more guns and crewmen, he was furious.

Several days later, GENERAL PICKERING encountered a larger vessel, the ACHILLES, and was able to outsmart this vessel with her crew that outnumbered the GENERAL by three to one. After two hours of battle, Haraden ordered his sweating gunners to load with crowbars, cargo from a previous prize, and anything that would fit in the guns. After receiving this terrible volley, Jones wrote, "I accept his offer the more readily, for after all it was a recognition of our independence."

U.S.S. Constellation vs. L'Insurgente 1799

From the battle at sea on February 9, 1799, in which the CONSTELLATION captured the French frigate I'NSURGENTE, these words made history: "Good discipline is considered by all who know anything of service as the vital part of a ship at war." This was the first test of our new naval frigates. The CONSTELLATION is our oldest warship afloat. This ship can be seen in Baltimore, Maryland, where she was launched September 7, 1797.

In the first decisive naval action of the War of 1812, Captain Isaac Hull commanded the CONSTITUTION, defeating the HMS GUERRIERE in a savage fight which lasted but a half hour. It was on July 19, 1812, that Captain Hull and his ship dismasted GUERRIERE and brought her down, and his ship CONSTITUTION earned the nickname "OLD IRONSIDES." When the two ships came in range of each other, Captain Hull said, "if that fellow wants to fight, we won't disappoint him." This famous ship can be seen in Boston.

During the battle of Lake Erie on September 10, 1813, Commodore Perry made his famous words come to life, "We have met the enemy and they are ours." The victory of the Americans against the British along the Northwest Frontier played a key role in retaining this area for the United States during the War of 1812.

The U.S.S. SOMERS

The 19th century U.S. Navy brig SOMERS, the ship that inspired Herman Melville's novella "Billy Budd," was found in 110 feet of water five miles off Vera Cruz, Mexico in 1986. It was during a training voyage in 1842 that the SOMERS gained its notoriety. It was on board this ship that the Navy's only alleged mutiny occurred in 1842. Three young sailors were hanged from a yardarm for plotting the mutiny. The ship, commanded by Captain Alexander Slidell MacKenzie, was the scene of much cruelty. MacKenzie was later court-martialed on five charges, including murder, conduct unbecoming an officer, and unnecessary cruelty, but was acquitted of all charges. It was after this court-martial that the Navy decided to train officers at a supervised land-based academy. The U.S. Naval Academy at Annapolis, MD opened in 1845.

A team of underwater archaeologists searching for the SOMERS said, "It was the closest thing to a storybook shipwreck they had ever seen." Decay and boring marine animals had destroyed much of the ship's wooden superstructure, but the SOMERS' metal plating had preserved the shape of the vessel's hull.

Sailors shunned the SOMERS after the mutiny and hanging, saying that it was haunted, and several reported hearing screams and seeing the ghostly bodies of the three

sailors dangling from the yardarms. The sinking of the 102 foot two-masted vessel, built in 1842, became the most sensational event preceding the assassination of President Lincoln. It occurred during a gale on December 8, 1846. The ship capsized and went down with 32 of its 76 crew members, while on blockade duty during the Mexican American War. The Navy considers the wreck of the SOMERS a war grave, and any human remains of the lost crew members that are found will be given a military burial.

The SOMERS episode was an overriding influence on Herman Melville, particularly since the SOMERS' second in command, executive officer Guert Gansevoort, was Melvin's first cousin. It was Gansevoort who inspired Melville to go to sea and eventually write the classic tale, *Moby Dick*. It was believed that Melville had not only a personal interest but inside information on the events on board the ship. A movie titled *Billy Budd* was made in 1962 of the classic story.

The superstition that haunted sailors on dark and stormy nights still brought fear to the divers of the expedition as they were hearing things and saying they saw things they could not explain. There were other spooky events that were unlike any other shipwreck. One of the divers, after diving by himself, came up and demanded to know who was yelling at him when he was down in the wreck. It seems as if there were no jokesters playing around. The fellow was surprised to find out that he had been down alone and no one could have been yelling at him.

More archaeological exploration has been planned by the original finders who plan to make a documentary film of the discovery of the ship. Although the discovery was made in June of 1986, it was kept secret until the State Department could arrange an agreement with Mexico to protect the site.

The CALIFORNIAN

This beautiful schooner was built along the lines of an 1849 Revenue Marine cutter. The CALIFORNIAN has a length of 145 feet, a beam of 24 ft. 3 in. and her draft is 9 ft. 5 in. She carries 7,400 square feet of sails and is powered by a 140-horsepower diesel. The ship has a clipper bow with a long jib boom and a figurehead of Queen Calafia, the mythical Amazon queen who appears in a 16th century Spanish romance novel as the ruler of an island in the Pacific called California.

The CALIFORNIAN is a training ship for 14 cadets, on which they learn the art of sailing by concentrated training courses in shipboard safety, seamanship, helmsmanship, meteorology, self-discipline, responsibility, and teamwork. The 135-ton CALIFORNIAN is operated by the Nautical Heritage Society. This vessel is a replica of the C.W. LAWRENCE.

Pride of Baltimore

This graceful topsail schooner was a model of a 19th century Baltimore clipper and was commissioned in 1977 as the PRIDE OF BALTIMORE. It was an affectionate name for an early clipper, the CHASSEUR, one of the most successful privateers active in the War of 1812. The city of Baltimore took great pride in this ship; she was built of better wood than her 19th century ancestors. The PRIDE was a 121-ton vessel, with an overall length of 136 feet and with a beam of 22 ft. 8 in. The ship was the first Baltimore Clipper to be built in 150 years and the first tall ship to represent a city and a state. Unfortunately, this vessel only sailed for nine years before succumbing to a microburst squall north of Puerto Rico on May 14, 1986. The schooner sank quickly with her captain and three crew members, all lost at sea. The PRIDE OF BALTIMORE had logged more than 150,000 nautical miles during those nine years at sea, equal to six times around the globe.

After its tragic sinking, an outpouring of unsolicited public support led to the building of the PRIDE OF BALTIMORE II, which was hoisted aloft and launched from her Inner Harbor birthplace on April 30, 1988.

The Hyder Ally

It was on the morning of April 7, 1782 that the privateer HYDER ALLY, a merchantman under the command of Captain Joshua Barney, made naval history. The HYDER ALLY was named after an anti-British prince. The land war was going badly for the British; however, Britannia ruled the sea. Their blockades strangled the trade of every Colonial harbor.

The British man-of-war, GENERAL MONK, under Captain George Rodgers and several smaller vessels had expected the enemy to scatter and run. Instead, to his astonishment, the HYDER ALLY, which was escorting a convoy of trading vessels to the French West Indies, steered directly towards him under full sail. The bowsprit of the GENERAL MONK rammed into the privateer's forward rigging and became hopelessly entangled, locking the two ships together and rendering the British ship's big guns useless. Captain Barney's Kentucky sharpshooters perched in the rigging picked off the enemy "like squirrels" as they tried to scramble over the bulwarks.

After an hour of deadly battle, Rodgers hauled down his colors, nearly 70 men dead, dying, or wounded. The destruction of the GENERAL MONK, having lost half her crew to a vessel half her size, was one of the most humiliating British naval disasters in the War of Independence.

The story of Captain Joshua Barney did not begin nor end with the GENERAL MONK clash. Captain Barney emerged as the deadliest enemy hunted by the Royal Navy off the American coast. Having plundered and sank more than 20 big British ships or brought them as captives to Philadelphia, with his motley crew of part experienced seamen, part farmers and frontiersmen, Captain Barney became known as the lone wolf of the seas from Long Island to Chesapeake Bay.

Repeatedly with his ship the VIRGINIA, he had slipped through the net of the British naval blockade by a hair's breadth before she was caught and blown out of the water on Chesapeake Bay. Barney was among the captured survivors and for five months he was placed in a prison ship hulk with hundreds of other prisoners in New York Harbor awaiting shipment to England. After he had tried to organize a mutiny, he was placed in double irons. When fever raged through the stinking hulk, the British agreed to negotiate an exchange of prisoners. Captain Barney returned to the action

with a new ship, a 16-gun frigate, the SARATOGA. The SARATOGA was nearing Delaware Bay when she was run down by the HMS INTREPID, and a single broadside settled the fate of the ship.

Once more, Captain Barney was clapped in British irons. Prison walls held the redoubtable Joshua Barney for little more than a year before he made his escape, which made him a legend of the American Revolution. Just how he contrived to flee from the prison in a British naval uniform is still not known. In Plymouth, he found shelter with friends until he was able to escape in the dark of night in a small boat to cross the Channel to France. Stopped at sea by a British cruiser, Barney declared that he was on a secret naval mission. He was arrested, jumped overboard the next night, and was picked up by a French fishing smack.

Eventually, he made his way back to America after having been given up as dead. Returning to his squadron in the Chesapeake Bay once again, Captain Joshua Barney was given command of the privateer HYDER ALLY and a picked crew of sailors. When the struggle ended in 1783, Captain Joshua Barney was a national hero, and for the next 30 years he continued to serve his country.

Gloucester Schooner

This vessel was an American fishing-bark schooner used in Newfoundland waters. Schooners were built with a deep keel and a knockabout bow. Previously, all sailing ships had either a plumb or a clipper bow. With the new spoon bow design, this type of craft was capable of great speed. In 1891, an American yacht named GLORIANA revolutionized racing with a spoon bow, quite like the one pictured in this drawing. This type of ship came from Gloucester, Massachusetts, thus the name Gloucester schooner. This one was built about 1916.

The sport of yacht racing initially developed in Britain. However, in Holland, the sport was well known. The word *yacht* is the past participle of the Dutch word *jachten*, meaning to hurry or hunt. Yacht racing began to spread during the Industrial Revolution, when many fortunes were made and wealthy men were looking for a means to spend their money.

The GLORIANA

In about 1896, the American designer Nathanael G. Herreshoff built the GLORIANA, a small racing yacht but with a hull formed entirely different from anything built up to

that time. Her main feature was a long overhanging bow with the forefoot cut away to produce a straight line from the stem to a very short keel and ending in a long overhanging counter stern. The GLORIANA's hull form has virtually remained standard racing-yacht design ever since. In 1906 the 'meter' rules for the design of racing yachts were accepted worldwide.

The Six Original Frigates

Most of the American ships that went to battle in the Revolutionary War were privateers. Inspired by patriotism and the potential prizes of English ships, they harassed British commerce to no end. During the War of Independence and the War of 1812, in both of these encounters American frigates proved to be more than a match for their English counterparts.

In 1794, the United States Congress ordered the construction of six frigates to protect American maritime commerce. These were the CHESAPEAKE, CONGRESS, CONSTELLATION, CONSTITUTION, PRESIDENT, and UNITED STATES. The CONSTELLATION was the first at sea four years later under the command of Captain Thomas Truxtun.

The CONSTELLATION

The CONSTELLATION was the oldest ship in the United States Navy, launched on September 7, 1797. Thomas Truxtun was appointed by the government to be captain and supernatant of construction of the ship. His job even took him to the forest to hand pick the lumber that went into the CONSTELLATION. Truxtun had gone to sea as an apprentice seaman at the age of 12. While on shore leave in London, he was abducted by the vicious press gang and forced to serve in the Royal Navy. Thomas Truxtun served several months aboard the HMS PRUDENT, a 64-gun ship-of-the-line. When he returned home at the age of 20, Truxtun became a skipper of a merchant sloop, CHARMING POLLY. His ship was later seized by the British-sloop-of-war ARGO, a 28-gun vessel. He later became a privateer well known for his courage, integrity, and navigational ability.

President George Washington selected the name CONSTELLATION from a new group of bright stars, each representing a state in the union. The dimensions of the CONSTELLATION were 171 feet in length on deck, a beam of 40 feet and the main mast towered 150 feet above deck with another 17 feet stepped into the hole. She served as a commissioned ship until February 5, 1955.

It was not uncommon for a captain of an American trigate to issue 100 different rules and regulations at the start of a voyage. A sailor's day began at dawn with the Boatswain piping "Up all hammocks" which was answered with "Rise and shine." At the cry "lash and stow," the hammocks were emptied, taken from their hooks, and lashed up in double time. The crew had 12 minutes to take down their hammocks, bundle them up and stow them in the railed "netting" on the spar deck. Laggards were always awarded the worst tasks aboard ship.

Under the command of Captain Truxtun, the CONSTELLATION took part in the many famous exploits during the undeclared naval war with France. The French gave the CONSTELLATION the name, *The Yankee Racehorse*. This ship served against Confederate commerce raiders during the war between the North and South. She also served as a naval training ship. In 1940, this ship was brought back into full commission as a flagship of the U.S. Atlantic Fleet during World War II. In 1955, the CONSTELLATION was designated a National Historical landmark and is now moored at Baltimore, Maryland.

In August 1972, the CONSTELLATION was moved to Baltimore's Inner Harbor, where, on September 7, 1973, she celebrated the 175th anniversary of her launching. The U.S. Congress officially recognized this occasion by authorizing special silver and bronze medals to be struck by the Philadelphia Mint. The CONSTELLATION was designated the official flagship for the Nation's Bicentennial in 1976.

U.S.S. CONSTITUTION

The U.S.S. CONSTITUTION was launched October 21, 1797. In 1794, five years after the adoption of the Constitution and the beginning of our government, Congress passed an act authorizing the building on purchase of six war ships. This

ship was a combination of the best features of French and English ships of the day. The live oak, red cedar, white oak, pitch pine and locust, of which she was built came from virgin forest from Maine to Georgia. Today, only about 15 percent of the original ship exists. The copper bolts and spikes used were supplied by Paul Revere. In all her years of service, she never lost a battle. The CONSTITUTION carried 54 guns, although in the battle with the GUERRIERE she carried 30 long 24-pounders on the gun deck, and on the forecastle, six 32-pound carronades and two 12-pounders as bow chasers. The keel was laid in Boston. It was three years from the laying of the keel to the launching.

On August 19, 1812, the CONSTITUTION met the GUERRIERE, a British 44-gun frigate, in battle. The story is that shots from the GUERRIERE made no impression upon the outside planking of the CONSTITUTION, but fell into the sea, where upon one of the sailors shouted, "Her sides are made of iron," thus, the renowned name OLD IRONSIDES. The last great fight of the CONSTITUTION was thrilling and spectacular, for she engaged two ships, the frigate-built CYANE and the sloop LEVANT. It was on February 20, 1815, maneuvering from one ship to the other, they both surrendered after a hard-fought battle. Homeward bound with her prizes, OLD IRONSIDES made one of her famous escapes. Chased by a British squadron, she narrowly escaped having to end her days as an English ship. After a tour of the important seaports of the United States that started at Boston on July 2, 1931, and covering over 22,000 miles, OLD IRONSIDES returned to the Boston Navy Yard on May 7, 1934, to remain indefinitely. No ship more justly deserves a place in the affections of a country than does the noble old frigate CONSTITUTION, truly, "The Eagle of the Sea."

The CONSTITUTION was eventually condemned as unseaworthy and had it not been for the poet, Oliver Wendell Holmes, the famous ship might have been broken up. His poem "OLD IRONSIDES" in 1830 stirred up public feelings and saved the CONSTITUTION for future generations. She was rebuilt in 1833 and again in 1877 and later used for a training vessel. An Act of Congress authorized her restoration by public subscription in 1925. When the ship was completed, she visited 90 ports before returning home to Boston in 1934. The CONSTITUTION's statistics are as follows: length overall – 204 ft., beam – 43 ft. 6 in., foremast height – 198 ft., mainmast height – 220 ft,, mizzenmast height – 172 ft. 6 in., sail area –42,710 sq. ft., speed –13 plus knots, complement – 450, including 55 marines and 30 boys, boats – 2 cutters, 1 long boat, 1 gig, 2 whaleboats, 1 jolly boat, 1 punt, and cost – $302,718.

Isaac Hull, commander of the CONSTITUTION at the victory over the GUERRIERE in the War of 1812, gave a much-needed boost to America and her small fleet of frigates. Once and for all the myth of British invincibility at sea was destroyed.

COLUMBIA – 1793

The COLUMBIA was built in 1773 and launched on the North River near Scituate, in Massachusetts. This vessel was a two decker of 213 tons and 83 feet in length. The COLUMBIA was the first American sailing ship to circle the globe, and in 1793 she completed her second circumnavigation. This little ship played a major part in the history of the northwest area. Captain Robert Gray discovered the mouth of the Columbia River and named the vast river after his ship 12 years before the Lewis and Clark expedition. The voyage from Boston around Cape Horn up the Northwest coast and back took three years. The ship's carpenter, Samuel Yendell, was a veteran of the Revolutionary Navy and helped to build the CONSTITUTION. However, Samuel Yendell was chiefly remembered for having been the last survivor of the crew from the COLUMBIA. Yendell died in 1861.

Robert Gray was looking for the Pacific entrance to the Northwest Passage. Leaving Boston in 1787, Gray planned to buy furs from the Pacific coast Indians, sell them in China, and reap a profit in Boston with a return cargo of tea. His voyage was a financial failure but a geographic success. Gray explored more of the Alaskan and Canadian coastline than had all his predecessors, including Captain James Cook.

On his second voyage to the Pacific Northwest in the ship COLUMBIA in 1792, Gray entered the mouth of the Columbia River. He named this body of water after his ship. On his return voyage he returned to Boston with a handsome profit.

THE C.S.S. ALABAMA

The most-feared Confederate commerce raider was the C.S.S. ALABAMA. During the American Civil War, this ship ranged over 75 thousand miles and destroyed more than 52 Union vessels valued at $4.6 million. Captain Raphael Semmes took his ship on a 22-month cruise with orders to disrupt and destroy Union shipping from the Gulf of Mexico to the South China Sea. Her climactic battle with the U.S.S.

KEARSARGE on June 19, 1864 is viewed as ranking second only in significance to that between the U.S.S. MONITOR and C.S.S. VIRGINIA, which clashed in 1862 at the famous Battle of Hampton Roads.

The C.S.S. ALABAMA was built in Britain in 1861–62 and commanded by Raphael Semmes. This ship was a composite-built, 1,016-ton barkentine-rigged with a 300-horsepowered engine which gave her a top speed of 15 knots. While under construction at Birkenhead, the British government, as a neutral party in the war between the states, issued a detention order on her.

However, there were some delays and before the order could be enforced, the ship was put out to sea secretly, eluding the Federal frigate TUSCALOOSA. The ship was fitted out in the Azores, with guns brought from Liverpool by British ships.

The ALABAMA was commissioned on August 24, 1862. Between September 5, 1862, and April 27, 1864, the ALABAMA had captured some 80 Union ships as prizes, and doing damage estimated at $6 million. The issue of British responsibility for Union ships destroyed by this ship became a sore spot with the U.S. government. The so-called Alabama claims were finally settled by arbitration in 1872. The United

States was compensated by the ALABAMA and two other ships built by the British, the SHENANDOAH and the FLORIDA.

Captain Raphael Semmes, commander of the CSS ALABAMA, was part of a squadron defending Richmond. Semmes joined the U.S. Navy in 1826 as midshipman. When the Civil War broke out, he resigned his commission to join the Confederate Navy.

The U.S. KEARSARGE set out to put an end to this Confederate raider once and for all. The two ships engaged in a 70-minute duel at sea. The KEARSARGE, with her 11-inch guns, carried one less gun than the ALABAMA, but her battery was more effective at point-blank range. Also, her slightly larger crew of 162 had more manpower than the ALABAMA's crew of 149. All hands were called aft, mounting a guncarriage. Captain Semmes said these words:

> Officers and seamen of the ALABAMA the name of your ship has become a household word wherever civilization extends! Shall that name be Tarnished by defeat? The thing is impossible! Remember that you are in the English Channel, the theater of so much of the naval glory of our race, and that the eyes of all Europe are at this moment upon you. The flag that floats over you is that of a young Republic, which bids defiance to enemies whenever and wherever found. Show the world that you know how to uphold it to your quarters.

The ALAMABA met her demise while battling the U.S.S. KEARSARGE in the last single-vessel duel of the wooden ship era. The two ships faced off near the French port of Cherbourg, within view of about 17,000 spectators. After 70 minutes of combat, during which the adversaries steamed in slowly narrowing circles while exchanging more than 400 cannon shot and shells (only a fraction of which hit their targets), the severely damaged ALABAMA began to go down to the bottom of the channel. In foreign eyes, she stood as an honorable symbol of Confederate intransigency; but for the Union, she was a crippling force with which to deal with that had to be defeated.

Captain Semmes flung his sword into the sea and then plunged overboard, together with 40 of his ship's company. They were picked up and taken to England by the British and other neutral ships before the KEARSARGE's boats could reach them. Semmes, together with his men, joined the forces of General Joseph Johnston and fought in North Carolina in the last weeks of the war. Captain John Winslow of the KEARSARGE

said these immortal words about this gallant warrior: "We fought her until she would no longer swim, then we gave her to the waves."

The War Years from the Revolution to 1812

The generation from the Revolution through the War of 1812 lived at the high tide of the romance and adventure of the sea. Those were the days of the Algerine Corsairs, the undeclared Barbary war with Tripoli, running the embargo and smuggling, and the eventual Treaty of Hamit in 1805.

Even before the challenges of the Moroccan corsairs boiled over in the Mediterranean, America had its challenges in the Caribbean. France had declared war on Great Britain in 1793 and despite the United States' neutrality, American ships were raided by both sides. A voyage to the West Indies in those days could bring as much adventure and mishap as one around the world. While France was stealing our ships and their cargoes, England was fighting for her life. Her great defense was her navy, for which she must have men. The press gangs were waterfront pirates. Many an American lad served in the British fleet during the French wars. There was a hatred and bitterness toward the British which lingered for generations along the New England coast.

Ships of 1812

Many a story of the War of 1812 has been told and volumes of tales of voyages, the dramatic escapes by superior sailing, and the prizes of the privateers are all part of the color and adventure of the war years. In the coastal towns, every able-bodied man one way or another went privateering. The American Navy, which consisted of only six first-class frigates dating from Federalist days and about twice that number of smaller vessels, was clearly inadequate. England at the time had nearly a thousand ships of war. One week after the declaration of war, Congress authorized the issuance of letters of marquee and reprisal. Every owner of a small vessel began to think of making his ship into a private cruiser. Also, those engaged in regular trading voyages lost no time in souring letters of marque in the expectation of the added profits to be had from prize money.

One of the most successful privateers on the Maine coast was the DASH. Built in 1813 at Porter's Landing in Freeport, her speed was legendary. It has been said that the DASH never suffered defeat, never attacked an enemy ship in vain, nor was she ever injured by hostile shots. She knew no equal in speed. On her last cruise, tragedy

struck. As a squall came down on her, the DASH went down with her captain, his two brothers, and a crew of 60 able men. This ship is the subject of Whittier's poem, "The Dead Ship of Harpswell." Several of the most famous privateers of America were launched from the shipyards of Maine. The GRAND TURK was one such vessel, built in 1812 at Wiscasset, and bought by a group of 30 men, most of whom hailed from Salem. Her story is part legend and part historic fact. The GRAND TURK was the best sailing vessel out of Salem, and she was also one of the most successful. She captured over 30 prizes.

Another ship, the FOX, launched at Portland, Maine, had a remarkable success and became known as the "Million Dollar Privateer." Her richest prize was the British brig BELISE. She sent this prize into Saco, and at the sale, ship and cargo went for $205,927.78. This was her fiftieth cruise and she had netted $328,731.33 for her owners. According to Captain Elihu Brown, each seaman's share was $1,200.

FLYING CLOUD

The FLYING CLOUD, one of the most famous of all the fast clippers, was designed and built by Donald McKay in East Boston in 1851 and bought by Grinnell-Minturn and Company of New York. She was 1,793 tons, measuring 225 feet in length and 40 feet in the beam. Her main mast was 88 feet tall, and her mainyard 82 feet in length. This ship became renowned for her historic *maiden* voyage in 1851 from New York to San Francisco in 89 days, 21 hours. The average took 120 days. On this famous voyage, the FLYING CLOUD sailed a remarkable 374 nautical miles in one day.

In 1854, the FLYING CLOUD beat her old record by clipping off 13 hours from the previous record. The FLYING

88

CLOUD was built for the gold rush and China Trade. She was later sold to British owners and used on the Australian route. In 1873, this ship was used in the Canadian lumber trade until she ran aground, and in the process of refloating her, she caught fire and was totally destroyed. The FLYING CLOUD was probably the fastest American clipper of all. The British clippers were smaller and often sturdier, being for the most part composite ships with wooden planking on the iron frame while American clippers were wooden throughout. During the Civil War, McKay built a number of iron warships, among them the monitor NAUSETT. His great last ship was the GLORY OF THE SEAS, built in 1896.

The Pacific Fleet

The U.S.S. ESSEX became the first Navy ship to enter the Pacific, protecting American whalers during the War of 1812. The U.S.S. MACEDONIAN, a 28-gun frigate, rounded the Cape Horn and took up station in the Pacific in the summer of 1819, beginning the regular presence of the U.S. Navy in the world's largest ocean. The MACEDONIAN was relieved in 1821 by the 38-gun frigate, U.S.F. CONSTELLATION, and from that time on a "Pacific Squadron" was continuously maintained. An East India Squadron was established in 1835, later renamed Asiatic Squadron, and in 1903, upgraded to Asiatic Fleet. The Asiatic Fleet and Pacific Squadron were merged in 1907 to form the first United States Pacific Fleet.

Pearl Harbor

The U.S. Navy's first contact with Hawaii came in 1826 with the visit of the U.S.S. DOLPHIN. In 1887, King Kalakaua signed a convention with the United States granting the establishment of a coaling station and the use of Pearl Harbor as a ship anchorage. By the 1930s, Pearl Harbor had become an important fleet base.

The Black Ball Line

The big gamble that became a classic case of "Yankee whim" all began on January 5, 1818. The JAMES MONROE, a square-rigged ship of 424 tons, became the first of four ships to sail on a scheduled time, announced over two months before. This was the start of the famous packet service of the North Atlantic. Ships left on scheduled service, full or not full, with special attention to passengers and high value "express" cargo. These ships sought a fast passage, but were designed primarily for carrying payloads and only

secondarily for speed. Yet they could sail from New York to Liverpool in 28 days, 12 days less than the time most ships were sailing the same route. The idea caught on, and by 1822 there were four separate "lines" operating between Tow and Liverpool, and lines from New York to LeHavre, and from Boston and Philadelphia to Liverpool. The American packet lines had virtually monopolized the first-class passage and premium freight business in the North Atlantic.

The vessels were growing larger and faster. The Black Ball Line introduced for the first time in the history of the sea standards of regularity, reliability, and luxury that would be taken for granted after the year 1900. The Black Baller ships carried a large black ball or sun on their flag. The NEPTUNE was one of the last two packets built in 1855 for the Black Ball Line, then in its thirty-ninth year.

New York to Liverpool on Schedule

The Black Ball Line became so successful that competition took over and in 1822 two more lines operated the New York to Liverpool packet runs. The term "packet" applied indiscriminately to miscellaneous vessels that carried cargos bundled in packets and sailed on schedule. The three big lines were the Black Ball, the Red Star, and the Blue Swallowtail. A packet was a square-rigger with three masts, fore, main and mizzen. Packets were built to carry all the canvas it could, and then some. In the 1830s, shipyards along the New York waterfront were building expressly for the packet trade. Initially, packets were cargo carriers and passenger traffic were second. Sturdy construction was a requirement for vessels in the packet lines. The demanding career of a packet made them costly, however. A packet line ship moving cargoes might earn as much as $20,000 on freight in a year. Passengers and mail might earn an additional $10,000 a year. A packet could pay for herself in two years, even allowing for maintenance costs. Their combined assets of regularity, speed, and ruggedness won universal admiration on both sides of the Atlantic.

Crewing a Packet

Men of the packet vessels were a special breed. Unlike seamen on other ships, who might reef the sails and then go below to ride out a storm, packet sailors had to stay on their job no matter what the weather. Blinding snow and mountainous seas that kept the decks awash for hours and even days were only part of the life of a packet seaman. Ordinary seamen did most of the tedious work of hauling ropes on deck, and running

aloft to reef the sails. He also took the wheel at times. An able seaman was a master of many arts. He had to know the intricate workings of the sails, spars, and ropes. Also, he had to be a bit of a blacksmith to make hooks and rings for the blocks, and a carpenter to make a jury mast out of a yard in an emergency. An able seaman had to be a weaver, able to work rope yarn into mats for securing and protecting jury spars, small tasks as well as working aloft in a winter gale on the Atlantic, struggling to control flailing canvas while hanging onto ropes or spars that were sheathed with ice. His tasks were like those on any ship, but the demands of packet sailing gave maintenance special urgency.

The wages for a packet sailor were poor compensation at $15.00 a month. By the time the run was over, every sailor had a month's wages and a month's tensions to burn off. The pleasures of one night could strip a man's wages in the brothels, lining the pockets of prostitutes and barkeepers. Tattoo partners did a brisk business decorating torsos and limbs with all manner of artwork. One popular design was a large crucifix, touted with the promise that it would assure a sailor of a Christian burial should he be washed up on some pagan shore.

The Packet Era

These were the ships that brought many of the emigrants across the Atlantic. For a fee of three pounds five shillings, almost half a year's wages for many an Irish tenant farmer, an immigrant could buy a ticket in 1851 for passage from Liverpool to New York. This passenger contract promised food, water, and a berth.

Berths were fitted into the 'tween decks about 6 foot long and on some ships three tiers of bunks with only about 25 inches between the tiers. It was not possible to sit up in your bunk. On many packets, the berths were no more than a foot and a half wide. In heavy seas the rickety bunks sometimes toppled over catapulting passengers from their berths. In such tempest it was not unusual to hear women screaming, children crying, and men cursing as they thrashed about with other passengers, baggage, and flying slop buckets. Bedding and clothing remained damp and reeked with a moldy smell for the duration of the voyage. Odors were normal aboard ship, the bilge water, rotting wood, and lingering foul-smelling old cargoes, hides, and filth were all part of the package. Some ships had toilets, generally they were on deck beyond the reach of most passengers. Seasickness buckets were almost always briming over and often not available. However, according to British law, every adult passenger was entitled to three quarts of fresh water a day. The water was kept in whatever containers were at hand, instead of "sweet casks," that is, casks are not found. "Pure water" generally turned rancid

by the time it was rationed out. Vinegar was sometimes added to help check purification. Though an emigrant's ticket promised fixed rations, some cooks demanded bribes for what they doled out. Liquor was a better choice than water, it was also profitable for a captain who saw a market for grog. If a passenger felt the need to complain, quite often he was threatened with being put in chains or took a punch from the first mate.

Between 1846 and 1855, more than two million people, mostly poverty-stricken, sailed across the Atlantic. The voyage took 35 to 40 days, even longer if the ship met foul weather.

Scarcely two percent could afford cabin passage aboard a packet. Most were steerage passengers subjected to the worst possible conditions that could be thought of on board a ship. Privacy was something you soon forgot and for some it was a nightmare.

America was not the promised land for everyone. Many disappointed emigrants did in fact go home. In 1855, more than 18,000 left the New World. One unhappy soul told this tale which embodied the horrific experiences of many emigrants:

> "If you don't die of cholera or typhus on the ship then the snakes and alligators or packet crews will kill you, and if you're lucky to get by all this then the hostile Indians will finish the job."

Samuel B. Samuels, skipper of the packet DREADNAUGHT, described packet sailors as the toughest class of men ever to sail. They could stand the worst weather, food, and usage and put up with less sleep, more rum, and harder knocks and they had not the slightest idea of morality. Honesty and gratitude were just not in them. With men cut of this cloth, Samuels set record passages and became a legend in his own time. He required his crew to have the ships carpenter break the points off their knives, in this way ensuring knifing one another was seldom done on board his ships.

Many of the emigrants found work in the shipbuilding trades along Manhattan's East River. Yard owners called all the shots and made their own rules. Workers labored from dawn until dusk in terrible working conditions. It would be many years before workers were able to have any decent working environments.

A Pair of Pistols and Old Wallace. Twice a mutiny was resolved when Skipper Samuel B. Samuels, with a pistol in each hand and his dog Wallace at his side, made it known he was not going to stand for any trouble on his ship. In one incident, the crew threatened Samuels and planned to rush him, but they were rebuffed by the fangs of

Wallace, who was not to be reckoned with. His growl and snapping teeth served as a warning not to be too hasty.

On a second occasion, sensing trouble again with his crew, Samuels recruited 17 tough German emigrants and armed them with iron bars. When the ringleaders of the mutiny led the crew out of the fo's'cel (forecastle), they were met by Samuels at gunpoint and growls from Wallace not to mention the 17 tough Germans waiting to "iron" the problem out.

When the ship was warped to the dock at the end of the voyage, she was all shipshape from stem to stern. In answer to questions about trouble and mutiny aboard his ship, Samuels simply patted his dog on the head and said, "what trouble, what mutiny?"

Proud Names

The SEA SERPENT, the WILD PIGEON, and the FLYING CLOUD were some of the proud names given to the American clipper towing ships. Great skill and judgment were needed to rig these in strong winds and yet not be carried away or capsized in heavy seas.

The best known of all the American clippers was the FLYING CLOUD. She was one of 42 ships built in Boston by Donald McKay, who had begun work in a shipyard as a boy for $2.50 a week. This ship sailed from New York to San Francisco in 89 days and 21 hours, a record that was never beaten by a ship of her class. In 1989, the THURSDAY CHILD set a record of 80 days around the Horn to San Francisco. However, the FLYING CLOUD was a square-rigger built for the gold rush and her record still stands in my book. In one day, the FLYING CLOUD made a run of 374 nautical miles. She weighed 1,793 tons, measured 225 feet in length and 40 feet in the beam. Her mainmast was 88 feet tall. Her days ended in 1873.

The WITCH OF THE WAVE was rated at only 975 tons, yet she sailed around the Cape Horn in icy gales of midwinter heavily overloaded with a cargo of 1,900 tons. In the days of the great American Clippers, the customary voyage was first 17,000 mile run from New York to San Francisco, then from California to Hong or Canton, China for tea, which they carried either to London or New York. The American clipper ORIENTAL reached Hong Kong only 81 days out of New York and loaded a cargo of tea at $30 a ton, while slower British ships lay in the harbor waiting for cargoes at half that price. In 97 days from Hong Kong, she was moored at the West India docks in London and her owners received $48,000 in freight charges on this one voyage, a great profit for the year 1851. Clippers were constructed in England, but it was not

until 15 years later when the Civil War ruined the American merchant marine that the British once more ruled the seas.

The Old INDEPENDENCE

The INDEPENDENCE, built as a ship-of-the-line and later cut down to a frigate, was in the Pacific Squadron in 1847–49. In 1861, this ship was serving as a barracks and receiving ship and continued to do such duty until decommissioned in 1912. This vessel was the longest-lived naval tenant of the Bay of San Francisco.

The AMERICA

In the year 1851, the schooner yacht AMERICA won the $500 silver cup from the finest English yachts of the day in a race off England's Isle of Wright. Since that day, some $30,000,000 has been spent racing for the cup. Everyone who was anyone had a yacht in the golden age of yachting. Fortunes were staked on a race. It all started for the AMERICA when she breezed home with the competition left behind. The AMERICA was just over 100 feet long, with raking masts and a gilded eagle on her transom. This rugged schooner yacht served on both sides in the Civil War. In 1954, she was broken up and yet her life story of adventure endures.

A group of New Yorkers sailed their new schooner AMERICA to Cowes to try her against the competition on the other side of the Atlantic. In the year 1851, as the story goes, the AMERICA rounded a headland at the finish and came into view of the spectators, among whom was Queen Victoria. The Queen asked, "Who is second?" Her informant with a spyglass replied, "Your Majesty, there is no second!" When the AMERICA sailed home, she was both famous and a financial success. Several years later, her owners deeded the "one-hundred guinea cup" she had won to the NY Yacht Club and renamed it the "America's Cup" after their schooner yacht.

Sir Thomas Lipton, the tea king, built five beautiful sloops, all named the SHAMROCK, trying to lift "Old Mug" and won instead the hearts of the American racing world. An English lady once suggested to him that the Americans "put something in the water over there which makes you lose." Sir Lipton's reply was a classic: "I completely agree with you, madam, it is a better boat."

In 1937, the RANGER, the best J boat ever built, won the America's Cup series over the blue-hulled ENDEAVOUR 11, the British challenger. These were the mighty J boats, 135-foot racing machines that spread more than 7,500 square feet of sail. The

RANGER led the 1937 Buzzard's Bay Regatta with her 18,000-square foot parachute spinnaker, the largest sail ever made.

Today's Cup race matches 12-meter sloops about half the size and half as expensive as the J boats of a bygone era. The America's Cup race for the past sixty years has been contested off Newport, Rhode Island, where currents are minimal. In the best four-out-of-seven events, with inclement weather, there was always a threat the race could stretch to as long as three weeks. Each race is a "match race" involving only two boats, since 1958. America successfully held the Cup until 1983, when it was lost to the Australians and won back in '87. The New York Yacht Club held the American Cup for 132 years. The trophy has been symbolic of America's long-term superiority in yacht racing. In 1988, New Zealand with a boat that had a length of 90 feet at the waterline and challenged the American Stars & Stripes with a 55-footer at the waterline to a race that proved to be no race at all. The American catamaran ran away from the New Zealand boat, however, lost the race in the court. The law in this case, a 101-year-old deed in which the America's Cup rules are outlined, say that when challenger and defender can't agree on boats, the boats are restricted to a length of 90 feet on the waterline. The NEW ZEALAND is the biggest America's Cup yacht since 1938. This race will be the talk of the yachting world for many years to come.

RED JACKET

On November 2, 1853, at Rockland, Maine, one of the largest and handsomest vessels was launched before an immense crowd that had come to see the 2,306-ton clipper RED JACKET. Her figurehead, a life-size likeness of the Seneca chief whose name she bore, surrounded by heavy gilt scrollwork, was a bust of the same Indian warrior

on the stem. She was considered one of the most beautiful of the large clippers, trim and sharp, with graceful lines, arched stem, and exquisitely modeled stem.

No expense had been spared in furnishing her inboard and outboard with the best. The after cabin was finished in rosewood mahogany, satin, and zebra wood, which was set off by black walnut trim. She was towed to New York a week after she was launched to receive her masts, spars, and rigging. On January 10, 1854, she sailed to Liverpool. It was a memorable voyage for the RED JACKET. She arrived on January 23. Her elapsed time from dock to dock was 13 days, 1 hour, and 25 minutes. This is a record that still stands for sailing ships. The RED JACKET for six consecutive days averaged over 343 miles, and on the ninth day out the crew "spliced the main brace." This was to celebrate a 24-hour run of 413 nautical miles. About two months later, the LIGHTNING was to surpass this by 23 miles. It has been beaten on only two other voyages in the history of sailing ships. She never returned to America under the Stars and Stripes flag. The White Star Line immediately chartered her for the round trip to Melbourne. They were so pleased with her record of five months and four days, and a spurt from the Cape to Melbourne in 19 days that was never equaled, that they were anxious to keep her in their fleet even at a cost of $30,000.

With the rush for California gold and profits, a desire for speed was utmost in the mind of every mastership builder worth his salt. The maritime sensation of 1851 was the 1,610-ton TYPHOON. She made the passage from Portsmouth to Liverpool during the month of March in 13 days and 10 hours from wharf to dock, a feat unequaled up to that time. It was on her first voyage that she was given the name "Portsmouth Flyer." This ship was the first American clipper and the largest merchant ship ever seen in Liverpool.

One of the most beautiful clippers ever built was the NIGHTINGALE. She was named for Jenny Lind, whose likeness she carried beneath her prow as her figurehead. This ship was launched in 1851 and designed on the lines of a yacht. She was built for passengers who could well afford to pay for luxury. The ship was fitted out between decks with luxurious saloons and staterooms which were finished with carved and gilded moldings and panels. The stern was ornamented with the figure of Jenny Lind reclining with a nightingale perched on her finger. So proud and confident were her owners that they offered to match the NIGHTINGALE against any American or British ship for a race to China and back for a stake of $10,000. That challenge was never accepted. In 1851, the words "gold in Australia" started a new rush like that of California's gold

rush. The NIGHTINGALE was off to Melbourne. In the years she made many runs in record time. In 1893, after four decades of adventure, she went down at sea.

ANN MC KIM – 1832

One of the most famous ship-rigged Baltimore Clippers was the ANN MC KIM, built in 1832–33 by Kennard and Williamson of Baltimore. Money, experience, and workmanship were not spared to build this new ship. Truly a work of art and a credit to her builders, the ANN MC KIM was used in the China trade until 1847. She was 649 tons, and 143 feet long, with a 31-foot beam and a draft of 17 feet. Not all historians agree, but some say that the ANN MC KIM was the first prototype clipper, considered to be the ancestor of the true clipper. The first true clipper was the RAINBOW, built in 1845.

This ANN MC KIM was probably the first ship in which an attempt was made to give a large sailing vessel the lines of a small ship built for speed. This design was the outgrowth of the fashion of the day for fast ships. At first, shipowners were not unduly impressed since her capacity, though larger than that of a Baltimore clipper, was still relatively small. The ship was sold to Howland and Aspinwall of New York in 1837. The ANN MC KIM ended her days under the Chilean flag and was broken up at Valparaiso in 1852.

Her design was not copied, but American shipbuilders modified her lines and produced the greatest sailing vessels of all times, the Yankee Clippers of the '50s. They were known the world over as the greyhounds of the sea. During the 1840s the "clipper" came to life— she was a new age in sailing.

LIGHTNING

In 1853–54, the famous shipbuilder Donald McKay built four ships at Boston for James Baines of Liverpool; the LIGHTNING, CHAMPION OF THE SEAS, JAMES BAINES, and DONALD MCKAY all became part of the Black Ball Line, carrying emigrants from Liverpool to Melbourne, Adelaide, and Sydney. The LIGHTNING was the first and most celebrated quartette built for Baines. This clipper ship was 244 feet long and had a beam of 44 feet and was 1,468 tons register. The ship was constructed with white oak knees and pine decks. She had two decks, a large midship house with six state rooms, a poop, and an extensive forecastle for the crew. This ship was well

furnished with cabin accommodations unequaled, and supplied with beds, bedding, and even a steward's attendance and a stewardess for the ladies.

On her maiden voyage from Boston to Liverpool, the LIGHTNING made a day's run of 436 miles, and on her first voyage from Liverpool to Melbourne she made this passage in 77 days. On her homeward voyage, the LIGHTNING made it in 64 days, three hours and ten minutes, a record which was to remain unbroken by other sailing-ships.

The LIGHTNING was advertised as the fastest ship of the day. Her record was never equaled in sail. Some 30 years would pass before a steamship did better. She carried a huge spread of sail, 13,000 square yards. Her rigging was strong and made to take the sea; her backstays were made of Russian hemp, more than three and a half inches thick.

The LIGHTNING continued in the Australian service until 1857, when, together with other clippers, she was used to carry troops to India to suppress the rebellion. In 1869, this ship returned to the Australian trade.

U.S. MISSISSIPPI

The frigate U.S. MISSISSIPPI was the third vessel of this type to be built for the U.S. Navy. The first steam frigate built was the FULTON I, which blew up in 1829. The second FULTON was used for experimental use, which led to the development of the U.S. MISSISSIPPI. She was a navy frigate, except the stack. The U.S. MISSISSIPPI was used as a flagship in the Mexican War. This ship was the first steamer to go around the world. In 1863, her career came to an end when she was burned at Norfolk to keep her from the hands of the Confederates during the Civil War.

GREAT WESTERN

The GREAT WESTERN was the first steamship built to make regular crossings of the Atlantic. She was 236 feet in length and 35 feet in the beam. Like the MISSISSIPPI, the GREAT WESTERN was a wooden paddle steamer, the largest of her day and the first ship designed by British engineer Isambard Kingdom Brunel.

This vessel spent eight years in transatlantic service, during which she made 67 crossings. Her side paddles were 28 feet 9 inches. The GREAT WESTERN was also equipped with four gaff-rigged masts and was capable of carrying 148 passengers. The last ten years of her working life were spent on voyages between Southampton and the West Indies. The great steamship was broken up in 1856–57. Her luxury was unparalleled in her day.

CHAPTER IV
WESTWARD HO:
They came by ships to the West Coast

A Growing America

As the nation grew, so did the horizons for American shipbuilders. The west was a wild country, but there was opportunity in the new frontier and a precious metal called GOLD! The cry was heard the world over. One of the greatest mass exoduses ever seen was the rush to California in the middle of the 19th century. It was "westward ho" for prospectors throughout the world. But how do you get to the gold fields—over land or by sea? The stories of many take you around the Cape of Good Horn in ships that stirred the seafaring heart. Yankee Clippers knifed through wind-swept seas bound for California as if they were walking on water. With bone in her teeth, a clipper ship was the last to sail. In winds that would cause others to reef sail, clippers could carry every possible scrap of canvas until her masts quivered at breaking point. American clipper ships rode the tempest like giant sea birds.

> Fly a full suite of sails, fill the jibs at her bow and the staysails between her masts, a starboard studding sails outrigged on her mainmast and foremast.
> It's Westward Ho!

They Came by Ship... to The West Coast

The first ships to enter San Francisco Bay were Spanish in the year 1775. An excellent chart was drawn of the Bay and the gateway entrance. The earliest known drawing of a ship on the Bay was found in 1806.

The first settlement began in 1776 under Spanish rule. Despite opposition, the Russians established a post at Fort Ross in 1812, 75 miles north of the great Bay. This post served as a base for the hunting of sea otters. When the otters became too few in number to make hunting profitable, the Russians withdrew in 1841.

American whaling ships appeared along the coast of California as early as 1791. Whalers frequented Richardson Bay for food and water. But for the most part, the vast solitude of the Bay was disturbed little until the events of 1846 to 1849. Gold discovered in California in 1848 began to change the scene of remoteness to one of mass migrations.

The California Gold Rush brought a forest of masts into Yerba Buena Cove. When the ships anchored, entire crews abandoned ship and headed for the gold fields. Abandoned hulks were used as warehouses, hotels, and prisons. From 1851 to 1853, many deserted ships came to rest on the mud flats of the Cove. By 1855, the imprisoned ships found permanent graves, as the filling-in of the Yerba Buena Cove was almost complete.

The Italian fishing boats provided another facet of the development of the Bay. By 1850, the Italian fishing industry in the Bay was well-established. During the next two decades, the waterfront changed rapidly, with the pile drivers constantly at work.

The average earnings of a single voyage from New York to San Francisco during the gold rush worked out to about $78,000. The SOVEREIGN OF THE SEAS earned more than $84,000 in freight rates on her maiden voyage.

Sailing to San Francisco

As commerce in the Bay continued to grow, ships of every kind came to San Francisco. The tales told by men who sailed on the lumber ships in the early 1850–60s were unbelievable. A common story told in the east of the west was that there were "trees so big twenty men with arms outstretched can't reach around them." The only contact the lumber mills had with the market in San Francisco was by offshore ships. The world has never known a more inventive era for methods of loading lumber.

From 1885 until 1905, San Francisco was the principal port in the world for sailing. Not long after 1908, the price of whalebone collapsed, and the whaling vessels found

their way to the mud flats and desertion. The Great Age of Whaling came to an end around 1910.

San Francisco Bay, however, did not die. She became one of the great ports of the world. The bay, at low tide, measures 450 square miles in surface area within a shoreline of approximately 100 miles. The bay receives water from two main sources, the Sacramento River, and the San Joaquin River, both which flow from the east into the Delta. The bay proper extends nearly 40 miles south-eastward from the point at which the Golden Gate breaks through the Coast Range from the Pacific Coast, and about ten miles northeast. Today, the shoreline is continually changing as wharfs and housing developments push further and further into the bay.

"Thar She Blows!"

Many flags have flown over the West Coast since 1542 when the mariner Juan Rodriguez Cabrillo unfurled the ensign of the Spanish Empire on the beach at San Diego and claimed the land for Spain. In 1579, only 37 years after Cabrillo, Sir Francis Drake sailed up the coast and raised the flag of the Queen of England in a cove just north of San Francisco. The English settlement was named New Albion. Drake, like Cabrillo, missed the bays at Monterey and San Francisco because of heavy fog and storms along the coast. Gasper de Portola and Father Junipero Serra came overland to central California from Mexico in 1789 and raised the flag of Spain not far from where Cabrillo had done so 227 years before.

In the settlement of Fort Ross, the Russian flag was raised by Ivan A. Kuskov on September 10, 1812. Six years later the French pirate Bouchard sailed into Monterey Bay and had the flag of Buenos Aires raised over the custom house while he raided the sleepy little village. The flag of the Mexican empire was unfurled over the Presidio of Monterey on April 11, 1822, celebrating Mexico's victory over Spain after 11 years of fighting for independence.

The first American flag that appeared in California was not the stars and stripes, but a special flag carried by John C. Fremont as he marched up and down the California territory from 1844 to 1846. This special flag had 13 red and white stripes like the regular American flag, but instead of stars in the upper left-hand corner there was an eagle with a pipe of peace in its talons. The Bear flag of California, which appeared briefly over the plaza at Sonoma in the summer of 1846, heralded the revolt of American settlers against Mexican rule.

On July 7, 1846, Navy Commodore John D. Sloat raised the American flag over the custom house at Monterey. One week later, Thomas Fallonun furled the stars and stripes over the plaza in San Jose. Another interesting flag that appeared in central California was the Confederate flag. It arrived in August of 1865 when Confederate Captain James Waddell was preparing to lay siege to the city of San Francisco in his commerce raiding ship, the SHENANDOAH, until he learned the Civil War had ended.

The Cape Horn Story

The pages of history on the story of American sailing ships which came from the East Coast to California can be divided into three major epics. The first occurred from 1822 to 1848, when the hide and tallow trade was attractive to shipowners in the East. The second period was from the beginning of the California Gold Rush in 1849 through

the end of the 1860s. The third period began in 1869 and continued until the last days of the great sailing ships in 1909.

The excitement of gold in California brought about a very active trade around the Horn. Many ships in the early years made the voyage in six months if they were fortunate. The blue-green waters of the Cape are filled with sunken vessels who were less fortunate. It was the clippers that began the real rush to the West Coast. However, the completion of the transcontinental railroad in 1869 changed the migration picture of the late 19th century. Foreign competition cut deeply into the Atlantic Coast shipping trade. Cape Horn trade was definitely confined to shipping trade, especially low-revenue commodities. The clippers gave way to the Downeasters, ships built to better handle larger cargos that were more economically efficient.

When a Cape Horner sailed through the Golden Gate, the crew were always greeted by a Whitehall boat pulling up to the mizzen chains. The night salesman would pass out cards to the captain and mates for a ship chandler or a better class hotel. Within a short time, other boats would appear, enticing the crew to stay at this or that sailor's boarding house. As evidence of good faith, a bottle of whiskey was usually at hand. After a few weeks, when the sailors' wages were spent, the boarding house masters would send the crews back to their ships. Sometimes the boarding house masters would send other men to the ships by kidnapping or deception, selling their services to ship captains for what became known as "blood money." The selling of men into involuntary servitude as sailors became a highly organized enterprise.

In the years that followed the Civil War, California wheat and barley production increased rapidly. By the 1880s, the region was producing 40,000,000 bushels of wheat annually. Most of this wheat was being exported to Europe. The British iron and steel hulled ships were the primary transporters of California wheat. By the 1870s, British ships became commonplace in San Francisco Bay.

It was also not uncommon to see a "lime-juicer" unloading coal from Newcastle. Before the general use of oil for fuel on the Pacific Coast, vast quantities of coal were imported from abroad. The coal trade formed a convenient leg in the round the world voyage of British and French vessels. These ships would carry general cargoes from Europe to Australia, coal from Australia to San Francisco, and grain from San Francisco around the Horn to Europe. Coal and cement were two of the cargoes most frequently brought out around the Horn by European deep-water ships in the last great Days of the Sail.

SOVEREIGN OF THE SEA

The SOVEREIGN OF THE SEA was built by Donald McKay, America's most famous ship designer. At his East Boston shipyard, McKay produced one great clipper ship after another—32 in all. In 1850, McKay launched one of his great clippers called STAG HOUND. This ship was the wonder of all who saw her. Designed and built in 60 days, her hull measured 226 feet in length. Her mainmast was 200 feet, and her spars carried 11,000 yards of canvas.

As more and more gold seekers clamored for passage west, and those who arrived offered fantastic prices for supplies from the east, the building of clipper ships was accelerated in 1850. Those who could not afford clipper fare (as high as $1,000) formed joint-stock companies and crowded onto slower ships. These less expensive ships could take about 240 passengers on the 14,000-mile trip from coast to coast in about 160 days.

In 1852, the SOVEREIGN OF THE SEA sailed to California in 103 days, fighting through what was described as "tremendous seas, southwest gales of almost inconceivable fury, furious snow, and icy rains." Although she lost two top masts off Valparaiso, she was still able to make her way to California. Even jury-rigged, SOVEREIGN OF THE SEA managed to sail along at 12 knots. At the end of the perilous journey, as the sea-beaten ship approached its San Francisco berth with the capstan, her crew created a new version of an old song:

Oh Susanna, Darling

Take, oh take your ease;

For we have beat the Clipper fleet—The SOVEREIGN OF THE SEA

During the voyage, however, there was little poetry in the minds of the sailors as they thrashed around Cape Horn. The beat to windward was the most difficult stretch of sailing in the world. The Yankee crews were a brawny lot far removed from the romance of sea stories circulated among the green horns back east.

The reality of a sailor's life was treacherous both on and off the seas. They often lay aloft in the sleet and cold rain to fist icy sails. If the fierce winds did not pluck them from the yards, or splitting canvas whip them off, they then would often face each other's sheath knives in waterfront brawls at the end of a voyage. They were typically a tough lot to manage; it took a skillful and determined captain to command them.

Successful captains were both rugged and charismatic. One of the most colorful ship captains was Robert H. Waterman. Sailors called him "Bob" or "Bully" Waterman, according to their likes, and regarded him as "one of the most inhumane monsters of the age." He began his sea adventures at the age of 12, commanded a packet at age 24, and

then switched to clipper ships. The first clipper he sailed was SEA WITCH. Driving his ship and crew to the breaking point, Waterman set the world's first permanent sailing record, sailing from Hong Kong to New York in 74 days 14 hours.

The USS CONSTITUTION

Another Boston shipyard creation was the USS CONSTITUTION, is the world's oldest commissioned naval warship still afloat. Launched in 1797 and knick-named *Old Ironsides*, it was one of six original frigates authorized for construction by the Naval Act of 1794. Her first mission was to protect American merchant ships from Barbary pirates in the First Barbary War. She and her crew famously defeated five British warships during the War of 1812.

The Gallant Mary Patten

In the archives of sailing, there is a story of one Mary Patten, a beautiful young lady from Boston who made history with heroic deeds aboard the clipper ship NEPTUNE'S CAR. Mary Patten was hailed as the "Florence Nightingale of the Seas." Her name is known to many merchant mariners of this day. The Patten Hospital in King's Point, New York was named after her.

Captain Joshua Patten took his young wife, Mary, like many clipper ship captains, with him on several of his voyages to ports around the world. During the long days at sea, Mary was the link that saved her husband and his ship from sure disaster. Despite the fact that the officers were for the most part New Englanders, the crew were a motley group made up of shanghaied foreigners, tough derelicts and packet rats. Yankee sailors usually avoided American clippers.

Even though potentially explosive conditions existed on all clipper ships, many captains sailed with their wives aboard. Captain Patten took command of the clipper NEPTUNE'S CAR in 1885, accompanying him on one of his voyages to the West Coast was his wife, Mary. The NEPTUNE'S CAR was built in Virginia and launched in 1853. She was 216 feet long and one of the fastest clippers afloat.

The hazardous 15,000-mile voyage around the Horn was rarely made in less than 100 days, the wild winds from the forbidding continent were always unpredictable and the prevailing storms from Antarctica created navigational problems for ships as they worked their way through the treacherous waters off Cape Horn. Before the ship

sailed away from the jaws of the westerly gales, Captain Patten become deathly ill from what was called "brain fever." Modern medical books liken brain fever to encephalitis.

Early in the voyage, trouble began when the first mate was put in irons for his disregard of orders, demoralizing the crew and delaying the ship. It was customary for members of the crew to make sizeable bets with other ships as to which ship would reach port first. The crew became restless and it was not long before the NEPTUNE'S CAR fell back in the race with the clippers.

San Francisco was still many miles away. It was obvious to Mrs. Patten that her husband was faced with a grave situation. She knew she must act at once. With the first mate in irons, she called the second mate and told him that she had decided to take over command of the ship while her husband was ill. Mrs. Patten called the crew together and asked for their help and assured them she could plot a course and navigate the ship to San Francisco. The crew gave their whole-hearted support and carried out their tasks to the man. It was an all-out effort and struggle to sail the NEPTUNE'S CAR into the Golden Gate, and in 136 days from New York, the arrival date was November 17, 1856.

News of the near disastrous voyage helped to raise funds for the ailing captain and a safe voyage home to Boston for his wife. Much of the proceeds came from the captain's Masonic friends.

During the harrowing sea adventure, Mary Patten was coping with another problem. She was pregnant. Her first child was expected the following March. Less than two weeks after her arrival in Boston, her son was born. He was named Joshua Adam Patten, after his father.

Captain Patten never recovered from his illness long enough to realize that he was a father. He was removed to Mclean's Asylum in Somerville, Massachusetts, and died on the 25th of July in 1857.

BALCLUTHA

The BALCLUTHA was launched in Glasglow, Scotland in 1886. She was a steel-hulled merchant ship of the late Victorian period. The BAL (town) CLUTHA (Clyde River) is the ancient Gaelic word for the site of Dumbarton, the town where the ship's original owner, Robert McMillan, had his home. The overall length of the BALCLUTHA is 301 feet from the end of the bowsprit to the outboard end of the spanker boom. She made her maiden voyage around Cape Horn to San Francisco with cargoes of wine and spirits loaded in London, hardware from Antwerp, and three times coal from Wales. On

returning to Europe, she carried grain from California.

The BALCLUTHA rounded Cape Horn a total of 17 times. Throughout the 1880s and 90s she made voyages to New York for case oil, to Rangoon for rice, to Iquique for nitrate, to Callao for guano, and New Zealand for wool. This ship was also known in Plymouth, Amsterdam, Rotterdam, Antwerp, and Havre. The registered home port for the BALCLUTHA was Glasgow, Scotland, but once launched and sent to sea she never returned.

On a voyage from Calcutta to San Francisco in 1899, word was received from her owners that she was for sale. The days of a deep waterman were over for the BALCLUTHA. In the years to follow (1899–1902), the BALCLUTHA became a lumber cargo ship and sent north to load lumber for Australia. She sailed under the Hawaiian flag and in 1901, a bill was passed and signed by President McKinley for the purpose of giving the foreign BALCLUTHA United States registry. The BALCULTHA was the last ship to fly the Hawaiian flag at sea.

While on a chartered voyage to Alaska, the ship struck a hidden reef near Kodiak Island. The crew was saved but the vessel was run hard aground on the offshore reef. The BALCULTHA began a new career with the Alaska Packers' Association. After going aground, she was sold as she lay to the Alaska Packers for $500. She was patched and sailed back to San Francisco where she was repaired. In 1906, she was renamed STAR OF ALASKA. After a quarter of a century of service in the Star fleet, the STAR OF ALASKA made her final voyage north in 1930. She was the last square rigger left in the salmon trade. The Alaska Packers' famous fleet was called the Star Fleet. There are only two Stars left out of the original 19 ships and only one of them still carries her fleet name, STAR OF INDIA.

The ship was sold again in 1933 after several years of idleness. The next 20 years she sailed under the name of PACIFIC QUEEN. Several times she was rented out to the movies. In the Laughton-Gable version of *Mutiny on the Bounty* she was used as

part of the fleet. Slowly deteriorating, the old "lime juicer" was towed to San Francisco in 1952. This grand old ship lay up on the mud flats until 1954 when bought by the San Francisco Maritime Museum. The ship was restored to her original state as a Cape Horn square rigger and rechristened the BALCLUTHA by Mrs. India Frances Dunn, who was born aboard her in 1899. The name India came from the location of the ship and Frances because they were bound to San Francisco.

A remarkable yearlong community effort in which 18 bay area labor unions and other volunteers donated 13,000 hours of work, and more than 90 business firms contributed $100,000 in supplies and services, made it possible to see this old ship as she sailed in her hey days. Although her 25 sails are no longer set, nor her average crew of 26 men will make ready for sail, nor the chief mate call out "Lay out there and furl in the jib!", today you can see this ship completely restored and under her original name, on permanent exhibit by the San Francisco Maritime Museum.

In the following chapter, we will continue to explore the historic movement of millions of people to the western regions of the American continent, fueled by the California Gold Rush.

CHAPTER V
VENTURES OF COMMERCE:
Tales of hardship and success

They Came from Everywhere

From the cry, "Westward ho!" the world seemed to funnel into California. People from all walks of life found their way to the shores of this land of great promise. From New York and Boston and other East Coast ports came vessels like the SEA WITCH, which achieved great records never to be equaled in the history of sailing. The clipper-ship era, for all its glories, came and went with a rapidity reminiscent of our modern-day spacecraft. The clipper era began in America in the late 1840s and ended in England a generation later.

The original clipper ships were built for the sole purpose of commerce— the New York-to-China run; it was only a matter of time before the gold of California and Australia would drive the demand for express freight sky-high. The new clippers were longer, leaner, and swifter. A sailor had regarded 150 nautical miles as an excellent day's run, but by the 1850s, American ships could routinely make 250 miles in a day. In 1854, the clipper CHAMPION OF THE SEAS sailed downwind averaging almost 20 knots for a 24-hour period, setting a record that would never be beaten by a sailing vessel.

The real beginning of the American clipper predates the American nation itself. During the Revolutionary War, all but a handful of the ships in the Continental Navy

were sunk or captured. It was the swift American privateers who won glory and profit by harassing British ships. The same story holds true for privateers and frigates against the Royal Navy in the War of 1812.

Ventures in commerce were not always success stories in the days of the sail. Many sailors paid the price for a voyage to hell. Hardships were all a part of the game. Few men have ever gone down to sea in ships and not known the fear and pain of Neptune's domain.

Point Cabrillo

In the late 1800s, squid was caught and dried almost exclusively for export to the Orient, where it had been considered a delicacy for centuries. Squid, also called "calamari" or fruit of the sea, by the Italians, was considered unique for its delicate flavor.

Chinese fishermen living near Monterey used torches to fish for the squid near the docks and attract them to the surface. Their catch was then dried at Point Cabrillo in the Pacific Grove, near a then-thriving Chinatown.

Lighthouse Point

Later the squid were dried in southeastern Monterey in an area known as Fisherman's Flat. The coal fires used for drying squid may have led to the "mysterious fire" (as historians call it) which destroyed Chinatown around the turn of the century.

Since Medieval times, giant cuttlefish and kraken have been considered ugly, menacing creatures to be feared in the sea. There are tales of monsters rising to the surface, enfolding sailing ships—sperm whales dragging them to the depths. But squid is actually a far cry from the giant squid of mythology.

As Monterey's main fish crop, sardines, began to taper off in the 1900s, fishermen began to can squid for shipment to Greece and Italy to be used as low-cost food for factory workers. By 1943, squid fishing in Monterey employed up to 600 fishermen and cannery workers. Three years later, 2,000 people were fishing and working in the canneries to process the squid during off seasons from sardine fishing.

Lahaina's Whaling Era

A whale of a story that must be told is the Lahaina sage; it's a story of Hawaiian royalty, lusty whalers, and New England missionaries. Lahaina is a seaport town on the island of Maui, one the islands in the Hawaiian chain. The first contingent of New England missionaries sailing from Boston to Hawaii in 1820, aboard the brig THADDEUS. In later years, Kamehameha the Great established the seat of the monarchy in Lahaina following his conquest of the islands.

In the mid-1800s, Lahaina's sea port served as a mooring ground for hundreds of whaling ships whose fun-loving crews turned the port town into a whaler's playground second only in reputation to San Francisco's notorious Barbary Coast. Lahaina's whaling industry lasted some 40 years. At times as many as 500 ships weighed anchor in Lahaina's waterways.

The old whaling capital of the Islands is now a National Historic Landmark and its citizens are engaged in a restoration project to preserve the town's colorful 19th century structures. At the waterfront there is a reconstruction of the coral block wall with a plaque that talks about the fort that stood on the Lahaina waterfront from 1832 to 1854. The wall was put up to protect the town after it was bombarded with cannon balls from sailors who fought missionaries trying to protect the women from the lusty appetites of the visiting ships' crews. A short stroll from the waterfront fort is the old prison Hale Paahao, built in 1854 from the coral blocks obtained from the original fort wall. The prison was used to house the rowdy seamen who missed the sundown

curfew. Though the missionaries who preceded the influx of sailors by some 20 years did their best to maintain some order, Lahaina became a roguish wild town.

The THADDEUS

In 1820, the brig THADDEUS brought the first missionaries to the Hawaiian Islands. The ship was built in Troy, Massachusetts in 1810. She was 85 feet long, with a beam of 24 feet and 7 inches. The ship sailed with 43 people aboard. The voyage was 18,000 miles and took 163 days. The American Board of Commissioners for Foreign Missions paid $2,500 for passages of the missionaries, besides provisioning them for a long voyage.

The THADDEUS was sold a short time later to the Hawaiian Government for general use between islands. The venture was too expensive and later discontinued. The hull rotted and later disappeared. A model of the THADDEUS can be seen at the Mokuaikua Church, Kailua-Kona, Hawaii.

First Whaling in The United States

When whaling is mentioned one is apt to think first of Nantucket and New Bedford, Massachusetts. Few people realize that the whole whaling industry had its beginning

off the coast of Cape Cod. It was two Truro men, Captains David Smith and Gamaliel Collings, who were the first to venture to the Falkland Islands in pursuit of whales.

From East to West

The deep harbor of New Bedford, Massachusetts and the adjacent island of Nantucket were the East Coast whaling centers. By 1847, it boasted 347 vessels hunting whales along the Atlantic Coast.

Sandy Point Light Chesapeake Bay

During the War of 1812, British war ships found they could weaken fledgling economic defenses of the New England states by seizing the whaling ships. The whaleships taken as contraband of the war were prime targets, but the courage of the crews of these ships were a factor the British could not manage. Whale oil and wax were in great demand along with whalebone for canes, carriage whips, combs, and later, corsets for ladies.

The East Coast waters were being overfished and gradually whaling captains began working their way around the Horn and up the West Coast to California. By 1838, the whaling industry had shifted from the east to the west, all the way from San Diego to Eureka. Yerba Buena (San Francisco) was a little port where USS anchored for 25 years before the gold rush started. San Francisco became the largest whaling center

in the world between the years of 1880 and 1900. It was often called the New Bedford of the Pacific. Sausalito was a sheltered cover where the whalers came to refill their water casks and gather wood. The fresh water from the nearby springs was well known among the Yankee whalers. The little port of Sausalito was called "El Puerto de los balleneros," the port of the whalers.

Whalers have been hunting for centuries before the great whaling ships were built late in the 19th century. In Europe, large-scale whaling began in the Bay of Biscay. The Basque whale fishery was well established in the 12th century and is probably at least two centuries older than that.

The whale has been hunted in open rowboats, sailing craft and in fast steamers; all outfitted with hand harpoons, nets, blubber knives, prickers, spades, pickaxes, coshes, and grapnel. In the early days, the whale was hunted with poisoned arrows, leaving the whale to suffer for days before dying and being washed ashore. A bomb lance patented in 1850s was fired from a gun, filled with gunpowder, and designed to explode by a fuse in the stem only after it was inside the whale.

The bloody whaling revolution of the 19th century gave way to the cold sad horror of the 20th. New whaling implements include electric harpoons, rocket-launching devices, helicopters, and sonar gear that indicates the whales swimming direction and distance from the ship.

Pacific Coast Whalers

Whaling reached its peak in this country around 1850. About 600 whaleships and 18,000 seamen were circling the globe in search of the great whale. At that time, about 70,000 people looked to the mighty beast for their livelihood. Pacific coast waters were teaming with humpback whales off Monterey Bay. It was not unusual for a ship to leave a California port for a few months or up to as much as two years and return with 1500 barrels of top-grade oil. Some ships were known to have sailed for up to four years before returning home.

A seaman's pay was low but he could share in the profits of the catch; a good haul on one voyage could make a man modestly wealthy. A large whale could provide 230 barrels of oil plus the whalebone. In 1857, whaling practices were changing in that land stations were being constructed to render the whale. A barrel of oil was bringing $13.00 and a fleet of ships able to bring in the blubber of 3,000 whales could earn a station as much as a million dollars. The overkill was in full swing, and it appeared the whale was doomed. Then, in the early 1900s, two incidents completely changed the industry. From the hills of Pennsylvania, a new kind of oil was being pumped out of the ground, called petroleum. From this new kerosene, which burned better and cheaper than whale oil brought about the end of the whaling days. Ladies' fashions were also changing, hoopskirts and flexible whalebone for corsets were out for good.

The CHARLES W. MORGAN

The CHARLES W. MORGAN is the last of the wooden whaling ships to survive. This ship was active in the industry for 80 years, from 1841 until 1921, logging 37 long distance voyages, more than any other whaling vessel in history. It escaped the Confederate raiders, the ice of the Arctic, and even the U-boats of World War I, the ship went on to become

the focal point of the maritime museum at Mystic, Connecticut. The CHARLES W. MORGAN was the last survivor of the great 19th Century Yankee whalers. She earned nearly two million dollars for her owners, before she was retired in 1921. This vessel was launched in 1841 in New Bedford, Massachusetts. Today she lies tied up at Chubb's Wharf in the heart of Mystic Seaport. The ship is rigged as a double topsail bark and can be visited year-round as a floating museum.

Returning from one of her long voyages, the MORGAN had grossed $44,138.75. The normal division was a third to go to the owners, another third for expenses of refitting the ship for her next voyage, and a third to the officers and crew. Captain Samson received about $4,000, a large sum in those days.

Consider how the harpooner Nelson Haley earned $400 during his sailing adventures. During the course of his long voyage, "Nelt" Haley had asked for cash advances and had made some purchases from the ship's slop chest. His advances and purchases added up to $200, leaving him a total $200 for four years of danger and drudgery. Between 1842 and 1846, New England whalemen returned home with the oil from some 29,000 sperm whales in their holds. Whale oil was used

primarily for fuel and lubricates and the source of products that were worth between $8 to $9 million annually. Averaging 55 feet in length and 63 tons, the sperm whale was the species on which the age of whaling depended.

A Special Breed of Men

Long months and even years at sea, the danger of the job, plus many encounters with Spanish, Mexican, as well as the British, hardened a crew in both body and soul. Flogging aboard ship was a way of life. Not all, but many captains were not only tyrannical but often brutal in order to keep their motley crew in check. Landing in San Francisco after long months at sea, the crew would seek out fandango palaces, brothels, bars, and brawls. This constant threat to the peace and property did not end until the decline of the whaling industry in California. San Francisco's Barbary Coast no longer knows the sound of the whalers and the smell of their ships, but night life still lives on.

American Whalers

A typical whaling bark of the 1850s was built in New Bedford. As the migration of the center of activity of whaling shifted to California, so did many Yankee whalers change

their hailing ports. Though some of the whalers were "ship rigged," that is, with yards on all three masts, the great majority were barks, having the mizzen mast rigged "fore and aft." The average whaler carried four boats on davits, ready to lower at a moment's notice when the whales were sighted. Some carried five and in addition, two spare boats lashed on the "bridge" between the main and mizzen masts. On the starboard side, a staging was swung out, on which the mates stood when the whale was being stripped of its blubber. Between the fore and main masts was a large brick stove with two kettles built in, where the oil was boiled out of the blubber. This was known as the "try works." Passing ships always knew when a whaler was in the neighborhood from the smoke by day and the glow of the fires on her sails by night. Many of these whalers departed for the whaling grounds, and as many as three years may have passed before their return. Whalers cruised in the Atlantic Ocean and the Bering Sea in the summer, and were laid up during the months that the whaling grounds were closed by ice.

The male sperm whale, the largest of the toothed whales, averaged 55 feet in length and 63 tons in weight. Because of its seemingly unlimited numbers and the great value in oil (as much as 1,890 gallons of oil from one animal) the sperm whale was the species on which the great age of American whaling depended.

The Argonauts of 1859

Gold in California! The dramatic discovery of gold found in the winter of 1848 in the foothills of California set a world in motion. It was estimated that at least 1,000 vessels were engaged in the race to California in that epic year of the Argonauts. The year 1849 definitely stands as a high point in the history of the days of the sail. Unlike the Greek myth of Jason and the Argonauts in search of the golden fleece, the Argonauts of 1849 found little of the gold that was said to flow in the rivers of the West. In the years of discovery, no less than seven hundred ships took departure from American ports. The gold was there but was soon in the hands of big, consolidated corporations which left very little for the green horns from the East and the emigrants from distant shores.

The ship BROOKLYN arrived in Yerba Buena (the city destined to become the gem of the West), aboard were the first Anglo-Saxon colonists, 238 Mormons led by Samuel Brannan who became California's first millionaire. Brannan set up a newspaper which became the California Star. The first news of the gold in California was received with incredulity and skepticism. Only when ships began arriving with California gold dust and bullion, and President Polk's declaration that the gold was indeed found in California, did the world engulf with a tidal wave of hysterical, grasping humanity. It

was said that since the migration of the Children of Israel, never was there such an exodus out of the lands as was seen in the year of 1849. Most of the ships that arrived in the early years, within two weeks the passengers and crews took off for the hills. What they did not realize was that when they arrived, they discovered they were not the first to stake claims, but were a part of a mass company of venturesome lads from all ports of the world, all looking for that pot of gold.

Many a disillusioned argonaut took the first available ship home. Only a few Jasons ever put their hands on the golden fleece, a few caught glimpses of it; however, most settled back to their mundane trades far removed from the towns and cities whence they came. Some found new and not always honorable ways of coaxing the gold, not from the earth, but from their fellow miners. Many a young man who had survived the long voyage around the Horn perished from the cholera, influenza, and smallpox that scourged the gold fields.

The Long Voyage

When the ships arrived in the bay, it was every man for himself. Many would never see one another again. The plans of tying their floating home to a San Francisco wharf as a haven of rest or a store in trade was soon shattered by the realization that due to the harbor congestion, only fap-out anchorage was possible. The cost to bring passengers and goods from the ship to shore was ruinously expensive. Trade goods from the ships were piled on the beaches like mountainous dumps. There were no buildings to house the useless knick-knacks. It cost more to lighten a cargo ashore than it did to haul it around the Horn. No one was interested in buying or even stealing much of the cargo left behind.

The Lone Survivor

The VICAR OF BRAY is the only ship that survived the Gold Rush of 1849. This tiny English ship was one of the more than 700 vessels to race to San Francisco. This ship was found in the Falkland Islands in 1966. Records showed that on November 3, 1849, the VICAR OF BRAY arrived from Valparaiso. But unlike most of the ships that arrived during the gold rush, the VICAR was not abandoned by her skipper. Captain Charles Duggan stood fast by his command. Six crewmen left for the gold fields where upwards of $1,000 a month could be made. Due to the cold climate of the Falklands, 85 percent of the original ship is still intact.

The Australia Gold Rush

Following the gold rush to California, a new rush began as thousands of eager diggers poured into southwestern Australia from all over the world. Sydney, like San Francisco a few years earlier, found its men folk preferring to do a little prospecting on the land down under. Bullock drivers left their loads, shepherds left their flocks, bank employees sent to establish branches in the gold fields were taken in by gold fever. It was a man named Edward Hargraves, an adventure-loving lad from New South Wales, who left his cattle and came to California to prospect for gold and became discouraged and homesick returned and started the ball rolling down under. The race was on again for the ships with wings of cloth.

Hardgraves began to think about the land and how it was similar to the hills and gullies of California, and the same outcroppings of granite, slate, and quartz were like those of his home. Was gold hiding there waiting to be found? Within a few weeks the gold craze hit Australia, with Edward Hargraves appointed commissioner of crown lands, and given grants and annuities so he never actually had to work in the mine fields. An aborigine shepherd once found a big yellow stone which later proved to be so heavy that it was split into two pieces in order to carry it in his saddle bags. When melted down, it weighed 106 pounds.

Some other Australians who had not found gold in California took ships for home. From 1851–56, thousands of men left England in sailing ships bound for the gold fields of the world. In one voyage, the American clipper LIGHTING took back a cargo of a million pounds of gold, arriving in Liverpool by way of founding the Cape of Good Hope 64 days and 3 hours after leaving Melbourne, Australia.

The clipper ship era lasted only a few years. Steamships were finally accepted by the world's sailing businessmen as being more practical in the trade world. It was also difficult to find young men willing to endure the constant danger of shipwreck, the brutal treatment, and miserable conditions of the long hard voyages. Brief as their life span was, the California clippers were the highest point in the history of sailing. By the end of the 1850s, shipyards were closing through lack of orders.

Shanghaied

Many young men found their way to the sea by the "Shanghai Route." The selling of drugged and drunken men to wind-ship masters for $30 to $50 per person was common. Human life and dignity came cheap, and after the camps (suppliers of seamen to shipmasters at a price) were paid their blood money, life became a living hell for many men sold like cattle and beaten to death. It was cheaper to buy a new crew than to pay off the old one.

The term, "sent to Shanghai," or "Shanghaied," originated in San Francisco on the Barbary Coast in the 1850s, but the practice went back even further to the Saxon kings of old. Crimping was big business, and when manpower was at a premium, trapdoors in saloon floors, together with spiked whiskey, were the means of filling the foc'sls of Orient-bound square-riggers.

Port Townsend, port of entry for Puget Sound, Washington, was another wide-open town for sailors. Saloons and brothels were dangerous hangouts for loggers down from lumber camps. Many a young lad woke up on the deck of a three-masted bark and found himself a hundred miles off Cape Flattery bound for Shanghai, with no recollection of the document they had signed committing them into a ship captain's service.

A voyage could take up to two years or more to return from the mines. During the Gold Rush, many green horns returned from the mines and became victims of the crimps. It was a good idea to watch your "Ps" and "Qs" and not to be hasty to have that next drink in the back room of some waterfront saloon. The expression "Ps" and "Qs" came from the days when men would run up a "tab" at a tavern or saloon—"Ps" for pints and "Qs" for quarts.

Decrepit Hulks

The brig EUPHEMIA was purchased by the city of San Francisco and used as a prison ship. In 1892, a steam shovel unearthed the timbers from the hulk of this ship while building at Sansome and Sacramento Streets. Many decrepit sailing vessels were put to useful and unusual purposes in the gold rush era. In 1851, there were 148 vessels in use on the mud flats offshore. The hulks were used as warehouses. During a disastrous fire on May 4, 1851, the NIANTIC, the APOLLO, and the GENERAL HARRISON, among other hulks, were destroyed. The wooden planks between the high-and-dry hulks acted like powder trails, spreading fire rapidly.

When the ships from around the Horn and other parts of the world came to San Francisco during the gold rush, it was only a matter of time before the crew took off for the goldfields. At one time, as many as 250 ships were left in the bay by their captains and crews. They were there for the taking. Today, much of the landfill covers the hulks of ships from the 1850s. The new buildings along the waterfront are built over the tops of many historic ships from the past.

The Bay in the 1850s

A wharf scene in the hey days of the gold rush was a busy place. Ships of all sizes and descriptions from every port in the world came to San Francisco Bay. Cargo was unloaded when and if labor could be obtained. It was a wild and wonderful place.

SADIE

The SADIE was a three-masted bald-headed schooner of 310 tons gross, built by Bendixsen at Fairhaven, California, in 1890. She achieved fame by making a voyage from San Pedro, California to Gardner, Oregon, in 1898, loading a cargo of lumber and returning to San Pedro in under 17 days. The SADIE made the south-bound trip of over 900 miles in the record time of about 80 hours.

North to Alaska

Loading offshore was not only a story of the Mendocino dogholes, but even more far-reaching after the turn of the century when a great increase in demand for pine lumber from Oregon and Washington began to attract mill operators. It was the northerly migration for lumber that brought about the end of the little steam schooners. These ships were built to handle short hauls between Mendocino and other southerly ports in California. The steam schooners used in the Alaskan gold rush of 1898 were successful only because gold-seekers were willing to travel in anything. Safety and comfort were of little importance; those with gold fever cared little about strength and dry bunks.

From San Francisco up the coast and off Cape Flattery to the Inside Passage, the cry was "North to Alaska." One of the most hazardous sea-lanes in the world is the 1,000-mile, Inside Passage of Alaska to Seattle, Washington. Plagued with fog, blinding snowstorms, hidden reefs, and icebergs from the glaciers, many disasters took place because of the mad scramble to haul freight and passengers to Skagway.

Mendocino Coast

The Mendocino Coast, to the early mariners, was a rugged, cliff-like stretch where grim, murky fog often soaked the shoreline and made loading a bit of hell for these little ships and their crews. Even on clear days, they were always aware of the fact that they were the intruders. One of the world's richest stands of lumber still towers unmatched by time and beauty much as it did in the early days of our country. Through thick veils of fog, early-day schooners sailed into the dark canyons, deep draws, and shallow coves to load their cargoes of lumber for San Francisco to ports around the world. They had

only one chance to guide their ship close-in while underwater reefs and ledges boiled with white water surf. Fatal indeed was the fate of a single moment of error. Before the wagon trails and railroads were built in the North, the coastline "ports" were the only way to reach the hidden mills and rich redwood forests. Many ships were lost to the pounding and slashing seas that only permitted "doghole" loading, a task that was done every day by master seamen. Dogholes were indentations in the rocky coastline, where a small ship might crawl in, squirm around, and crawl out with its payload of lumber.

The world's oceans and seas cover more than seven-tenths of the globe's surface. The oceans have played an important role in human history. Before the roads were built, the coastal waters were the avenues of commerce. The development of America can be traced through the conquest from ocean travel. Many seafaring men lost their lives off the Mendocino Coast.

West Coast Ship Builders in San Francisco Bay

The story of sailing on the West Coast must also include the shipyards and a few of the major ship repair plants that dotted the shoreline of the bay. Ship building on the bay began during the Spanish and Mexican era. Small vessels were needed to ship food, hay, and grain to the presidio and the missions from the nearby ranches. With the coming of the gold rush, the tempo of transportation on the bay and the need to use the river byways brought ship builders to San Francisco and other points nearby. The building of fine wooden ships continued on the bay until after the first World War. With so many ships using the bay, shipwrights began to establish facilities capable of handling repairs as well as building ships. The first dry dock was completed in 1851, at the foot of Second Street in San Francisco. It was over 40 years after the gold rush that ships were built with iron or steel hulls. Since 1849, the Union Iron Works had built mining machinery and with an eye to the future, they began to make plans to build steel vessels in 1880. The first steel ship on the Pacific Coast was launched at this yard in 1885; she was the 800-ton steam collier ARAGO.

The first major ship repair plant on the bay was the Pacific mail Steamship Co. operating its machine shops at Benicia in 1850. This establishment became the largest and the first industrial enterprise in the state of California. Repair facilities sprang up everywhere, and San Francisco was to become one of the world's greatest ports. In 1871, John W. Dickie and his brother James came to San Francisco from Scotland and began building wooden ships. In 1882, the Dickie Yard at San Francisco was the principal shipbuilders in the area. In 1890, the move was on to migrate to Oakland Estuary.

The yard of Hay and Wright in 1898 was credited with building more wooden steam schooners than any other shipyard on the coast.

Benicia on the Carquinez Strait built ships as far back as 1849, but her greatest fame came when the yard of Matthew Turner was located there in the years of 1883 to 1903. Turner, who began building wooden ships at San Francisco in 1868, launched more vessels than any other individual builder in North America. Over half of the 228 ships launched by Turner were built at the Benicia yard. World War I revived wooden shipbuilding at Benicia, as the high wartime cost of freight rates stimulated the building of schooners and barkentines, some even powered with low-powered auxiliary engines.

In the 1906 earthquake, the only known damage to shipping as a result of the quake was to the wise steamer COLUMBIA. The COLUMBIA was on the Union Iron Work's hydraulic lift dock when the shocks came, she fell over on her side but sustained little damage. The COLUMBIA is also remembered as having been the first steamer fitted with Edison's incandescent lights when she came out in 1880.

The Fishermen

The Civil War marks the close of an era in the fishing industry in Maine. Castine, Maine, the wealthiest town in the states in proportion to its population, had been the great salt depot of eastern Maine. But after 1857, Castine's importance as a fishing and shipping center rapidly decreased. There were great losses sustained by the principal merchants during the Civil War. The once numerous fleets of fishing schooners became smaller and smaller as such ports as Portland and Gloucester gained an advantage, being nearer the market. The railroads brought about a great increase in the fresh fish business. Ice pans quickly replaced the salt bin on the bankers.

Herring, which from time immemorial has been the people's greatest food fish, abound all along the coast but especially in Passamaquoddy Bay. As early as 1808, the Scotch method of smoking fish was adopted, and all along the shore smokehouses sprang up. This business as late as 1900 amounted to nearly 6,000,000 pounds a year. The sardine-packing business, which commenced in 1875, expanded to such an extent in 25 years that it was occupying 68 factories, employing 6,000 people, and producing a $3,500,000 product. In this business Maine has a natural monopoly, for there are no small herring suitable for this purpose south of the state line.

Shipbuilding up and down the coast has since the earliest times been stimulated by the demands made upon it by the fishing industries. It is the fisheries which keep the art of shipbuilding alive to this day. Just as at any time in the three centuries since the launching of the first wooden ship, the yards on the coast of Maine have been active and busy. The increasing demand for fresh fish called for faster and larger vessels.

STAR OF INDIA

This ship was launched on the Isle of Man in the Irish Sea between England and Ireland on November 14, 1864. Originally, she was named EUTERPE, for the legendary Goddess of lyric poetry. This ship was an iron, full-rigged vessel, intended for cargo and limited passenger service between England and India. As the EUTERPE, she made 21 trips around the globe. From London, Glasgow, or Liverpool she would head out into the Atlantic, round the Cape of Good Hope and square away in the "Roaring Forties" to go booming along across the Indian Ocean and bound for some New Zealand port. On her voyage homeward, she'd head eastward to take advantage of the prevailing winds and pass Cape Horn after crossing the Pacific. From the Horn, it was up the Atlantic and eventually home to England.

The EUTERPE was sold to the Pacific Colonial Ship Co. of San Francisco and was placed under Hawaiian registry; when Hawaii became a United States territory, it enabled her to obtain American registry not otherwise available to a foreign-built vessel. The ship was used in the export timber trade out of Puget Sound. She hauled lumber out to Australia, coal from there to Hawaii, and sugar for the last leg of the triangle back to the mainland. The Alaska Packers Association of San Francisco bought this vessel and renamed her the STAR OF INDIA. From 1902 until 1923, the STAR OF INDIA engaged in the salmon trade in the North. The STAR OF INDIA is now the pride of San Diego, California and is the oldest merchant ship afloat.

The ALMA

The last remaining San Francisco Bay scow schooner is still afloat. This hard-working little vessel was built in 1891. The ALMA was designed to carry bulk cargo including coal, sand, lumber, and hay. She was used on the bay and nearby rivers until gradually phased out as trucks and highways began taking over her livelihood. Scow schooners with their shallow draft made it possible to load on creeks and sloughs where other craft could not penetrate. Farm products in comparatively small lots were loaded in the south bay and shipped to San Francisco. At one time, there were over 200 scow schooners operating on the bay. The ALMA finished her career as an oyster shell dredger in 1958.

The C.A. THAYER

The THAYER was the last active commercial sailing vessel on the West Coast. Built in 1895, this schooner had a varied career in maritime commerce. She carried lumber from Hoquiam to California until 1912, then became an Alaskan salmon packet and finally a cod fishing vessel in the Boring Sea for the Pacific Coast Codfishing Co. of Poulsbo. Today, this ship can be seen at the Hyde Street Pier National Maritime Museum in San Francisco.

The C.A. THAYER was one of 35 similar three-masted schooners built for the lumber trade by Hans Bendixsen at Fairhaven, on Humboldt Bay, near Eureka. This ship was named for a partner in the E. K. Wood Lumber Co. The THAYER was purchased by the State of California to be restored and preserved.

The AURORA

Little is known of the shipwreck AURORA, but from accounts of shipwrecks, the death of the AURORA is not much different from tales of disaster told about other ships that were blown off course and went aground. Mariners from the past were at the mercy of the sea. Once blown off course, their fate was usually sealed in disaster.

Ships were often caught in heavy seas or giant swells. Sea waves are caused by the wind blowing over the water locally. These waves tend to be more peaked in comparison to swells. If allowed to build for several days in a steady wind over an unlimited distance in deep water, seas can grow to a wave height of about one-half foot for every knot of wind.

Swells are the remains of heavy seas no longer supported by the wind that caused them. Storms over the ocean can easily build waves as high as 15 feet and sometimes two or three times as high. As these waves travel away from the storm, they lose their

The Shipwreck Aurora

sharp crest and become smooth on top. Swells actually travel faster than the seas so the two kinds of waves are constantly going in and out of phase with each other. When the crest of a swell catches up with the crest of a sea, the total wave height is the sum of the two wave components. A 7-foot sea and a 9-foot swell add up to make a 16-foot wave.

Huge waves can overtake a ship and break high over its stem. Such waves have been known to flood the ships interior, wash crewmen overboard, and destroy a ship's superstructure. This may have been the fate of an indeterminate number of ships.

Shipwreck

Mariners of an era past were at the mercy of the sea and few distressed vessels were able to summon help from a passing ship in the night. Ships disabled at sea wallowed at the mercy of storms. During the day, a ship could invert the ensign as a sign of distress, but at night had only to fire a barrel of pitch on deck, hoping to have some passing ship see their flames. Once a ship was blown off the shipping lanes, there was little likelihood that they would be seen in a storm. It was sure insanity to try to weather a storm when the ship was dangerously near the breakers. Before a ship was torn in half on the reef, the crew took to the long boats and made their way toward shore. A message was placed in a bottle, after its contents were drained in a final rite, in order to let the world know the fate and final record of what had happened to the ship and

crew. This was the only way that a ship in distress and fear of going down could hope to reach loved ones left behind.

The entrance to Humboldt Bay is strewn with the wreckage of ships that failed to cross the bar safely. Heavy seas were often the cause of disasters, many ships were lost and there are few recorders that tell of crews ever reaching port safely or being picked up at sea. Disasters have occurred almost within hailing distance of their port of destination. Bottles have been picked up containing messages scribbled on pages torn from logbooks and yet nothing to tell the tale or even a board of the ship were ever found.

The picture, THE SHIPWRECK, is a story of the way incidents such as this were not front-page news but were given a mere mention on the back pages of daily newspapers. This ship was a fully loaded schooner with lumber for San Francisco. Heavy seas were running off the coast and the ship's captain was certain his ship would clear the bar and make her way down the coast. Following the shoreline close-in was often disastrous.

Fog and rain squalls sometimes sealed the disastrous fate of overloaded vessels, putting them at the mercy of the night. Breakdowns at sea were also a threat and accounted for many ships loosed and slammed against rocks and sandbars, breaking their backs as if they were but toys. Deck loads of lumber were continually shifting in heavy weather and caused these small schooners to lose control. Once the elements took command, there was little one could do to hold fast in such storms. Many ships became victims of the offshore clutching reefs. Collisions were another concern among captains of lumber schooners along the coast.

On the Rocks

The thick fog of night could chill the bones of even the heartiest of old salts. The wreck of the VALENCIA led to the building of the West Coast Lifesaving Trail and the improvement of lifesaving conditions on the whole coast. Many mariners could not distinguish one

lighthouse beacon from another and ended up on the rocks to leave their bones in a watery grave.

The trend of the current on the northwest coast of America is such that all wreckage and flotsam caught in the current are swept northwards, and deposited on the southwest coast of Vancouver Island, even from latitudes south of San Francisco. Oh, for a quaff of ale and a dry bunk and a warm stove.

C.S. HOLMES

C.S. HOLMES was a four-master that remained in service until World War II, long after other windjammers were dismantled and left to rotten row. The C.S. HOLMES set speed records on the Puget Sound to Fiji Island run and from Grays Harbor to Guaymas. In 1904, she completed a 38-day record run from Port Blakely to Suva. In later years the C.S. HOLMES was reduced to the humiliating status of a river barge, a melancholy contrast to this beautiful vessel that once sailed into the blue Pacific sunset under full sail.

WINSLOW

The WINSLOW in Elliot Bay awaited a tow to the drydock at Eagle Harbor. On July 28, 1907, the four-masted schooner WINSLOW, two weeks out of San Francisco sailing for Puget Sound, plunged into Duncan Rock with all sails set. She began filling immediately after striking the almost-hidden reef to Seaward of Cape Flattery. A boat was lowered and the crew, except for the captain and two men, put away from the ship. Although the decks were completely awash, the ship remained afloat throughout the night. The crew returned at dawn, and enough sail was reset to keep her off the Vancouver Island coast until the tug TACOMA arrived to tow the water-logged schooner to Seattle.

Cape Flattery was named in 1778 by the English explorer Captain James Cook, after he searched without success for a harbor along the indented coast. The Cape marks the southern end of Juan de Fuca Straight, a rampart of the Olympic Peninsula.

MABEL GREY

The death of the MABEL GREY, a three-masted schooner that was shipwrecked with a load of lumber off the coast of Mendocino, California, occurred on December 21, 1905. Many gallant lumber carriers met their last port in this way, never to sail again, as the pounding waves violently crushed their wooden hulls on the jagged coast.

BANGALORE

The BANGALORE was a full-rigged iron ship built in England in 1886. This vessel has become one of the mysteries of the days of the sail. She vanished without a trace. In 1908, she left Norfolk, Virginia, on a voyage to Honolulu with a cargo of coal for the U.S. Navy. The ship was last seen near the Equator, but from there the story ends. The BANGALORE was 260.2 feet in length, a beam of 39.9 feet, and displaced 1,743 tons. A theory on what happened came to light some years later. It was believed that the BANGALORE may have had a collision off Cape Horn with FLKLANDBANK during stormy weather. Both ships disappeared without a trace.

MADAGASCAR

This ship was a full-rigged ship built in 1837. She vanished in 1853 somewhere in the Atlantic. She was carrying a cargo of gold. It was believed that the crew had killed the officers in a mutiny then burned the ship. Trying to escape the ship with the gold, most of the crew were lost. There were three survivors. One was later hanged in San Francisco for murder.

MARY CELESTE – 1872

The MARY CELESTE mystery is a classic tale of the sea and the real story will probably never be known. The story begins in 1872 in New York. MARY CELESTE and another ship the brigantine, DEI GRATIA, from Nova Scotia, left New York ten days apart, both vessels were headed for the Mediterranean. The two captains had met in New York and had known of each other's sailing plans.

On December 4, 1872, near Gibraltar the DEI GRATIA crew were astonished to see the MARY CELESTE drifting under short canvas. The captain of the DEI GRATIA noted that the ship was not only drifting but did not seem to have a crew onboard. The captain sent the first mate and two seamen to check on the crew to ascertain the problem onboard the CELESTE. They found the ship to be abandoned, her lifeboat missing, the ship to be in seaworthy condition, and her log with no entries after November 24, 1872.

Everything was not shipshape on board, however, there were no signs of violence or a struggle. There were no clues as to why the crew abandoned the ship. Her cargo, barrels of alcohol, was only slightly damaged. The binnacle broken and the chronometer and sextant were missing. Food was even left on the captain's table as if he just stepped out for a minute. A crew from the DEI GRATIA decided to sail the MARY CELESTE to Gibraltar, where an inquiry was conducted. Nothing ever came of the investigation; no answers were to be had from the questions asked. It will always be a mystery to why the ship was abandoned and what happened to the crew. A long battle over who owned this derelict lasted for years.

He Met Davy Jones

This was the name humorously used by sailors for the spirit of the sea. DAVY JONES' LOCKER was the bottom of the sea, the grave of all ships that ever have sunk to their final resting place.

First Recorded Wreck off Vancouver

The brig WILLIAM, bound from San Francisco to Victoria, BC, was the first recorded wreck on the southwest coast of Vancouver Island. She went ashore about four miles east of Pachena Point on January 1, 1854. The captain and cook were both drowned, but the rest of the crew made it the shore safely and were later taken to Sooke by the Indians who found them.

A wreck dramatically illustrates the hazards of navigation. The brig CYRUS sailed from Steilacoom, Washington, on December 11th, 1858, laden with lumber for San Francisco. She left port on the 15th, but conditions were such that she took six days to work her way out of the Juan de Fuca Strait, only to run into a heavy gale which forced her to heave to.

The cargo in her hold and on deck shifted in the tremendous seas causing her to leak so badly that the ship was impossible to keep her running free. The captain, in desperation, ran for a shelter in Port San Juan. At the mercy of Poseidon, the CYRUS drifted ashore at the head of bay, unable to beat or tack her way out; she became a total 1033 when her anchor chain parted and tragedy struck on December 23, 1858.

The Towline at The Bar

Sailors from all ports of the world that ventured across the Columbia River Bar never forgot their perilous voyage against the river's rush to the sea. The Columbia River Bar guarded the channel leading to the grain docks at Portland, Oregon, some 94 miles upstream. Many of the square-riggers of the "wheat fleet" came to grief at the turn of the century.

There was no easy technique for a sailing vessel to pass the alluvial deposits from the river bottom. It took an expert pilot with a powerful steam tug and towline to pass the bar. The summer months were no better than winter. Even the summer calms, with swift tidal currents, could sweep a ship onto the shoals.

When foul weather off the bar clashed with the westerly swells of the Pacific, and the great outpouring of fresh water from the Columbia River generated an impassable crescent surf, it took guts and prayers to challenge this sinister bar of the northwest. Throughout the storm-plagued winter months, scores of ships lay off the bar for as long as six weeks, awaiting some break in the weather and a tow.

The sea has never been tolerant of human error and many a captain attempting to cross the bar on their own have left the bones of their ship on the North Pacific Coast. It took many years to learn the hazards that took the lives of so many good men at sea. At the entrance to the Nitinat, for example, a person can cross safely for only six minutes at high water slack.

The citizens of Portland became angry with the poor safety measures and the seriously threatened cargo shipments. Construction that began in 1885 built the first 1,000 feet of rock jetty that would extend seven miles and divert the tidal currents on the bar to make them scour a deep, straight channel through the sands. The perils of running the inlet were never eliminated. In 1906, 96 vessels were destroyed and their cargoes of good Oregon spruce were vomited from their holes.

Seattle to Port Townsend

Gone Forever

Archeologists working on a gold rush-era ship at a building site in San Francisco were forced to give up their discovery for "progress." The ship rests in fill land at the foot of Telegraph Hill, lying north-south and listing toward the bay, about a half mile east of Fisherman's Wharf. The area was once part of the bay. The vessel is believed to be the most intact ship find ever encountered in San Francisco. The site is that of the new headquarters of Levi Strauss. Unimpressed with the pleas for more time to recover the ship, the blue jeans spokesman said that the building will proceed on schedule. It was a great loss for historians who had recovered part of the bulwark, some chain, a hatch cover, and other archeological finds. It was believed the ship was scuttled in 1852 for construction of pier pilings where a city park was to be developed. Many of the new waterfront buildings in San Francisco are built over the hulls of sailing ship from the Gold Rush of 1849.

The FLYING DUTCHMAN

Ghosts played a great part in the life of the ancient mariners. Many of the old nautical ballads sing of phantom visitations. The most ubiquitous form of ghost that worried seamen were the type that commanded a ghost ship. The FLYING DUTCHMAN tale is a legend known the world over.

Vanderdecken was Captain of a Dutch ship trying to beat off the Cape of Good Hope towards Table Bay. For weeks the head winds prevented him from making the passage. In despair, he roared from his poop deck, "Neither God nor devil will stop me Founding this Cape of Storms!" Thereupon God appeared from out of the clouds saying, "I am mightier than thou- twill profit ye little to defy me! For eternity ye shall sail alone through these seas with only your cabin boy in attendance. He shall be turned into a demon and the viands he'll serve ye daily will be uneatable!" And that was it as the Lord disappeared in the captain's story. When Vanderdecken looked around, his passengers and crew had gone, and he was left with only his demon cabin-boy.

Old time sailors say that when a ship sights Vanderdecken, storms arise, the drinking water turns sour and food changes to beans. The DUTCHMAN comes close irrespective of the direction of the wind and tries to hand letters to the crew of mortal ships. If humans take these letters misfortune will dog them forever. However, not one of these letters has ever been found. The ship is always under full sail and heads in any direction, not being bothered by wind, sea or even rocks. Her appearance signifies the coming of a gale, spelling trouble for all hands aboard.

The COPENHAGEN Ghost Ship

The COPENHAGEN story is one of the great mysteries of sailing ships, much like that of the FLYING DUTCHMAN. This ship was built in 1924 for the Danish East Asiatic Company and was the biggest sailing ship in the world. The vessel was used as a training ship for Danish naval officers. She was a five-masted fully rigged ship well known for her grace and beautiful lines. The ship was manned by 60 cadets plus the commissioned and petty officers. The COPENHAGEN had all the latest up-to-date improvements in equipment of the day, including a 500-horse-powered engine and state of the art communications systems.

The COPENHAGEN was bound for Australia on December 14, 1928. This ship was built for rough weather and sailed with ease along the "Roaring Forties." This ship did not sail along known shipping lanes; it was not unusual for them to remain at sea without giving someone their where-a-bouts. But more than 100 days had passed without news of the ship, which left Argentina for Australia with 75 men aboard. In Denmark, the people were optimistic, yet why hadn't she used her wireless? It was an immensely long sea route the ship was sailing, and her course was set for Tristan da Cunha. Tristan was discovered by the Portuguese in 1517. Lying about a third of the

way from the Cape of Good Hope to Cape Horn, it was considered one of the loneliest islands in the world.

The East Asiatic Company decided to send the motor vessel, the MEXICO, out in search of the COPENHAGEN. After a year had passed without any word from the lost ship, it was officially regarded lost at sea. However, for years sailors continued to see this five-masted ship at sea, usually at night or during a storm when it was difficult to make her out. One account from the men on watch of an Argentine trading vessel felt there was no doubt that they had seen a sailing ship scudding before the wind less than a mile away, a ship of enormous size with five masts. From the lightning flashes they could see this "phenomenon" about a point off the port bow. The men remained on the alert till dawn, anxiously watching for this vessel to return. She would have been easy to spot for she was 450 feet long and carried over 7000 square yards of canvas. Could it be she was a half-submerged derelict drifting at sea?

The fate of the COPENHAGEN was unknown. It was not until December of 1938, ten years after the COPENHAGEN had left the Rio da la Plata, that a trawler brought into Cape Town a possible clue as to the fate of this ship. Along with his catch, a bottle was found. After the captain tried in vain to uncork the bottle he smashed the neck and to his amazement found a roll of paper with some words scrawled in English. The words were almost incomprehensible yet the name KOBENHAVEN (COPENHAGEN) and the position: 47 degrees 37' south and 02 degrees 14' could be made out faintly. There was no doubt that it referred to the ship's location, about 625 miles southeast of Tristan da Cunha, on the outskirts of the Southern Ocean. The authenticity of the message could never be proven because it was not signed. But the words "Easterly winds" and "Icebergs...surrounded" provide an explanation to the mystery.

Derelicts At Sea

There is a certain awe at the sight of a derelict drifting amid a vast open body of water. The discovery of such a ship aimlessly bobbing on the horizon has a mystical feeling about it. The sound of rigging flapping in the breeze, the mournful groaning of the timbers and masts with fragment sails hanging like crepe chill even the hardest of old salts.

The derelict WYER G. SARGENT drifted for 615 days, covering an estimated 5,500 miles before she was destroyed on March 31, 1891. The W.L. WHITE was immortalized as the "White Ghost." In the summer of 1888, this ship was abandoned in a Caribbean hurricane and eventually found its way to the Gulf Stream. The ship

drifted an estimated 20-40 miles a day, and ultimately sank off the Hebrides after a voyage of about 5,780 miles.

The longevity record goes to the FANNIE E. WOLSTON, which was abandoned October 14, 1891, and was last sighted on February 20, 1894, some 859 days as a derelict and having drifted about 7,000 miles.

Storing safety at sea was not profitable, for every inch of a ship was used on long voyages. There was little room for lifeboats and those that carried them found out too late that their lifeboats were not designed to withstand the rough treatment they would take at sea. Some lifeboats were easily overturned or waves crested the gunwales and the craft would swamp in the pounding surf. Unfortunately, many skippers relegated safety to a position of secondary importance. Delivery of cargo and passengers on time was the primary goal in the early days of the sail.

Life in the Fo'c'sle

A sailor's life aboard ship in the days of the sail was far from a pleasant day sailing on a bay. It was always cold, damp, and musty in the fo'c'sle (forecastle). The crew was usually a rough-and-ready gang of men from every nationality and all walks of life. Shipboard life was uncomfortable at best and on some ship's life was made even more so with drastic punishment from a captain who enforced his control over his men to the point of mutiny. Being keel-hauled (dragged on ropes beneath the ship's hull) was one way to discipline an unruly lad. A man could have his hand pinned to the mast with a knife for taking something from another sailor. The crew was divided into rotating watches of four hours each, off-duty time was whiled away in the time-honored practice of swapping sea tales and singing old sea chanteys in the fo's'cel.

Cramped quarters made tempers flare and privacy was unknown to men who sailed before the mast. The crew ate only one hot meal a day, usually around noon. Hot or cold a sailor's diet was monotonous. The staple of all nautical diets was ship biscuits, salted pork, a bit of cheese, and beans and onions. Supplies stored in leaky barrels caused much of the food to turn bad. Weevils attacked the biscuits and the meat putrefied. To wash down a meal, a crew might have wine or water, both of which quickly spoiled in their wooden casks. Wine turned to rancid vinegar and water became so foul and smelly that sailors held their noses while they drank it. Scurvy was the big killer of seamen due to the lack of fruit and vegetables and the absence of Vitamin C in the sailor's diet.

In the following chapter, we will further explore hardships on the sea and the tremendous challenges that sailors faced as they moved across dangerous waters from continent to continent.

CHAPTER VI
SAILORS TAKE NOTICE:
Ships Lore and Life at Sea

The story of hardships was real, but the lure of gold had a greater pull on the lives of young men who met the supreme test for any sailor. When their voyage was achieved, they developed confidence in themselves that they could face any difficult circumstance. It was said in ship lore that no better sailors had lived than the veterans who sailed around Cape Horn. Even with the torture of frostbite, poor conditions, weeks of cold food, wet clothing, and having to go aloft in the middle of a black and screaming night, it brought success to some and adventure to all.

Men who went down to the sea in ships learned that the romance of a sailor's life was only in the mind of a fiction writer. He soon found himself "swinging aloft twixt heaven and earth" and if he slipped it was overboard unto a hungry sea. The lad soon learned to speak a new language, from the salty lips of old "down-east johnny cake" or down a "plum-duff" come Sunday morn. You learned your lesson well for the punishment was harsh. A sailor's haughty spirit was soon brought to a halt and for many it would show the scar of pain.

Many of our ancestors came to these shores in sailing ships from around the globe. There is a kind of patriotic pride as we stand in awe of sailing ships. Tall ships symbolize our roots and the making of a great country.

She Sailed the Seven Seas

Sailing vessels have always been referred to in the feminine gender because they were a thing of beauty, and women have traveled on ships for centuries. Under the bowsprit of many ships, a bare-breasted beauty was thought to calm the raging storms. Richard Henry Dana, author of "Two Years Before The Mast," wrote about the custom of hanging a length 6-foot rope over the side of a ship on her homeward voyage, to be used by wives and sweethearts to pull the ship home with magical speed. Ancient mariners launched their new vessels by sacrificing a young girl and spattering her blood on the

bow to placate the devil in the deep blue sea. Human sacrifice was abandoned, but the ritual of ship-christening at launching is still a woman's job.

A Bygone Language

Many of the terms we use today have lost their original meaning. The vocabulary of old-timers and boys from waterfront communities spoke of barks, brigantines, ships and topsail schooners and tales from aloft, words that would be meaningless to this generation. Today, you might hear someone say, "running afoul" of someone or something. This expression conveyed a not too pleasant entanglement of rigging and spars. When we refer to a predicament as "the bitter end," this referred to the hazardous situation of a ship with all her cable out to the wind-lass-bitts, with no reserve to ward off disaster. We do not realize that we are using sea language when we speak of an honest man "above board," or a well-informed one as "knowing the ropes," or in the morning we "turn out" and at night we "turn in."

"Backing In" and "Canting Around"

Old sea captains spoke of the wind "backing in" and "canting around" meaning the weather could be foul or fair. "Backing" means against the sun, which is from the east by way of a northerly quarter to the west. "Canting" or "hauling" was the reverse (let's haul out of here). When the wind beckoned, it usually meant that good weather would not last, but it might be expected.

Lore and Legends of The Sea

Ship launching and the custom of christening a ship goes back to the time of the ancient Greeks and Egyptians. It was the custom of their day to deck a vessel with wreaths of flowers and leaves. A priest performed the ceremony of dedicating the ship to a goddess. As the ship left the way and struck the water, wine was poured over it or on

the ground as an offering to the goddess who would protect it. Even after Christianity was well established, the ceremony remained.

Sailors would refuse to board a ship that had not been christened in the conventional way. It was believed that each ship had a soul and would be doomed to hard luck if it was not properly launched. It is no longer a religious custom; however, the essential part of a launching is the breaking of a bottle of wine across the vessel's bow as she begins to slide into the water.

A Coin for Charon

Nautical customs tend to stay the same for centuries. In ancient days, Greek sailors made sure that a coin was put at the heel of their ship's mast. Also, it was important for the coin to face up, otherwise bad luck would haunt the ship. They believed that the mythical River Styx was crossed into the land of the dead when a person died. The coin at the ship's mast was to pay Charon, the ferryman, in case they should be lost at sea.

This strange practice continued long after its original meaning had been forgotten. Even today, some small sailing vessels have their hidden coin aboard for good luck. What kind of coin and where it is hidden is known only to the vessel's owner. Not only for good luck, but also to provide a way to prove ownership of the ship if it were to be stolen.

Best Foot First

An old-time sailor will always make sure that his right foot was the first foot to hit the deck of a new ship.

Whistling Up the Wind

In the days of the sailing ships, it was firmly believed that whistling would bring wind. A sailor whistled softly for a light wind and loudly for a gale. Woe to the man who forgot himself and whistled during a storm! This is the origin of the expression "Whistling up the wind." On a calm day, the captain might order his mate, "Matey, whistle us up a breeze and make it a fair one!" Many old-timers swear that it worked every time.

Buccaneer Ghost

The island that is the apex of the much publicized "Bermuda Triangle," has more than just legends of cursed ships and haunted shores. Perhaps Bermuda's most famous

ghost is that of the buccaneer Henry Morgan. A group of Bermudians in 1775 stole gunpower from under the nose of the governor and shipped the powder to George Washington for his fight against the British. When Captain Morgan found out, he flew into a rage and cursed the island, saying that as long as the descendants of those responsible survived in Bermuda, his ghost would haunt it. So it is to this day, on hot still summer days, clouds form over Bermuda in the shape of the island itself and Bermudians looking up will say, "There's the ghost of Morgan back again."

A Pirate's Lady

In the history books we seldom read about Lady Looters, but there was one such person by the name of Anny Bonny, a beautiful impetuous little scraper who was the daughter of a wealthy Carolinian lawyer. When she was only sixteen, she joined a band of pirates and lived an adventurous life. Anne was an expert shot and a fine swordswoman. In her later years, she became an able captain. Lady Luck was with her when she was captured by the authorities, for she was released. However, at age twenty she just disappeared. Anne Bonny was never heard of again. Like the famous pirate Sir Henry Morgan, no one knows what happened to her.

The Tale of Grace O'Malley

Grace O'Mally was the daughter of well-to-do pirates and inherited leadership of her father's ships. Born on Clare Island off the coast of Ireland, she grew up aboard her father's ship, and at an early age she became a crew member. As a young girl she was scarred by a mother eagle when she was climbing a cliff near her father's farm. The prominent scar on her face was intimidating to those she fought. Her ships preyed on shipping between Cork and ports in Spain and Portugal. In her later years, she had become gray-haired, but the eagle talons' scar still burned brightly across her brow. With a pistol in one hand and a sword in her other, she became a fiend and fought as well as any man her size. Queen Elizabeth once offered a reward for her capture, but she always eluded her pursuers. Many Irish legends are told about Grace O'Mally.

A Bermuda Legend

In 1934, a ship, manned only by skeletons, sailed safely through the reefs and into Ely's Harbor, a feat most living and experienced sailors would never attempt.

A Sailor's Taboo and Superstitions

There were many superstitions and taboo words among men of the sea. A sailor or fisherman in certain localities were most averse to the mention of a rabbit. A sailor never took a rabbit on-board ship and never referred to a rabbit except to say, "a furry thing."

Pigs, preachers, and some women were also considered unlucky objects to have on board ship. Preachers were proverbially unlucky. Foul weather was sure to follow a ship that had a minister on board. At sea their name was never mentioned. The presence of a woman was sure to spook a crew at sea. However, there were women aboard ships, often disguised as men. Their real names never appeared on the ship's muster list.

A voyage was never begun on a Friday; this was a widely spread superstition. It was considered a fatal mistake to name a ship after an ocean or sea. In early times, on many ships' horns an object marked with magical signs and believed to confer on its bearer supernatural powers or protection were often carried as talismans.

"Son of a Gun"

The life of a seaman was harsh in the day of the sail. Going to sea was like being jailed, with the added risk of drowning. Warships, or as they were called ships-of-the-line, were crammed with officers and men and had little ventilation with no plumbing.

Food was not only unlike home cooking in the days of the sail, but it was often deplorable. One way for a man to forget the weevils in the biscuits was to give him a ration of grog (watered rum) and a slice of chewing tobacco. It was said that the salt pork and beef were so hard that they would take a polish. Even the drinking water had green scum on top. Yet there was always someone who could wrench a tune from a fiddle, and someone else who could dance a jig or sing a song. Work at the capstan was always easier with a chanteyman to lead the gang in their grunting, heaving chorus. Working with their hands kept many a man busy, and some of their handy work can still be found today.

Flogging for misdemeanors were common and some men even ran the gauntlet, with every seaman aboard taking a fierce swipe at their shipmate. Humane officers eased up on this sort of thing, but there were others who were willing to have a man flogged through the fleet, which usually killed him. It was no wonder that when a ship came to shore that the crew went wild and lived a little and roistered about the town, for it would not be long until the ship was ready to weigh anchor on another voyage to sea.

On English warships, it was a good idea to keep a crew aboard ship while in port, lest they desert. In the home port wives were allowed, one per man, with no questions asked. A seaman's woman was brought to the jampacked "tween deck" where she would share his hammock slung between the ships' guns. It is said that the phrase "son of a gun" originated here.

The English navy never had enough men to man her ships. In the early days, scurvy and the fevers decimated the crews. Between the years 1774 and 1780, as many as 176,000 men shipped out to sea and 1,243 were killed in action, 18,541 died of disease, and 42,069 deserted. Ships that were short-handed often stopped merchantmen at sea to search for navy men who had deserted their ship for better treatment. The impressment of Americans during this time and their forced service on British ships was one of the causes of the War of 1812.

The British Navy had no regulation uniform before mid-19th century. A sailor often carried all his worldly goods in a kerchief. American tars or sailors had it better; they were paid and fed more than British Jacks.

American battleships began with the AMERICA, classed as a 74-gun ship-of-line. This ship was given to the French in 1782 to replace the French ship MAGNIFIQUE lost in Boston Harbor by grounding.

The Twenty-One Gun Salute

Naval traditions and customs suggest, but does not specifically state, that first, it is an old superstition that to fire an even number of shots in a gun salute is bad luck. Also, the limit of 21 guns was originally established as an economic measure. At one time as many as 40 or 60 guns were fired in certain foreign navies.

Sea Chanteys

Seaman performed their routine chores to the rhythm of sea chanteys for they helped to annul and to aid in coordination. There was a song for all jobs: "long drag" chanteys like "Blow the Man Down" were sung as an accompaniment to such slow tasks as raising a topsail yard, and "short drag" chanteys like "Haul the Bowline" were sung when a rope had to be tightened in short, quick motions.

Chantey songs included words and phrasing that were centuries old. Although it might sound like gibberish to a first voyage passenger, it was understood by seamen the world over. Frequently, a song or chantey was led by a sailor who had the knack

for incorporating the idiosyncrasies of various crew members into the lyrics. The work became much more tolerable and even agreeable because of such men. They were usually popular both with his fellow crew men and his superiors.

The specific situation in the one line in the old sea chantey "Blow the Man Down" goes, "Give me some time to blow the man down," simply meaning to set a pace that leaves the other fellow out of breath.

Nautical Miles vs. Land Miles

A nautical mile, or knot, is about 6,080 feet. The land mile is 5,280 feet. To many people, the nautical mile seems a much more sensible way to measure distance than the land mile. The nautical mile measures an exact fraction of the earth's round surface, but the land mile only measures the approximate distance marked off by 1,000 paces.

"Gone by the Boards"

The origin of the expression that a person, thing, or custom has "gone by the boards" was originally a nautical expression with the same meaning as "gone west," but in this case over the side. In other words, it meant dead or finished.

Letters Across the Ocean

In the early days of the sail, communication was very primitive. People generally had to take the precaution of sending several copies of a letter by different vessels to make certain that at least one copy got through. Merchants often operated in the dark, buying goods without knowing the state of the market. Beginning in 1755, the British government sailed 200-ton brigs that specialized in carrying mail across the Atlantic, and most international communications were simply left in port coffee houses to be picked up by the master of a vessel bound for Europe or America. Letters exchanged across the ocean often took half a year or longer.

Pirate Treasure

Between the years of 1640 and 1730, piracy and marine knavery were at an all-time high in America. Pirates' loot estimated to be worth $100 million is believed to be buried just off the mainland, on a few minute islands in the Atlantic. But for the most part only a few stray gold and silver pieces were ever found.

As noted earlier, Edward Teach, better known as Blackbeard the pirate, buried a large portion of his profits on Amelia Island, some 30 miles north of Jacksonville, Florida. For over 50 years, treasure seekers have searched for this trove, but only a few people have ever cashed in on Blackbeard's treasure, and those were the fake map sellers. The catch with all treasure hunts is the authenticity of your map. The supposed treasures captured by Blackbeard's QUEEN ANNE'S REVENGE were not to be found.

Southwest of Florida, in the Yucatan channel, lies a sandy patch called Isle Mujeres, the Isle of Women. Here was the home and headquarters of a highly successful Spanish freebooter named Mundaca. Somewhere on this island rests a lifetime of looting, some three and a half million silver pesos that Mundaca left behind. When he died, he left neither a map nor a will to the treasure.

Cocos Island, off the Pacific coast of Costa Rica, is barely 20 square miles, and most of the island is covered with wildly tangled undergrowth that blocks off the sun. The moist earth and foul humidity will rot a man's shirt off his back. A stench of rot and decay fills the air, together with a whining hum of ferocious stinging flies. Cocos Island is one of the most fascinating places with three distinct hordes of treasure reportedly buried somewhere on the island.

Around the turn of the 18th century, Edward Davis, one of the numerous freebooters who plundered the coasts of Central America they called New Spain, made Cocos Island his headquarters until he finally vanished without a trace. Shortly before his farewell venture, he is believed to have hidden a treasure in the amount of 700 bars of gold, 20 water kegs filled with gold doubloon, and more than 100 tons of Spanish silver. Another great treasure on Cocos Island belonged to Benito Bonito who is believed to have buried 150 tons of gold on the island. Bonito had dropped anchor in Wafer Bay, at the north face of the island. In later years, explorers found the horribly splintered skeletons of his crew or those he saw fit to stay with the treasure. There is every chance that the gold lies somewhere near his anchorage. Bonito himself was buried at sea.

The third documented treasure is of Lima, a trove which has bedeviled the effort and hopes of more treasure seekers than any other hoard on the face of the earth. This little island is determined to hold fast to the treasure it was given.

The Cocos Island and Her Legends

Isla del Coco is the Spanish name for this treasure island of the Pacific. The island lies about 400 miles west of the country of Colombia in South America. It is undoubtedly the most mysterious depository of buried treasures on the face of the earth. Robert

Louis Stevenson's *Treasure Island* used this island as the prototype for his famous book. Many of the scenes from Daniel Defoe's story *Robinson Crusoe* were taken from actual reports of Cocos Island, however, Juan Fernandez Island was the locale of Robinson Crusoe's adventures.

The lure of the Coco Island treasure has attracted some very interesting people, including Count Felix von Luckner, the old German "sea devil" of World War I, and Sir Malcolm Campbell, the British race-car driver, the actor and adventurer Errol Flynn, and many more gold seekers. All the adventures arrived with maps of varying authenticity and were able to whet their appetites with bric-a-brac of piracy scattered around the island. Parts of the interior have never been explored because of the heavy jungle growth. The island has fresh water from streams flowing down from the cliffs, and wood enough to make it an excellent hideout for pirates. The island is well outside of the trading routes of ships that tracked down from California to the Cape Horn.

For nearly 200 years, the Spanish Main was the playground of pirates. A new sailing route had to be found, it seemed safer to ship gold and silver down the West Coast and around the Horn, rather than risk a Caribbean crossing.

The S.S. CENTRAL AMERICA

In 1989, just weeks before Hurricane Hugo devastated the coast of South Carolina, treasure hunters recovered a king's ransom in gold from a ship that sank off the same coast 132 years ago. The booty from this shipwreck is the richest in U.S. maritime history.

The CENTRAL AMERICA foundered off Charleston, SC in 8,000 feet of water during a hurricane on September 12, 1856, with the loss of 425 lives. The ship was bound from Panama to New York, via Havana, and was carrying the monthly shipment of gold from the San Francisco mint and the California gold fields.

The ship was carrying three tons of gold bars and coins which, at today's prices, are estimated to be worth as much as $450 million. The divers brought up gold coins in mint condition and represent most of those which were minted and could be worth even more to collectors.

One of the super rare gold double eagle coins from the wreck was appraised at $8,000. There are thousands more of them to be picked up by the jubilant discovery expedition. A variety of gold bars and bricks have been found, one of the bricks weighs 62 lbs., which makes it worth almost $2.7 million dollars at today's prices.

In 1857, the news of the CENTRAL AMERICA was as sensational as the TITANIC was to be nearly 60 years later. This shipwreck and loss of the gold caused bank failures

across the country and was a big factor in the Panic of 1875, which was one of America's worst economic depressions.

It was said that when all the treasure was recovered it could be double that of the previous estimates, making it a breathtaking $1 billion dollars. The divers dubbed their find "the yellow brick road" by one dive leader who said, "I never dreamed it would be like this. The gold piles look like a waterfall." Three years of intense work went into finding the ship and lining up investors to finance the treasure hunt. With new sonar scanning technology, the expedition's ship ARCTIC EXPLORER located the wreck after scanning 1,400 square miles in 40 days.

After finding the wreck, the problem was how to recover it. The team built a remote-controlled, 5-ton robot they called Nemo, which could lift items as large as a 1,000-pound anchor or as small as a dime. Another problem was solved when they came up with a rubbery compound to retrieve coins damage-free. With the remote-controlled robot, the expedition carefully excavated the wreck and about three tons of gold was lifted to the surface.

According to the expedition leader, the highly rewarding treasure hunt could have lasted another 18 months. The venture came about in 1983 when Tom Thompson, an underwater engineer whose hobby was locating shipwrecks, got together with geologist Bob Evens and a former newspaper reporter Barry Schatz to find the CENTRAL AMERICA.

The expedition concluded the most likely spot was a flat plain off the Caroline coast known as the Blake Ridge. The ship lies some 160 miles off the coast. The world's oceans and seas cover more than seven-tenths of the earth's surface. New diving techniques have resulted in many new treasure discoveries.

Sinbad the Sailor

From the collection of Arabian stories comes a hero of seven mythical voyages. The stories of Sinbad the Sailor were probably based on the experiences of sailors during the period around 800 AD. The seven voyages of Sinbad are fairly familiar in structure, for all his encounters were while sailing from Basra with merchandise when he would end up being marooned or shipwrecked and met with supernatural dangers. In all his ventures, Sinbad always survived through his resourcefulness, luck, and escapes returning home with a fortune.

During Sinbad's first voyage, he sailed from Basra and found an island which turned out to be a living creature. This closely resembles the creatures described by Pliny and Solinus in their attempts to describe the whales of the Indian Ocean.

On the second voyage, Sinbad and his crew encounter the Roo—a bird so immense it could drop great boulders upon the ships at sea and carry away grown elephants for its gigantic offspring. The Roo was also mentioned by Marco Polo on several of his voyages. He even described this monstrous bird in detail: how its eggs resembled great white domes and how one of its feathers was presented to the Khan of the Mongols. He told of the Roo's supposed home somewhere south of Madagascar and about the dodo birds (not yet extinct) and how they were chicks of fearsome monsters. It was during the second voyage that Sinbad discovered a Valley of Diamonds and overloaded his ship, and it sank.

On the third voyage, Sinbad landed on the Island of the Apes and confronted a cannibal-giant who trapped the crew in his house. They escaped through a ruse very similar to that used by another great legendary sailor, Odysseus, and his superhuman achievements in the ten years he wandered before he reached his home. His story is found in Greek mythology in Homer's *The Odyssey*.

Sinbad's fourth voyage found him shipwrecked by a storm and washed ashore on an island inhabited by cannibalistic tribesmen. Once again, the story was like Homer's *Odyssey*.

During his fifth voyage, the Roe's came and destroyed Sinbad's ship. Stranded, he makes a deal with the Old Man of the Sea.

On his sixth and seventh voyages, again Sinbad is shipwrecked and marooned. The adventures of Sinbad, while often drawn from mythical legends, still provide an accurate picture of the trade and seafaring in the 9th century.

Monster of Monterey Bay

In the 1975 *Guinness Book of Records* this story is told. The largest known octopus is the common Pacific octopus (Octopus Apollyon). One specimen trapped in a fisherman's net in Monterey Bay, California, had a radial spread of over 20 feet and scaled 100 lbs. Could it be that there are octopuses of even greater size lurking in the depths of Monterey Bay? In 1896, the remains of an unknown marine animal weighing an estimated 6-7 tons were found on a beach near St. Augustine, Florida. Tissue samples were sent to the U.S. National Museum in Washington, DC and in 1970 they were identified as

belonging to a giant octopus with an estimated tentacle span of 200 feet. Monsters of the deep have been reported from man's earliest voyages into the sea.

Monsters of the Deep

From the early days when man first ventured out to sea, stories of monsters of the deep have been a part of the lore of the sea. Tales of horror appear throughout the annals of sea history and to this day these strange sightings of sea creatures still find their way in the places where sailors gather to unwind and down a brew and tell of their days at sea.

A story of a giant sea monster was recorded during the second World War. An enemy ship sank an Indian Army boat in the South Atlantic and 12 men on board were left to fend for themselves in a raft. The most appalling day or moment of all came on the sixth day at sea. A gigantic shape appeared slowly behind the raft with giant tentacles. For some time, this thing seemed to stand off and contemplate its strategy. Then, it deliberately reached out and grabbed one of the men in the raft and slowly pulled him overboard into the water. The men on the raft made a futile attempt to tear the tentacles away but were unable to match the strength of the creature. The monster was perhaps a giant squid, the most fiendishly equipped of all the marine creatures that lie hidden beneath the oceans.

In 1966, the U.S. Navy research vessel San Pablo was 120 miles off Cape Bonavista, Newfoundland. Suddenly a sperm whale hurled itself out of the water ahead of the ship, entangled in the tentacles of a giant squid. The crew of the ship were oceanographic experts and they all agreed that the whale was at least 60 feet in length, and the squid was every bit its match.

Another vivid description survives from a sailor who was aboard a British trawler in the Indian Ocean during the second World War. It was his habit on the "graveyard" watch to lower a cluster of electric bulbs to the water. Fish of all description were attracted to the light, and easy to catch. On one night, all the fish had vanished. As he gazed into the water, a circle of green light glowed in his illumination. This green unwinking orb suddenly gazed at almost point-blank range with a single eye penetrating like a beam of light. The body outline was that of a colossal squid. The tentacles were two feet thick with suction disks clearly visible, the creature was as long as the 175-foot ship.

Captain Arne Gronningsaeter, in the 1930s, reported an attack of a squid on his ship, the 15,000-ton tanker BRUNSWICK, sailing in the South Seas off Samoa doing 12 knots when a great squid overtook her, then turned and attacked the ship amidship.

The monster could not grip the hull and was finally cut to pieces by the propellers. Also, in his logbook were reported two other attacks in almost the same way. In the Indian Ocean, in the last century there were reports of a 150-ton schooner, PEARL, being capsized by a giant squid. The PEARL was becalmed in the Bay of Bengal and the report came from the crew of a steamer, the STRATHOWEN, who said they had seen the giant tentacles simply pull the ship over with all hands lost.

In 1896, an enormous corpse was washed up on the shore at St. Augustine Beach in Florida. The body weighed six or seven tons, and was 21 feet across, 7 feet thick, with one of the tentacles measuring 32 feet long. The skin was 3 inches thick and almost impervious to axe blows.

Mermaids Do Exist

Historical evidence from many lands indicates that mermaids really exist; ask any old-time salt at Kelly's on the wharf. However, some amazing accounts even describe the capture of the half-fish, half-human and other encounters have been reported with these remarkable creatures from ancient mythology to modem times. Among those reporting includes fishermen, Jesuit priests, milkmaids, a physician, and the famed British explorer-navigator Henry Hudson.

The following accounts are from around the world, representing an array of amazing stories which one may find a little hard to quaff down. However, they make great tavern tales on a cold winter night.

In the year 1430, in Edam, Holland, after a heavy storm washed out several dikes, milkmaids, using a boat to reach their flood-stricken cows, were amazed to spot a mermaid floundering in the shallow muddy water. The story goes that the milkmaids brought the mermaid home, dressed her in female clothing but were unable to teach her to speak.

Off the west coast of Celebes in the year 1560, fishermen near the gulf of Mander caught no less than seven mermaids. This incredible catch was witnessed by several Jesuit fathers and M. Bosquez, the personal physician to the Viceroy of Goa. A mermaid was captured in the Baltic Sea in 1531 and was sent as a gift to King Sigismund of Poland and seen by all his court. The sea creature lived three days.

In 1608, Henry Hudson wrote in his log that a mermaid with long black hair, a woman's upper body and lower body like a porpoise had been observed by two of his crew.

In 1717, an account of a mermaid caught off the Netherlands was recorded, estimating her to be 59 inches long, she uttered little cries like those of a mouse. The account was published by Louis Renard of Amsterdam.

The ATLANTIC

A famous painting of the schooner the ATLANTIC is shown on the open sea at full sail. It bears the legend, "With a bone in her teeth and the best girl on the towropes." The meaning of this legend is that "bone in her teeth" refers to the white foam under her bow, and the reference to the "best gal" means homeward bound.

The Graveyard of the Atlantic

Cape Hatteras, NC today is the place to enjoy the ocean and surf some waves. Few people today seem interested in understanding the history of this once graveyard of the Atlantic. The romantic old Cape Hatteras Lighthouse still stands, but within the arc of the beacon, the rotting carcasses of hundreds rest on the bottom of this most treacherous water of the seven seas.

The 208-foot lighthouse, the tallest in the nation, rises at about the north-south mid-point of the Outer Banks. The 175 miles of shifting dunes and beaches embrace the North Carolina Coast as well as four centuries of vivid history.

Sir Walter Raleigh's colony was lost here a generation before Jamestown. Blackbeard did his pirating from here. From the lighthouse it is easy to see why more than 600 ships have perished here. This is the point where the north-bound Gulf Stream, the warm ocean river mightier than a thousand Mississippi Rivers, runs head-on into the cold, southbound Labrador Current. They collide at Diamond Shoals, a barely submerged shelf stretching 14 miles out to sea. The effect is like water brought to a sudden boil and the result predictably savage. The shoals grab a ship and hold it; the waves flog it to splinters.

In the days of the sail, men in fragile boats raced through the surf to the foundering ships, having spotted them from the coastal lighthouses. Many tales of horror and heroism out on the maelstrom are inscribed in the Outer Banks folklore.

Graveyard of the Pacific

Off the coast of Vancouver Island from Port San Juan to Cape Beals has become known as the "Graveyard of the Pacific." On the northwest coast of America, the current is such that all disabled ships, wreckage, and flotsam caught in the current are swept northwards, even from latitudes south of San Francisco, California and are deposited on the southwest coast of Vancouver Island, particularly in the vicinity of Carmanah Point. This was, in the days of the sail, and still is the main contributing factor to most shipwrecks.

Devil's Triangle in The South China Sea

It is believed that a "devil's triangle" exists in the South China Sea. The triangular area bounded by Manila, Hong Kong, and Taiwan. Documents from 600 years ago recorded the strange phenomenon of ships disintegrating at sea on calm, windless days. According to these documents, ancient men of the sea had told stories of ships that vanished without a trace in the South China Sea 600 years ago.

The phenomenon compares to the so-called Bermuda Triangle of the Atlantic. It is believed that the disappearance of many ships in this area was the work of huge whirlpools formed by the convergence of various ocean currents in the area where islands interfered with the natural flow.

Fifty Foot Wall of Water

A massive wave 50-foot high triggered by an earthquake or volcanic eruption was recorded on August 8, 1868, in the port of Arica in Peru (now Chile). The devastation killed most of the towns' 10,000 inhabitants, but from this tsunami a most unusual

phenomenon also took place. The U.S.S. WATERCE was anchored offshore when its lookouts spotted the approaching monster wave. The crew of 234 members clutched their lifelines as the 50-foot waves swept over the ship. The WATERCE managed to rise to the surface and ride the crest of the wave, which carried the ship three miles up the coast and two miles inland.

When the ship came to rest, the crew discovered that their boat had been deposited in the middle of the desert, 200 feet from the Andes Mountains. Miraculously, the crew was unhurt and there were no injuries reported. The WATERCE was undamaged, but it was impossible to return the ship to sea. The ship was sold to a hotel company at an auction, then subsequently used as a hospital and then as a warehouse before seeing its final service as an artillery target during the Peruvian-Chilean War of the Pacific in 1879.

Slush

"Slush" is an old word meaning "refuse." In the British Navy, it consisted of fat, grease, and other waste from the galley. Somewhere along the line, the idea of selling the slush to raise money for a fund for enlisted men in trouble came along. It became the "slush fund."

Pilot Bread

During the days of the sail, bakers advertised pilot bread among other items. Pilot bread was a hardtack or biscuit very durable and was carried on ships especially to be served when stormy weather made it difficult to cook. It stays as solid as concrete for a long time. A variety of the same is still sold by grocers today.

Home Remedies for a Sailor

Many old-timers believed that iron was good for a person. It was not uncommon for a sailor to put rusty nails in the bottom of his drinking cup. Broken shells were added to the water in the kettle to keep the pot clean and to strengthen a sailor's bones.

Lord Horatio Nelson

Lord Nelson (1758–1805) was possibly history's greatest naval commander, yet he was constantly seasick. At the time he defeated Napoleon's navies for his native Britain, he also was suffering from gout, recurring attacks of malaria, chest and lung

pains, rheumatic fever, and mental depression. In addition, Lord Nelson was missing his right eye and arm, lost in battle.

Royal Navy Terminology

From the archives of the days of the sail some interesting expressions have come down the line. A language used in the past is relatively unknown by many sailors today. Here are a few of the old terms:

> GROG—a traditional two-part water, one part rum.
> TOT—a standard daily ration for the day, one eight-pint rum.
> SIPPER—a small gentlemanly sip from a friend's rum issue.
> GULPER—one big swallow from another's tot.
> NEAT—a ration of rum without water.
> SPLICE OF THE MAIN BRACE—a double tot for a job well done, or an invitation aboard for free drinks. Saying to a friend, "let's splice the brace!" was another way to say, "let's have a drink!"
> BOB'S-A-DYING—in Lord Nelson's day Bob's-a-dying meant a drunken bash.
> LONG SWIG AT THE HALLIARS—meant to "tie" one on.
> YOU CAN'T KEEP A GOOD MAN DOWN—at the battle of Trafalgar, Lord Nelson died in action. The body of Nelson was preserved in a large cask of brandy and guarded day and night by a sentry. One of the sentries nearly deserted his post when in the middle of the third night, there was an exhalation of gas from the body and the lid rose from the cask. Perhaps this was the source of the expression, "You can't keep a good man down."

Rum

"Rum" is an abrupt word of only three letters and yet it conjures, more graphically than some full-length novels, the flavor, the spirit, the action-packed stories of the Spanish Main, free-booting pirates, American whalers, Buccaneers, the sea-roving British Nancy, and much else that we think of as swashbuckling. The role played by rum in the slave trade was so integral as to be known as the "Triangular Trade." Rum was used to buy slaves in Africa. The slaves were sold to the sugar planters in the Indies to make rum and the slaves were purchased by the planters with rum.

The origin of the word "rum" actual is lost in the foggy sea of time. It is believed that the 17th century British sailors who came to love this beverage hailed it as the "rumbullion" and "rumbustion," both words indicating heart approval. As time sailed on, the word became shortened to just "rum." Another sailor yar is that in 1745, a British Admiral named Vernon, at a loss to stem an outbreak of scurvy taking a terrible toll of his men, in desperation cut their daily ration of beer and in its stead gave then a new, unknown beverage "rum" in honor of the Admiral's nickname, "Old Rummy."

Evidence also points strongly to rum being Chinese in origin, dating back to about 800 BC. Cane was grown in the lower Yangtze and it is quite likely that the Arab spice traders came upon it there and subsequently introduced the drink to Spain. It is a matter of fact that Isabelle was quite aware of the importance of sugar can when she sent Columbus off in search of a new route to the Indies. On the second voyage of Columbus, he set out sugar cane plantings in what is now Puerto Rico.

As early as 1575, stills were producing rum in the New World. By the mid-1700s, South Carolinians were not only downing thousands of barrels of it but trading a goodly portion of rum with the Indians. Rum was the "grog" of pirates, privateers, and buccaneers alike. The hard life of New England and its severe winters, the rugged existence aboard the great whaling ships made rum a popular grog among the Yankees. In fact, it was so dearly loved that there are frequent references to it in the writings of many Founding Fathers, among them John Hancock and John Adams. Rum was called the "Spirit of '76."

Early in its history, New England made a "rough grog" as well as importing finer goods from the Indies. In 1764, the British endeavored to control the rum trade with a measure called the "Molasses Act." All their curtailment succeeded in doing was to make smugglers of some of the most prominent families in the colonies and gave them one more reason to rebel. Many a vessel struggling around the Horn had the captain's personal rum cask lashed to the mast. The crew drank the inferior New England grog. The life-giving and nourishing qualities of rum have been known from its earliest use to the present day.

The Ship Carver

Almost every ship had its own carver, usually a man of considerable skill who in many cases had served an apprenticeship under an older master of the art. His certificate attested to his competency. The skill was sometimes handed down from father to son, as in the case of the Seaveys of Bangor and the Littlefields of Portland, Maine. Carved

often from a single block of wood, or from several blocks doweled together, the figurehead was bolted to the stern head under the bowsprit. Elm or oak was used by many of the early wood carvers, but craftsmen of Maine preferred the softer and more workable pumpkin pine. The scrollwork on which it rested set off the beauty of the figurehead. Some ship owners were willing to pay liberally for elaborately carved figures. One such full-length figure was that of Jenny Lind for the clipper ship NIGHTINGALE. William Southworth received $250 to $400 for his work; he was well-known for his carver's ingenuity and artistic ability.

Figurehead

Sunup to Sundown

A shipbuilder's day was a long one, from sunup to sundown before the middle of the 19th century, when the ten-hour day was adopted. During the summer months, a workman was at the yard as early as five o'clock in the morning and did not knock off until seven at night. He had a half hour off at six for breakfast and three quarters of an hour for dinner at noon. Well into the 1840s, skilled craftsmen received a dollar a day. In the '50s, a skilled worker could receive $3.50 for his labors. Ordinary workmen or helpers some $0.75 cents, while the boy who tended the steam box or turned the wheel in the ropewalk toiled all day for $0.15 cents. Many of the builders boarded their workmen and for those who preferred to live at home could buy a satisfactory meal for only $0.8 cents.

"Grog Oh!"

During the early days in the building yards, strong drink was thought a necessity. Before work was begun, the men gathered in the shipyard store to warm up from those frosty mornings along the water ways. There they were served their portion, consisting of a tumbler of rum and two of water. Sometimes molasses was added, this mixture was

known as blackstrap. This was repeated at eleven o'clock and at four in the afternoon. The welcome cry of "Grog Oh!" often brought the workers together to celebrate some special occasion. The raising of the stem or the last plank would be a time to gather around for a bit of grog. As the temperance sentiment grew, yard after yard gave up the custom and the coffeepot replaced the grog dipper.

One for the Road

"When the sun is over the yardarms it is permissible to take a drink." This usually meant eight bells, or high noon, generally speaking.

The Passing of the Ships' Figurehead

The cruiser-bowed ships of today no longer carry figureheads, like the stately eagle which adorned the clipper GREAT REPUBLIC. The DELAWARE adorned an Indian chief during her life at sea. A bronze copy of the figurehead stands at the United States Naval Academy, the famed bust of "Tecumseh" whom midshipmen regard as "god of 2.5," their passing grade. They toss pennies out to him. Old seamen said that to remove the figurehead would make a ship haunted, a ship with a hoodoo.

The old figureheads were essentially of an age at which we are apt to look with a smile of slight superiority— an age of superstition and sentiment. This is an age of science, and science cannot be reconciled with superstition; thus, we look back at history and smile at what was once very important in the lives of early seamen.

The long voyage was an undertaking involving years from families and home ports, months at sea with no prospect of landfall, and nothing to entertain them during long middle watches in the Trades but their own imaginings. Today, with the most up-to-date luxury liner to the humblest tramp, no ship is out of touch with land for more than two or three days. It is, then, any wonder that we smile at superstition, and that figureheads and other fancies have found their rightful place in the limbo of the past. Perhaps the most varied career vouchsafed to a seagoing Queen was that reserved for the Queen of England, Queen Victoria. This figurehead with a rose in her hand went graciously to sea at the bow of the four-masted barque BUCKINGHAM. Built in 1888, this ship was the only vessel in the British Mercantile Service to be launched by Queen Victoria.

This ship had a varied career under several different flags, but the Queen remained with her throughout even to her end, which came on Christmas Day in 1922 when she

collided with a steamer off Wilson's Promontory. The figurehead of the Queen, still firmly clasping her rose, was left in the steamer's galley, and BUCKINGHAM succeeded in making port without her. In the lawsuit that followed, damages were awarded for the mutilated head, and thus was the Queen took revenge.

Figureheads were often family affairs to the mid-Victorian shipowner including wives, daughters, twins, and even the master himself. One of the first to do this was James Baines, owner of several famous clippers. Donald Mackay, that renowned builder of so many Boston clippers even went to sea resplendent in the bonnet and kilts of a Highland Chieftain.

Windjammers like the STAR OF INDIA switched to iron bowsprits and even iron and chain bobstays, but they never gave up their figureheads. Painted figureheads were customary in coasting vessels, but for the beautiful ships which in the full glory of their womanhood were the ultimate perfection of the ship maker's art, a painted figurehead was never thought of. The Indian Chief of the RED JACKET, the grandees of Marco Polo, the curly-haired sailor boy of the CHAMPION OF THE SEA, the mail clad warrior of SIR LANCELOT, and the most famous of all, the witch Nanny of the CUTTY SARK— all these were painted with several coats of the best white enamel.

Thus far, we have talked only of the figureheads of merchant ships, but, except in the case of the East Indiamen, the use of figureheads in the merchant Service only became common with the beginning of the 19th century. Long before that time, however, the fighting ships of the Royal Navy had been decorated in the most elaborate manner imaginable, not only with figureheads, but with heavy scrolls and "gingerbread" work, which added greatly to the cost of the ship herself. The story of the figurehead goes back to the earliest days of seafaring, for it was inseparably interwoven with the religion and superstition of the men who first went down to the sea. Roman galleys, Viking long-ships, the ARGO of the ancient Greeks, all these carried a spiritual guardian who was to appease the dark gods and give them protection at sea. Kings, Queens, Dukes, and a vast number of symbolic figures such as Neptune, Hercules, Orion, and other figures went to sea on the bows of ships the world over. On the H.M.S. BRUNSWICK the Duke of Brunswick was carved complete with full Highland costume and wearing a cocked hat. During a battle in 1794 with the LE VENGEUR the hat was shot off. The crew ran aft and asked their captain to replace it with his own, who, realizing the ignominy that the noble Duke must be suffering, gave the deputation his own gold-laced hat to the carpenter to nail on the figurehead. A figurehead which has a great story is the one on the EURYDICE, a wooden ship launched in 1843. The figurehead

is of a black-haired woman with a broad black sash uplifted above her head with hands outstretched. Round her neck hangs a telescope, whereby there is a story. The EURYDICE, after being refitted in 1854, was commissioned for further service and later became a training ship for Ordinary Seamen. In 1878, when returning from the West Indies, she foundered off the Isle of Wight in a storm and all hands except two were lost. The figurehead, however, was found quite unscathed by divers and round her neck was hanging a telescope in the same position in which it is now placed.

The skill of carving came to America from England with families such as the Hellyers, whose F. Hellyer of Blackwell was responsible for the CUTTY SARK. In this modern day, there are few figurehead artists left, for art is one of a passing generation. May the carvers of old be not forgotten but their works continue to be the prize they once were so long ago.

Church Ships

The art of building model ships is as old as its parent art, that of shipbuilding. Vessels of all types have been found by archaeologists in all parts of the world. The tombs of ancient Egypt have yielded many great and beautiful little models. From these early clay models, it is easy to see how the Egyptians sailed on the Nile; some of these models are manned by miniature crews, each member performing some duty or task which was important to the craft and the mission on which they were about.

Since these models of clay were made, models have been built and fashioned from a great variety of materials and in many ways. Elephant and walrus ivory, as well as whales' teeth, were used for hull and spars, and there were models built of ivory with rigging made from silk and sometimes black or white horsehair.

The finest examples of the modelmakers' art are the so-called Admiralty models. Built by naval architects, master-shipwrights, or shipbuilders from original plans before the ship was built. So complete were these ships in every detail, so carefully rigged that today we can tell the seafaring methods used to build the great ships of old. The most prolific producers of miniature ships were the sailors who sailed the great seas and waterways. Most of their models were jackknife-carved from solid blocks of wood and are known as "sailorman's models." Many early models of this kind are found hanging in churches around the world. They were the only offering the poor sailor could make in appreciation of his safe return from a hazardous voyage at sea. Collectors know them as chu crude, with exceptions, for they lacked accuracy of lines and proportions, but they are nevertheless representative of ship types and rigs of various periods in time.

Fire Ships

These instruments of destruction were an idea as old as naval warfare and were used by the Dutch in their war with England. Drake had great success against the Spanish with his fireships, not for the destruction they did, but because the Spanish were panicked into leaving their anchorage and drove out to sea. How a fireship was fitted out depended on the type of vessel used; basically, they were small vessels filled with combustibles and explosive material. The English 18th century ships which were built or converted as fire ships had rows of ports cut in their lower decks and hinged at the bottom so that they would stay open and serve to let air in to speed the burning rate and to attack the enemy ship from the windward when she was either holding her wind or disabled. Only large and important ships were worth the expenditure of a fireship as there was a good chance of being sunk by the enemy guns before she could grapple. If she fired too soon, she would bum out harmlessly and if too late, the crew of the target might un-grapple her and free themselves of any fire or explosive material. It took a lot of cool nerve and good judgement to attack with a fireship.

The Captain and His Crew

It took a particular kind of man to meet the qualifications of a ship's captain. They had to be tough, single-minded, ruthless men of action who loved only two things in this world: their ship and speed. They had to know their ship and how to make the most of all she had to offer. The masts might bend like reeds and ropes strain and hum near the snapping point in a shrieking gale, but they called for more sail. Jamming on more canvas and riding the storm was one thing, but the least bit of clumsiness or lack of judgment and away would blow half an acre of canvas, carrying with it a mast, ropes, yards, and crew. Some captains were heroes of their day, their records and exploits were followed in the newspapers by readers young and old. New England shipowners paid their captains a fortune.

A rigid class system was developed aboard ships that is still part of the custom of the sea. From the early days of sailing the crew's quarters were usually under the forecastle. Few crewmen ever went farther "aft" than the main deck. The half deck was the private haunt of the midshipmen, quartermasters, and officers. The poop deck was the sacred lair of the skipper and his highest officers. The ordinary seamen, sailors of the forecastle, have rarely been written about to any glory. Even since the days of the galleys, the men who owned ships and the men who commanded them have had little thought to the

welfare of the men who would man the ship. The crews of the galley ships were slaves and treated as such. In later years, the sailing ships were not much of an improvement. Although they were beautiful from the outside, on the inside sailing ships were often filthy, crowded, disease-ridden holes. Few men in the early days shipped aboard of his own choice. Money solved this problem: crews were "hired" by force, bribed, kidnapped, drugged, and sold. For Columbus to sail in 1492, a crew of sailors were taken from the cells of the Palos de la Frontera jail.

Ordinary seamen, whether on naval or merchant ships, lived in a badly ventilated, horribly overcrowded hole in the forecastle. Many of these lads, whose only crime was that they had been victimized and who had never even seen the inside of a ship before, might then be whipped into shape by one of the most rigid systems of discipline the world had ever known. For the slightest evidence of defiance or disobedience, a sailor might be tied or nailed to the mast and lashed with a whip to set an example for the rest of the crew. Aboard some ships, his meals were a rancid and odorous mess brought to the forecastle in a big tub. This was set in the middle of the floor and all sailors dug into the same pot with their spoons, elbowing for their share of the meal.

Little wonder that the sailor's life was short. If he survived scurvy and other diseases, keelhauling, enemy gunfire, food poison or starvation, he would surely die of overwork. It was taken for granted that on every long voyage a certain number of men would die of one cause or another.

The CHALLENGE And Captain "Bully" Waterman

On July 13, 1851, the New York City waterfront was alive with anticipation for it was the day the clipper ship CHALLENGE was about to set off on her maiden voyage to San Francisco. Up to that time she was the largest and most imposing clipper ever built. The CHALLENGE was a 2,006-ton vessel with a 230-foot mainmast and 12,780 square yards of sail. The crowd came to see not only the ship, but the celebrated Captain Robert Waterman, former captain of the first true clipper ship, the SEA WITCH. It was with this ship that Captain Robert "Bully" Waterman stunned the world on its voyage to China from New York in 74 days in 1849.

While the onlookers enjoyed the gals who came down to see the sailors off, a loud cheer went up when the captain arrived and walked up the plank. Some of the old-timers who sailed under his iron fist were not a part of the cheering audience shouting final farewells. Watchers ashore spoke of the graceful clipper ship with a reverent tone as she winged her way toward romance and adventure on the high seas.

However, for her crew it was to be a voyage to hell and the memory would last forever. Once the ship left port, Captain Waterman took on a Jekyll-Hyde contrast. He would assemble his crew on deck for a strange symbolic ritual, where with a bucket of sea water he would splash his own face to convey that he was washing away his shore manners and assuming a different person, one to be feared if you were insubordinate in any way. His next ritual was to collect an arsenal of pistols, knives, and knuckledusters from his crew while he ordered his crewmen to form a line and file past the ship's carpenter, who stood at an anvil and knocked off the tip of the sailor's knives which all sailors carried.

In case of trouble, Captain Waterman had his mate, James "Black" Douglas, subdue any problem that might cause someone to speak his gripe among the crew. An iron belaying pin along with a few curses soon brought a sailor to his knees. A lesson was usually the fate of the first crewmen to step out of line. Waterman would have him stripped to the waist, tied by his wrist to the rigging and then flogged. "Bucko" mate "Black Douglas" as he was called by many an unhappy crew, enjoyed his role on the hell ship CHALLENGE. Flogging with a cat o' nine tail whip was only one way to deal out punishment at sea. A cat o' nine tails was a whip consisting of nine knotted cords fastened to a handle—so called because it left marks like scratches of a cat.

The entire crew had to watch the beating, an experience few crewmen ever forgot. Many lads would carry the marks of punishment for the rest of their lives. Captain Waterman would have a man flogged senseless for so much as hesitating before replying to his question. Congress forbid flogging on all American ships in 1850. However, many clipper ship captains ignored the law and continued to flog on into the 1860s. Clipper ship crews had the dubious distinction of being among the last American seamen to suffer under the lash. Unfortunately, for those who found themselves about British ships, flogging was not outlawed until 1879.

The CHALLENGE reached San Francisco in 108 days. It was not long till a cry for a lynching party was raised by the men that gathered at the pier. Some 2,000 discontented seamen and other waterfront lads assembled for the hide of Waterman and Douglas. For two months, San Francisco's U.S. District Court rocked with sensational charges and countercharges about the voyage of the CHALLENGE. Waterman and Douglas accused the crew of mutiny, while the crew charged them with murder and assault.

As the trial progressed, the facts magnified many times when told and retold from bar to bar. Captain Waterman struck his helmsmen down for having dirty hands; another tale told in court was about the day Waterman had an injured sailor sewn up in a tarpaulin and pushed overboard, still groaning as he went over the rail. Three other

crewmen were shot for not climbing the rigging. There was no record of what penalty, if any, the court assessed in the Douglas case. Waterman was found guilty of only one charge, beating a crewman. It was said that despite the guilty verdict, the judge handed down no sentence. "Black" Douglas did pay the penalty, however, in a personal sort of way. He never was signed on by another shipper.

The CHALLENGE suffered most from the episode. All ships have a personality and a reputation. On her maiden voyage she had earned a bad name and was known for ever after as a hellship. After the trial, Captain Waterman retired, and Captain Land took over the ship but ran into real trouble. He was able to get a crew only after the Griswold Company had paid a $200 advance to every seaman for signing on. The CHALLENGE suffered two more mutinies before she foundered and sank off the coast of France in 1876.

Nikki the Lapp

Shipowners suffered from the gold found in the hills of California. They could not keep their crews from jumping ship. Ships lined the waterfront waiting for a crew and orders to sail for Hong Kong. They turned to the crimps, who virtually kidnapped the derelicts off waterfronts everywhere and delivered them to ships in exchange for an advance on the man's pay. Derelicts were not the only victims; a sailor newly returned from a voyage would saunter into a bar or a brothel and the next day find himself awaking from a stupor aboard another ship bound for China. The captains had no choice but to deal with the crimps; however, they did object to the frequent substitution of corpses and other unfair tactics. One San Francisco crimp known as Nikki the Lapp often delivered dummies cleverly made of sailor's gear stuffed with straw. He sometimes inserted a few rats in the dummy's arms to make it twitch like that of a drunken sailor.

Few crews ever included more than half a dozen able-bodied seamen who had voluntarily signed on; most of the rest of a typical crew of 50 or so were victims of the crimping dragnet. Men recruited in this manner did not often make willing, eager, obedient, sailors. The water fronts in the United States during these times were entirely unsafe for many able-bodied men. A crew could be made up of all sorts of humanity, more often than not by a man in the wrong place at the wrong time.

The clipper ship captain had to be tougher than his crew, a crew of kidnapped landlubbers and a few experienced but rebellious seamen. No one, not even the greenest hand, had any grace period to postpone the fearful experience of climbing the towering masts. A wise mate would mix his new hands with whatever experienced veterans he had aboard. You learned in short order to climb the weather side of the rigging, the side from which the wind was blowing, and to take advantage of the angle at which the ship was heeled.

The Last Resort

Not even a popular captain was immune from battling his crew. A crew soured by a single troublesome member could be led into a mutiny. In 1832, there was a mutiny that in the manner of its resolution stands alone in the annals of sea faring. It occurred aboard the ship SHEFFIELD when she was anchored in the Marsey River just before the packet was ready to sail. As it happened, the captain was ashore on last-minute business. Some of the crew began to terrorize the passengers who fled to their cabins and locked themselves inside. Their ringleader was an especially hardened fellow who had a way of turning men into mutiny rebels. But luckily for the captain, he received help from the least likely person aboard ship: his 20-year-old bride. She helped herself to a pair of pistols from his quarters and with a cool head strode on deck, threatening to blow the head off the first crewman who made another move. Stunned by the sight of this floating Annie Oakley, they stood as they were until the captain arrived to take charge. The mutineers were sent ashore and a new crew was rounded up. Thus ended a tale that, for all its shameless hyperbole, reflects the strength of one little lady with the will to stand off a crew of ruffians.

The Last Farewell

The day of the sail was just a moment in history. Like men, the great ships one by one met their death. Some went down where only latitude and longitude could record their

burial, others went up in a holocaust of flames, and others laid their bones on gravel, later to be found and towed from port to port by a noisy tug. A few found a period of what passes for glamour in their old age as moving-picture ships. From these, a generation that knew them not caught second-handed a little of their beauty and romance.

Some ships became known on the big screen. The INDIANA represented an old ship named the "Colonial Dame" in the picture *The Splendid Road* (1925). She also appeared with the BOHEMIA in *The Yankee Clipper* (1927). The LLEWELLYN J. MORSE was seen as the CONSTITUTION in *Old Ironsides* (1926), and the SANTA ANNA starred in the Metro-Goldwyn production, *Captain Salvation* (1927).

Cremation was the fate of many old timers, their ashes rest in many a boneyard on the west coast. That is all that is left of these tall ships after the shipbreakers dismantled them and burned their hulls for the metal they contained. The mudflats of Oakland Creek in San Francisco Bay stand out as the Arlington of maritime graveyards. From these backwaters of the bay lie the largest group of old weather-beaten wooden ships that once were the pride of the Bay. A ghostly stillness now surrounds these old hulls as their rotted rope-falls hang from rusty davits

and long frozen winches stand like a sentry watching over "Rotten Row." One by one the old schooners were stripped of their metal and that which was left was of little use.

"Press Gangs"

England carved an empire for herself with the help of her great ships and the men who sailed aboard these ships. The British Navy maintained gangs of tough armed men as professional kidnappers. These "press gangs" as they were called roamed the docks, saloons, alleys, and jails gathering up compromised men for crews aboard awaiting ships. Many a lad was ambushed in a dark alley and hit over the head with a blackjack only to find himself a helpless victim chained in the hold of a British warship, doomed to serve as a sailor.

American ships were better manned, but not much better. Kidnapping was a little less frequent until the gold rush, but it did occur; only within the last few generations have conditions really improved for the sailor. Today, sailors live in better quarters, eat wholesome food, and have regular hours to rest, although their hours are still long and the sea is still the master of their fate. Even today, brutal skippers still travel the seas. Gone are the callus-handed toughs whose rags streaked with tape, a bow-legged setter of sails, puller of ropes or a tightrope walker on the rigging of a ship bound for hell or high water.

Mutinies are few today and sailors do have some rights, thanks to the sailor's own fight and outraged public opinion. Ships today are built with people in mind, better living space and restrooms for the crew. The ability of ancient mariners to create, without advanced technology, great ships to sail to the continents of the world has led to a smaller world.

Sailor Take Notice

The U.S. government proudly announced that the "Shanghai" was a thing of the past when, in 1895, a law was passed requiring that the crew of a deep-water vessel be signed before the consul of the country whose flag it flew, or, if American, before a U.S. shipping Commissioner. The signing on of a crew was to be done in the presence of a government official, and only men in their full possession of their senses were to be accepted. It was not long before ways were found to slip around the law.

Port Townsend, Washington had a well-known firm by the name of Sims and Levy of Port Townsend who were, indeed, crimps of the Northwest sailing fleets. The

Shanghai story was not limited to San Francisco and Port Townsend, Everett had its Bucket of Blood Saloon with a backroom trap door. Astoria on the Columbia also had its trap doors for strangers looking for a place to hang up for the night.

In Port Townsend, there was an itinerant dentist who was partial to seafaring men. On his sign out front, it read, "SAILORS, TAKE NOTICE! Remember there are no dentists at sea!

Don't start on a long voyage with bad teeth, extractions guaranteed entirely painless!" When a ship was ready to sail and was shorthanded, a visit to the dentist was in order. It was no time at all until the dentist applied sufficient ether to his patients. When his dental patients woke up on board a lumber schooner and three hours out to sea, it was safe to say you were on your way and if you gave the captain any lip you might find your remaining molars being kicked out, painfully.

Today, Port Townsend retains the look of a small Victorian seaport. The downtown waterfront district and the residential area on the bluff above it were designated a National Historic District.

Captain George Vancouver, in 1792, sailed his ship up the Strait of Juan de Fuca, and turned into what is now Puget Sound. From his log he described this area as "a very safe and capacious harbor" which he named Port Townsend in honor of his friend, the Marquis of Townsend.

"Shall Suffer Death!"

Life on board a ship of the U.S. Navy was far from drinking a cup of tea or sail on a quiet lake. "Better your well lad for if not ye will know the punishment of the code." Seaside's general quarters, and regular morning and evening quarters for prayers, on the first Sunday of every month you had a grand "muster around the capstan," where you would pass in solemn review before the captain and officers who closely scanned your frocks and trousers to see whether they were according to the Navy cut.

This ceremony required your fullest and solemn attention. The reading of the Articles of War by Captain Clerk would take place before the assembled ship's company while you stand bareheaded until the last sentence is pronounced. This reverence for the code was a way of life and the captain's word was law and gospel.

There were some twenty offences – made penal – that a seaman may commit, and thirteen were punishable by death. "Shall suffer death!" This was the burden of nearly every article read by the Captain's Clerk, for he seemed to have been instructed to slide over the long articles and only present those which were brief and to the point.

The repeated endings of the articles would fall on you like an intermitting discharge of artillery. If by chance you did not comprehend the last paragraph, your ears would pick up the next arrangement of words, detailing all possible particulars of the offence described, and you breathlessly await, whether that clause also was going to end with the words... Shall suffer death! There was a glimmer of hope or alternative to a sailor who infringed on these articles. Some of them ended with the words: "shall suffer death or such punishment as a court martial shall adjudge." Death was swift but punishment worse than death was something else.

Captains and mates had to enforce such a fierce discipline on these ships so that no man dared to step out of line. The tales told by many homes from a voyage around the Horn were not all exaggerated. There is no doubt that the stories which abound in sea fiction of "bully" captains and "bucko" mates who had little regard for the lives of the crew were all too true. Many a lad knew the meaning of "belaying pin soup" and "knuckle dusters," taught by an officer who was able to "lick his weight in wildcats." Once at sea the captain and mates had almost unlimited power. However, not all ships were hell ships. Nevertheless, the stories passed down the line through the years often focused on the dark side of this period in time.

Keelhauling was another form of brutal punishment for breaking rules. This punishment was to throw a man overboard, tied to lines, and drag him from one side of the ship to the other.

Mutiny was by far the one offence that punishment was swift and guaranteed to put a rope around your neck. The yardarm penalty was mutiny. More than a few sailors and some officers have been hanged from the yardarms, high on the mainmast of a ship for "mutiny." Sometimes the "mutiny" was no more than a surly look when the captain gave out his commands. Convicted pirates were often hanged in chains along the Thames River and left rotting and sun-drying for years. The idea was that outgoing seaman would see the hanging skeletons and think twice before being tempted into piracy.

Hanged from the Yardarms

In the history of the U.S. Navy, only one naval officer was ever hanged for mutiny. He was Philip Spencer. In the year 1841, Spencer joined the Navy and later signed on board the SOMERS, a training ship. He was one of 13 officers on board, with a crew of mostly teenaged apprentices. Having gained the post through the influence of his father, John C. Spencer, Secretary of Wan under President John Tyler, Spencer was snubbed by the other officers. Compensating by being overly friendly with the enlisted

men, Spencer thought he could win some respect from the apprentice seamen, a habit abhorred by the ship's commander, Alexander Mackenzie.

Returning from Africa, Lt. Guert Gansevoort, second in command, informed MacKenzie of a plot to murder most of the officers and throw the "small fry" overboard and then take over the ship and turn her into a pirate vessel. Spencer was ordered to report to the commander, where on he was put in double irons after searchers found a paper with names of the crew written in Greek and designated "certain" or "doubtful" in his razor case. Two other men were arrested on this evidence, Boatswain Samuel Cromwell and Seaman Elisha Small.

Mackenzie, fearing that the mutiny might take place even with the accused ringleaders in custody, decided to hang the three men after hearing the advice of his officers. The hanging took place on December 1, 1842, and the bodies were thrown overboard. Commander Alexander Slidell Mackenzie was not court-martialed for his action nor has our Navy ever had a mutiny since then.

Sailors Preserve Old Sea Tradition

In an age of advanced computerization and sophisticated technology, many age-old traditions are becoming something which exists only in history books. But on the high seas, sailors around the world continue to preserve the old traditions that date back hundreds and even thousands of years.

Men of the sea from the 4th century have looked to the patron saint of St. Nicholas as their patron and protector. Even on new ships like the Royal Cruise Line's GOLDEN ODYSSEY, where the latest marine computerized equipment is in operation, St. Nicholas enjoys a prominent position of respect near the command post on the cruise liner's bridge.

When the ship was in its final phase of construction in Elsinore, Denmark, Greek crew members found an antique icon of their patron saint in a small shop along the Elsinore wharf. Considering such a find an omen for good sailing, the officers and crew quickly mounted the icon on a wall of the ship's bridge before the GOLDEN ODYSSEY sailed on her maiden cruise.

Today, passengers visiting the GOLDEN ODYSSEY's bridge for a first-hand look at modern seamanship also gain an appreciation for the ancient mariner traditions when they discover the respect the ship's Greek crew had paid to their patron saint.

The naming of St. Nicholas as patron saint took place in the 4th century shortly after Nicholas, then a bishop in Lycia, Asia Minor, was a passenger on a ship which

threatened to sink when it ran into a tremendous rain squall. The Bishop, who had managed to sleep his way through most of the storm, was awakened by the frightened crew who asked him to pray. He began to pray, legend tells us, and the seas were calmed almost instantly, and the ship was saved. Today, St. Nicholas is honored by all sailors, especially the Greeks, as their special protector. He is also the guardian of small children and is known as "Santa Claus" to youngsters in many countries.

Black Neckerchiefs

When the British admiral Horatio Nelson died in the battle of Trafalgar in 1805, all British sailors were ordered to wear black neckerchiefs over their middles as a sign of mourning. The custom spread and for many years sailors around the world wore black scarves or ties under their collars.

Lloyd's of London

The most famous underwriter for maritime shipping is the Lloyd's of London, However, there was never anyone named Lloyd involved in the company. In the middle of the 18th century, shippers and underwriters used to meet in a Welsh coffee house owned by a man named Lloyd. Gradually joining together to form a company, the group built a reputation known worldwide.

Scrimshaw, the American Folk Art

Scrimshaw is the art of carving and etching on whalebone and ivory. The term *scrimshaw* means two things. It denotes both the art forms themselves and the numerous products made of the craft. Making scrimshaw helped to pass the long months and years aboard whaling ships at sea. Whalemen of New England originated the maritime folk art. However, carving on elephant tusks was practiced for five centuries. The art is still being done today in the same traditional way it was done over 150 years ago. Whaling voyages would often last three to five years (the longest reported voyage was over eleven years).

There are several tales as to the origin of the word "scrimshaw," but research has never yet uncovered the true story. However, there were at least four men named Scrimshaw who practiced the art. Another origin of the word appears to come from the Dutch "Skrimshander," meaning one who indulges too much in laying around or a "lazy fellow." Whalemen lived a life of alternate fierce activity and unrelieved boredom. Scrimshaw

became a medium of relief from tension of the mind as well as the body. The pursuit was done by men in the forecastle as well as the captain in his cabin.

Cowrie Shells and Slave Money

The wreck of the GLENDOWRA on the Cumberland coast of England in 1873 was a graphic symbol in the era of profound change. The ship, heavily laden with a cargo of hundreds of sacks of money cowries, foundered in a storm and spewed her contents for miles along the shore. Cowries served as currency. In the triangular trade of ivory, slaves, and rum. When the slave trade ended it also ended the use of cowries as currency.

The Shall Game

Captain William Bligh of the H.M.S. BOUNTY brought an imperial harp shell back from Mauritius in 1810, thus stimulating interest in this rare species. Sligh's widow was offered a king's ransom for his shell collection. In May of 1882, it was auctioned for sale for the equivalent of about $20,000.

A Unique Culture

In summary, this chapter has provided some insight into the sailing culture of the great days of the sail. It was a brutal culture than many men and women did not survive. In the next chapter, we will explore the days of the rum runners and wild events on the famous Barbary Coast of San Francisco.

CHAPTER VII
FROM RUM RUNNERS TO THE BARBARY COAST:
Accounts from the Ship's Log

Life at sea on a vessel under sail was an endless toil with wretched cold, wetness to the bone and few moments of tranquility. Sailors had to climb aloft to the yardarms while screaming gales brought thundering waves crushing everything in sight. They then had to endure the rolling and bucking of the ship as they precariously hung a hundred feet, with arms hugging the yard beating the ice-hard billowing canvas with their fists, their feet balanced on a narrow line and the deck seemed below to be a mile away, while they struggled to grip and furl the forecourse before it carried mast and ship and crew to a watery grave. Equally hard to imagine was the awe sailors experienced at the vastness of the sea they endeavored to cross and the conflicting sense of isolation and close companionship they felt after months at sea out of sight of all land on the on and endless horizon.

However, there was another side to this lifestyle. Great adventure was on the high seas, from rum runners to the Barbary Coast. Rounding the Cape and finding a calm sea was a welcome scene, since many vessels met with disaster on this passage up the coast. The cold winds of the day and night were always overpowering, frequently washing men overboard. Gales, snowsqualls, and a high-running sea made many a lad wonder if he would live to see the morning light. Nowhere is death more painful than at sea. Ashore, there are bodily remains, and "the go about the street," but at sea a

man is with you one instant and the next he is gone—no one comes to take his place. A sailor's life is, at best, a mixture of "a little good with much evil, and a little pleasure with much pain," as Richard Henry Dana so classically said in *Two Years Before the Mast*.

DIRIGO

Braced up on the port tack, the DIRIGO heads out past Cape Flattery bound for the Cape Horn passage. Many of the old sailing ships avoided Cape Horn and sailed through the enclosed Strait of Magellan to the north, which had its own dangers and difficulties. In 1616, a Dutch navigator named Willem Cornelis Schouten discovered the cape and named it Hoorn, after his native town in Holland. In time one "o" was dropped from the original Dutch word. The Horn was a dangerous passage because of its strong west winds but was a less expensive route. The waters around the cape are rough and subject to violent storms. Many of the sailors who sailed these waters had a story to tell of the raging sea. Waves as high as hills, ceaselessly reborn by the promiscuous wind, battered the hulls of many ships and rolled over countless decks until the rails were awash.

The SEA WITCH

The SEA WITCH was the first sailing ship to sail the brutal Cape Horn passage in under 100 days. From a naval architect's point of view, the clipper SEA WITCH was one of the best of the clipper-ship designs. The SEA WITCH was built for the China trade. The world's first permanent sailing record was set in 1849, when the SEA WITCH sailed from Hong Kong to New York in 74 days, 14 hours. Captain Robert H. Waterman, known as "Bully" Waterman became a hero in New York, but as the years passed he would be known as the most inhuman monsters of his age.

174

The KAIULANI

The KAIULANI was the last Yankee square-rigger to sail around the Cape Horn. German submarines in 1941 had sunk so much of the world's tonnage that even old sailing ships were again fitted out for service. The KAIULANI was the ex-STAR OF FINLAND. The STAR OF FINLAND, or KAIULANI, was built by the Sewalls of Bath, Maine in 1899. This ship was the last square-rigger left in the Oakland Estuary by 1941.

The Great Lakes Story

The waterways of the world have been the routes of the explorers, missionaries, and adventures from man's earliest wanderings. The Great Lakes of the North were thought to be the passage to the China Sea that led to the riches of the Orient.

Jean Nicolet was the forerunner of pioneers in the land of the "seas of sweet water." In 1634, Nicolet, a Frenchman sent by Champlain, was one of the first white men to enter the Straits of Mackinac. European missionaries also made inroads into the Great Lakes region, following Indian settlements deep into this vast unknown country on the lakes of the wilderness. The history of this country would not be complete without the story of the Jesuits and their adventures.

La Salle, on the historic voyage of the GRIFFIN, sailed the first commercial vessel on the Great Lakes from the Niagara River to Green Bay. The GRIFFIN was 60 feet long of 45 tons burden. She had two square sails, a high poop, and from her jack staff floated the flag of France. She carried five small cannons. The GRIFFIN sailed away on September 18, 1679, with a cargo of furs from Green Bay but was never seen again. This ship was the first of many vessels that never came to port. It was more than 100 years before another ship of the GRIFFIN's size came to the lakes. The Great Lakes region became the "heart of the continent."

The five lakes that make up the Great Lakes are lined by three rivers and a deep inland strait. From the mouth of the St. Lawrence on the Atlantic to the head of Lake Superior is 1,500 miles by water. The lakes contain one-fifth the fresh water in the world, enough to cover the entire continental U.S. to the depth of 15 feet.

Long before the great port cities of Milwaukee, Detroit, Cleveland, Toledo, and Chicago emerged as industrial centers on the shores of the Great Lakes, the region was noted for a different sort of commerce. For 200 years, the fur of the upper lakes' region was a great source of wealth, as the region's forests and mines were to become

in a later century. More than 150 years ago it was a common sight to see these harbors crowded for miles with lumber scows, grain schooners, and tugboats churning up and down the lakes. The docks were laden with cargoes and the masts of sailing ships were like a floating forest. From the hills of red earth came Miron ore, used to make steel. Many cities in the region were named after the iron ore and coal industry. Cleveland, Conneaut, and Ashtabula mean ore. Sandusky and Toledo mean coal. Wheat was also an important commodity. Chicago was shipping 50 million bushels of wheat annually by 1850 and was the greatest grain shipping point in the world. The 28 miles from Bar Point to Peach Island make the Detroit River the shortest river in the world, and it's also the busiest.

The Great Lakes had a variety of rigs from sloops, barques, brigs, barquentines, and fore-n-aft schooners with two, three and even four masts. The square-rigged vessel gave way to the schooner because they could handle the shallow rivers and harbors. The crews that sailed the old windjammers were attracted to the Great Lakes for higher wages and shorter voyages. Most bulk trade voyages were two to three weeks.

The lumber trade reached its peak during the 1880s, the same time sailing ships reached their peak. There were 1,800 sailing vessels on the lakes during the 1880s. The last surviving full-rigged schooner built in 1875 was the LUCIA A. SIMPSON. She was wrecked in Lake Michigan, near Sturgeon Bay in the year 1929.

The history of the Great Lakes lumbering days was one of the richest to ruin, for the vast timber resources were short lived. It began in great volume while long lines of lumber schooners carried off millions of feet of timber. One by one the boom towns died. From these forests of the upper lakes many great cities were built.

West Michigan's greatest lumber port was Muskegon. During Muskegon's heyday there were 52 mills on Muskegon Lake, earning it the nickname, "Lumber Queen of the World." She also became the Red Light Queen, the Saloon Queen, and the Gambling Queen. This queen city produced 40 millionaires during the 1880s as its fleets carried nearly a billion feet of lumber annually.

Great Lakes transportation was strategic because there were no railroads to St. Louis and Chicago until the 1850s. The stage lines at the time were cramped and vehicles moved slowly over rough roads. The highways to the West were the Great Lakes and the Ohio River until the Civil War. Then came the cry "Westward Ho to California" and they came indeed.

One of America's greatest writers, Walt Whitman, descriptively wrote about the region. He said, "I Hear America Singing," and so it was. In the days of sailing and those years of fast growth all America sang. I can hear it now the words:

Oh, the Erie was a-rolling, The rum was getting low,

And I hardly think, We'll get a drink

Till we get to Buffalo.

No region on earth has been so transformed in so brief a time.

Three Killer Sisters Sank Ship

Modern day writers still write about the awesome Great Lakes. The mysterious sinking of the SS EDMUND FITZGERALD on a stormy night on Lake Superior was the subject of a popular contemporary song by Gordon Lightfoot. But to old-timers it was not a mystery; it was a trio of killer waves known as "three sisters." The explanation of the phenomenon given was a series of three huge waves that come in such rapid succession, a ship cannot recover from the first wave before the other two are upon it, pushing its bow under water and holding it there until inertia takes over and the ship dives to the bottom. This same theory has been given to the "Bermuda Triangle."

Among the few old salts to recall the sinking of many of the sailing ships of years past was Lyle A. McDonald. The EDMUND FITZGERALD sank claiming the lives of all on board, the captain, and his crew of 28 men. McDonald gave this story to a congressional committee. "I have lived the day and night of the EDMUND FITZGERALD many, many times, on lesser ships and during earlier days. I respectfully submit that the FITZGERALD did sink to the bottom of Lake Superior as the result of her having been caught precisely by the three sisters, or three big waves. The FITZGERALD submarined."

This was a dramatic departure from the rehash of more mundane and conflicting theories offered to a congressional committee in a renewal of hearings into the sinking of this ship that claimed the lives of all hands onboard. The Coast Guard and National Transportation Safety Board suggested the ship, riding low in the water with 52 million pounds of iron ore, sank when water rushed into her hatches on deck, either because they collapsed or were not properly battened down. Another theory suggested that the heavily laden ship crashed into shoals, ripping a hole in its hull.

Defending the honor of Captain Ernest M. McSorley and the rest of the crew, McDonald said it was fate. "I am amazed that the phenomenon of the three sisters is

not more widely known," McDonald continued with, "Most certainly the older sailors are fully cognizant of the fact that the three sisters are a reality on Lake Superior."

Lyle A. McDonald lived a rough life as a commercial fisherman on Lake Superior starting at the age of seven years old. He was familiar with the deadly waves of the lakes. His explanation of the phenomenon was not scientific enough for the congressional committee, just a tale from an old man of the sea.

The Wreck of The HESPERUS

One of the most famous poems ever composed was the Ballad of the Schooner HESPERUS by Henry Wadsworth Longfellow, first published in *Ballads and Other Poems* in 1842. The closing lines from this ballad tells the story:

Such was the wreck of the Hesperus,
In the midnight and the snow'
Christ save us all from a death like this,
On the reef of Norman's Woe!

The Castaway

The real-life prototype for the familiar character in the novel *Robinson Crusoe* was a man named Alexander Selkirk (1676–1720), though few people would know him by his true name. Alexander Selkirk was a hot-headed youth, perpetually in trouble and at odds with the people of his hometown. At age 19 he was ordered to leave the tiny Scottish fishing village of Largo for beating up rivals in the middle of the church services.

Alexander signed aboard a Dutch sailing ship bound for the West Indies. Six years later he returned to Largo and before long was back in trouble again. This time he roughed up his father and several of his brothers in a family brawl. Rather than make a public apology, he left to join a band of privateers in search of gold-laden Spanish galleons in the South Seas. He was known only as Selkirk to his newfound friends.

His ship, the CINQUE PORTS, left London in September of 1703. The CINQUE PORTS would never see England again. The ship was an old and overcrowded vessel. From the very first day they left England, Selkirk began clashing with the superior officer, Lieut. Thomas Stradling. As the CINQUE PORTS lumbered toward South America, Selkirk emerged as the leader of a grumbling crew. Rounding the Horn, they

encountered the Spanish fleet off the coast of Chile. The ship was able to survive the battle, but needed emergency repairs. Stradling anchored his ship off a rocky strip of beach known as Mas a Tierra, part of the Juan Fenandez group. When the ship was ready to sail again, Selkirk was not. He told Stradling he would rather be put ashore on that desert island than continue in a leaky ship with an ignorant commander. Stradling was glad to oblige. Begging to be taken back was of no avail, the ship sailed off without him. The CINQUE PORTS was soon to meet its end. About 1,000 miles up the coast, the ship ran aground off Peru. The entire crew was captured by the Spanish, tortured, and thrown into chains. Selkirk took stock of his few possessions and spent the first night shivering in a tree, afraid of the wild beasts on the island.

The first eight months on the island were the most difficult for Selkirk. When he wasn't scrounging for food and fresh water, he was fighting the elements and his agonizing withdrawal from the human race. Slowly he learned to adjust to his fate by living in a cave and fashioning a drinking cup from a coconut shell. With a knife made from an iron hoop, he began to mark the passing days on a tree trunk and hunt the wild goats that roamed the island. There was also an abundance of rats that had come ashore from passing ships. They were so populated that they nibbled at his feet and ate up his supplies of food. Selkirk found cats on the island that also came from ships that stopped long ago. With the cats he soon had the rat population under control.

Having used up all his gunpower, he learned how to hunt goats by pinning them down. With the speed of a panther, he acquired great agility. He made his clothing from goat skins and stitched them together with an old nail and some sinew.

A Bible had been left with his sea chest and from the writings he read aloud to help ward off madness. As the years passed, Selkirk learned to master his environment and made his own private kingdom. In January of 1709, four years and four months after his exile, Selkirk was found by two British privateers driven within eight miles of Mas a Tierra by a storm and his ever-burning signal fire. Looking like a shaggy man-beast dressed in goat skins, he was a wild bug-eyed stranger. However, Selkirk eventually regained his use of language and told his story.

Selkirk sailed with Captain Rogers and his crew and later distinguished himself in battle against the Spanish. This castaway was made master of a captured ship and enriched himself with a large, captured booty. Three years later he came back to England as a celebrity. His story was exciting copy and a good sea story was always in the news. Selkirk's story was eventually picked up by a writer named Daniel Defoe. Defoe renamed Selkirk "Robinson Crusoe" and used the castaway story to write a tale

of man's endurance over adversity. The story of Robinson Crusoe earned immortality. Alexander Selkirk was less fortunate. He returned to Largo, where the townspeople soon noticed his strange habits. In trying to adjust to civilization, Selkirk became increasingly moody and withdrawn. He would not live in the house but built a cave in the backyard behind the family homestead and secluded himself there with his many neighborhood alley cats.

Selkirk later joined the Royal Navy and went to sea again. His ship was off the coast of Africa when he contracted fever and died. He was buried at sea. Back in the cave in Scotland, he left behind his rusty old sea chest and a hand-fashioned coconut drinking cup. The cup was later placed in the Edinburgh Antiquarian Museum where it was later mounted on a silver pedestal.

Rumrunning and the "Real Mccoy"

The story of sailing would not be complete without somewhere telling the tales of rumrunning in our American history. Before we were a nation, in 1734, the British Parliament banned the manufacture and importation of rum and brandies in the yet-to-become-state of Georgia. This ban inspired seafaring men throughout the New World to rise up and begin a new trade, running rum in by boat from South Carolina.

In 1794, when our fledgling Federal Government imposed a tax of nine cents a gallon on all liquors distilled in the States, our seafaring men took the deed as a real challenge. America has always been a hard-drinking nation. While the rest of the world sipped delicate wine, Americans were a nation growing in a hurry and grabbed whatever would ferment. The actual onset of Prohibition in 1920 made us bone dry. This act brought on a new way of life for many a lad. In the early days of rumrunners, the Coast Guard had many other duties and it was hardly equipped to chase these hordes of boats up and down the coast.

Our nation's fair-haired hero of the era was a man whom we have all but forgotten. The "real McCoy," Captain Bill McCoy, was possibly the earliest "open sea" rumrunner of the Prohibition era. Both legend and McCoy himself credit him with founding Rum Row. Captain Bill McCoy was known for the product he shipped, it was always genuine and of the highest quality. Hence the epithet the "real McCoy" was extended to describe anything or anybody of genuine stock.

Young Captain McCoy was a fine sailor and from a good inland New York State family. He got his start in the "trade" when he got wind of a party in the Bahamas who wanted to ship some genuine foreign liquor into the U.S. With the $20,000 he

had saved and borrowed, McCoy bought a 65-foot fishing schooner, the HENRY L. MARSHALL. On his first run, his ship picked up 1,500 cases of liquor from a South American port and sailed to Savannah for a fee of $10.00 a case. McCoy received a return of 75 percent on his investment for his first mission. From that day on, Captain Bill did a job that made him a historical and legendary colorful character. He was always just outside of the law and clean as Monday morning wash. He learned to keep just outside the new 12-mile limit, strung out over 100 miles or more, tossing in weather and high seas, waiting for small relay boats to come and get their cargo.

The famous Rum Row ships ranged from schooners to good-sized freighters. The pickup boats had to produce identifying tokens, such as the matching halves of torn dollar bills held by the Rum Row skippers. Some carried good wines, brandies, and champagne, and others handled ethyl alcohol tankers. These "dealer" boats brought out their own bottles, labels, flavorings, and colorings and made artificial whiskey or gin on the spot. Many of the newly filled and labeled bottles were dunked briefly in the sea to give them appearance of being "fresh off the boat."

The Woman of San Nicolas

There is something about an island that has a strange and tremendous lure for many people. The coast of California has many islands that Indians, explorers, smugglers, and hunters sought out during the great days of the sail.

Sailors of the 19th century passed down the story of one island dweller, Juana Maria. Maria, an Indian woman, was alone marooned on San Nicolas Island, 70 miles off the coast in the midst of the Santa Barbara Channel Islands, for 18 agonizing years. At one time the island was home to a group of Indians who have long since gone the way of other extinct tribes. During Maria's time, however, the island was virtually deserted except for a small tribe of Indians. The padres from Mission Santa Barbara chartered a small schooner to bring the few remaining Indians back to the Mission. In August of 1835, the ship, PEOR ES NADA landed offshore to evacuate the families and some of their belongings. In the confusion of leaving, some of the families became separated. Juana Maria's infant girl was left behind. A tragic misunderstanding with her sister had caused the child to be left on shore. The mother's frantic search on board the ship and appeals to the captain were not heard above the howling winds of the storm upon them. The PEOR ES NADA was a small ship and could not take the pounding of the heavy seas and strong winds.

Concerned with the safety of his ship, the captain refused to send a boat back for the child. The Indian mother dove into the water and thrashed her way through the white capped surf to the beach. When Juana Maria finally found her baby daughter, she had been killed by wild dogs. It was several days before the realization came that she was alone and must survive on her own.

Just keeping alive was a full-time job. The next 18 years she lived much like the fictional Robinson Crusoe who was stranded for four years on a mythical island. The resources she needed were all around her, for there were freshwater springs everywhere on the island. Nothing was discarded: chips of obsidian were used for knives; fish bones made needles and fishhooks; twigs and grass made bird snares, while fibers and animal flesh were used to fashion ropes. Her shelter was a grass covered whale skull, and fire was had by using a wood stick drill. In the distance, she would occasionally see a ship, but none ever came ashore or saw her fire light in the evenings.

One day a man named George Nedever of Santa Barbara, while searching for otter among the channel islands, anchored his vessel offshore and sent out a landing party. Before departing from Santa Barbara, Father Sanchez asked Nedever if he would see if the woman was still alive after her long ordeal.

The queen of San Nicolas awaited her rescue. When the men from the ship reached her, they were surprised to see her simple grace and dignity. Although neither party could speak each other's language, they were able to communicate by signs and gestures. After a simple greeting, the men explained they had come to take her back to the mainland. She offered them food from the island, and then they were on their way. When she arrived in Santa Barbara, Juana Maria was delighted to see so many people who were interested in her well-being. They came from miles around to see the woman of San Nicolas.

This strange new world and all the fame that came to her was too much for Juana Maria. She lived only seven short weeks after her arrival in Santa Barbara. Her real-life adventure made Robinson Crusoe's story seem like a day in the park. May she rest in peace.

Cinque, the African Mutineer

In 1839, a new hero entered the annals of sea history. A slave named Cinque led a daring mutiny aboard a slave ship and attempted to sail the vessel back to Africa. Cinque was born the son of a minor chief in the land that is now called the Republic of Sierra Leone on the West Coast of Africa. In his tribal Mendia language he was

more properly called Sing-Gbe. Newspaper headlines told of his leadership, courage, and will to be free; and gave him the name Cinque.

Seized by black slave traders while walking in the brush, Cinque was eventually sold to a Portuguese dealer for shipment to Cuba. Like the rest of the slaves, he was chained by the leg to the others and cramped below the decks of the TECORA. It took all his strength to survive the three-month voyage with men, women, and children dying in their chains all around him. The slaves were force-fed like geese for sale in the market. They were also cruelly whipped into submission and had to rub vinegar and gunpower in their wounds to prevent infection.

On landing in Havana, Cuba, Cinque and 52 others were purchased by two Cubans named Jose Ruiz and Pedro Montez for what averaged out at less than $10.00 a head. From Havana, the slaves were packed aboard the schooner AMISTAD to be shipped to another port farther east. However, the AMISTAD never reached its destination. A mutiny took place under Cinque's command. Cinque was about 20 to 25 years of age, and said to be a match for any two men aboard the schooner. During the night, the slaves followed their leader on deck where the crew was sleeping. With the sailors' long cane knives, the mutineers quickly took charge. Cinque himself killed the captain and the ship's cook. The rest of the crew was put over the side in boats, except for Montez and Ruiz. They were kept on board to sail the schooner back to Africa. Under Cinque's command, the ship was to sail back to Sierra Leone, but he was tricked by his former masters. Each night the ship edged a bit north until after about 50 days, the AMISTAD wound up in New York waters off Montauk Point. Cinque and his men landed and purchased supplies with gold they found aboard the schooner. By now the word was out and an American coastal survey brig sighted the AMISTAD. When the American ship came along-side for boarding, Cinque dove overboard, evading his pursuers for almost an hour. He was later caught and turned over to the U.S. Marshall with his men.

Charged with murder and piracy, Cinque went to trial for one of the most sensational trials of the century. Many historians believe this trial was the cause of the Civil War. The trial reached all the way to the Supreme Court in February of 1841, with ex-President John Quincy Adams arguing the case with great eloquence and tack. The court ruled that since Cinque and his men were not Spanish slaves or subjects they must "be declared free, and be dismissed from the custody of the court, and go without delay."

Following the court trial, Cinque and the mutineers toured the North to raise money for their return trip. The tour was a great success; more than enough money was raised

to enable the band of Africans to charter the brig GENTLEMEN. They set sail for Sierra Leone on December 2, 1841, and safely returned to their homeland.

Cinque later became an interpreter at a Christian mission in Sierra Leone. Years later he was asked if he had it to do over if he would kill the captain and the cook of the slave ship or pray for them. Cinque replied, "Yes, I would pray for them and kill them." He remained a proud leader until his death in 1880. He was 67 years old when he died.

San Francisco's Barbary Coast

Life on the Barbary Coast also produced its tantalizing tales of the days of the sail. In the 1850s, the square mile bound roughly by the San Francisco waterfront on the east, Clay and Commercial streets on the south, Broadway on the north, and Chinatown on the west gained a world reputation for its wickedness. This plot of ground known as the Barbary Coast of San Francisco received its name, as the story goes, from an unknown sailor making the rounds of some of the dives in the waterfront area which became known as Sydney Town. The drunken derelicts he saw reminded him of Negroes chained in the holds of slave ships on Africa's Barbary Coast.

The Barbary Coast began with the California Gold Rush. Ruffians from Australian frontier towns and British panel settlements at Sydney and Tasmania colonized a waterfront area that one early historian described as a "stagnant pool of human immorality and crime... the haunt of the low and vile." The lowest of all Sydney Town dives was the Boar's Head, where the greeter was an angry grizzly bear chained near the door. Crime and debauchery brought the city near anarchy and prompted the formation of the first Vigilance Committee. Public hangings had a cleansing effect for a while, but by the mid-1860s the cancerous depravity had developed into the civic store known as the Barbary Coast.

During the 1870s, a Mexican fandango hall clad its "waiter girls" in such scanty attire that the crowds could not be accommodated, and the experiment had to be abandoned. Some of the better known "resorts" such as Tetlow's Belle Union, the Olympic, and Gilbert's Melodeon were for stags only and had curtained boxes for "freedom from constraint etiquette." Many of the resorts' entertainers became famous names like Eddie Foy, Lotta Grabtree, and Ned Herrigan, a Vallejo ship calker who, with Tony Hart, became the most celebrated vaudeville act in the country.

Then there were the local stars like Big Bertha, the 280-pound Queen of the Con Women, who would recite her life of crime and climax her show with a rendition of "A Flower for My Angel Mother's Grave." Bertha was so bad that she attracted huge

audiences. Her greatest triumph was in Romeo and Juliet. Her leading man was another town curiosity, Oofty Goofty, who was so terrible that he was thrown bodily from the theater and later bashed with a billiard cue by the famous John L. Sullivan. The word "shanghaied," meaning to drug or render insensible and ship out as a sailor, originated here on the Barbary Coast. The waterfront was the most dangerous region in the city for half a century. Sailors were robbed, murdered, and shanghaied all for a price.

Red-bearded Shanghai Kelly, the most infamous "crimp" of all, supplied crews for the asking from patrons of his boarding house on Pacific Street, which could be approached by skiff at high tide. Crimping was usually accomplished by inebriating a sailor and delivering him to a waiting ship for which the crimp would be handsomely paid. Men were bought for $30 to $50 a head. Crimping was practiced all over the world from the 17th century on but was most active during the California Gold Rush.

Another name remembered for her deeds was the ferocious Miss Piggott, who had a trap door in her bar over which she would lure a potential sailor, lace his drink with opium, tap his nodding head with a bung starter, and pull the trap.

Desertion, Crimping, and Blood Money

Desertion was not rare nor was it known only to a few ships. Sailing under brutal captains and mates with cruel punishment was in direct violation of their terms of employment, but at sea on some ships no one was spared from the wrath of hell. It was not until 1915 that congress passed legislation making ships' captains accountable for their actions at sea. This legislation applied to all kinds of vessels at sea. However, it was the sailors from windjammers who finally managed to push the reforms through. A crew had only two recourses in the days before the legislation reform; one was desertion, and the other was mutiny. The attempts of mutiny were few, for a man could be imprisoned for simple insubordination. No matter what the circumstances, a sailor who killed a captain or mate faced certain death by hanging.

Jumping ship for some sailors promised good jobs ashore. Some men were so set on leaving their hellships that they even left without waiting for their wages. Most of these men climbed right back aboard another ship bound for somewhere. Every waterfront port in the world served as a recruiting center for men to be sold and shipped out for another voyage. Taverns and boarding houses were hangouts for crimps, just waiting for new bodies to set up. A lone seaman often had the misfortune of being forcibly shanghaied to another ship before the sun set on his first day ashore. Once the captain of an outgoing ship had paid his blood money, it was up to him to hold his

newly assembled crew till they were well out to sea. It was not unusual for a crimp to sell a man to a ship in the morning and steal him again at night to be taken to another waiting ship for more blood money. Once a man was crimped (so called from a German word meaning "hooked"), his future was in the hands of his captain. Not all ports were rough-and-tumble boomtowns; some of the long-established European ports such as Hamburg, Rotterdam, and Liverpool were generally safe for sailors.

Captain Farragut and the Vigilantes

Keeping the peace in San Francisco Bay was a difficult task. U.S. Navy ships patrolling San Francisco fought the thieves who stole $4 million in gold from the Branch Mint. Battles raged between heavily armed Vigilantes and the State Forces. These were the grim possibilities confronting U.S. Navy Captain David Glasgow Farragut in the summer of 1856. Captain Farragut had been busy establishing the shipyard at Mare Island when a group of businessmen in San Francisco resurrected the Vigilance Committee. San Francisco was overrun with lawlessness; the Vigilantes vented their frustrations with the boys from the Barbary Coast by hanging several murderers and a few other lads who happened to be in the wrong place at the wrong time. The threat of open rebellion and the taking control of the city by the Vigilantes brought out still another organization, the Law-and-Order Party. The Vigilantes "arrested" a pair of Law-and-Order sympathizers, Navy Agent Dr. R. P. Ashe and California and Supreme Court Judge D.S. Terry. When commander E. B. Boutwell of the man-of-war JOHN ADAMS heard of Navy Agent Ashe's "arrest" he fired a letter to the Vigilantes telling them that holding a Navy Agent interfered with a federal officer's duties. Dr. Ashe was quickly released.

Commander Boutwell followed up with a stronger letter about Judge Terry. The Vigilantes interpreted the message as a threat to fire on the city, knowing that Farragut was the region's senior officer, the letter was sent to him. In handling the Vigilantes' rebellion, Farragut advised Boutwell to cool off and wrote to the Vigilantes that they were denying the Judge his Constitutional rights.

Captain Farragut didn't take any chances. He wrote a letter to the Secretary of the Navy and made certain that the batteries of the WARREN and DECATUR were in good order and that he had plenty of ammunition. The possibility of firing on San Francisco was very great. The next move was up to the Vigilantes. Staring into the gun barrels of three Navy warships, they released the Judge and disbanded. The Navy Department praised the manner in which Farragut had handled a potentially explosive situation. Captain

Farragut earned more commendations after his Mare Island assignment ended in 1858 for preparing a shipyard that helped the US in its early days of developing a two-ocean navy.

In later years, Farragut became the country's first Admiral of the Civil War. This new honor was bestowed upon him after he boldly bypassed a pair of fully manned forts in the bold sweep up the Mississippi to capture New Orleans. Farragut's victory in Mobile Bay, immortalized by his order to "Damn the torpedoes!", dealt the finishing blow to the Confederate Navy. It was Farragut's early days on the wretched Barbary Coast that came to a climax in 1906 when a famous earthquake destroyed the area, but she rose from the ashes like a taunting giant madame, seemingly bawdier than ever. However, the area was never quite the same after the earthquake. The ballyhoo years were declining and the Coast in later years became an attraction for tourists and celebrities.

Gone are the ruffians of Sydney Town and the crimps, but there is still some of the old action and nightlife that once echoed from this famous spot in a city born from a melting pot of humanity. The real Barbary Coast is dead but from her roots a child was born, much like her mother, but a lot tamer with a dash of bitters and a clean glass.

CARRIER PIGEON

The men who sailed before the mast came from all corners of the earth. Sailors one and all had a tale to tell over a brandy or two about the night they were sure they were going under. The boys from the Barbary Coast had earned their night on the town. The memories of disasters and old friends lost in a shipwreck were part of a sailor's life.

The first vessel to miss the Golden Gate and meet her death on the rugged California coast was the clipper ship CARRIER PIGEON. On her maiden voyage, after 129 days out of Boston she struck the rocks off Whale Point in the year 1853. Because of her wreck, as well as other ships that met a similar fate upon the rocks as victims of the dense California fog, a lighthouse was erected upon the promontory that bears her name, Pigeon Point.

WILLIAM

The treacherous seas extended Northward from the Farallon Islands to the coast of Vancouver Island. The first recorded wreck on the southwest coast of Vancouver Island was the brig WILLIAM, bound from San Francisco to Victoria, BC. The WILLIAM ran aground about four miles east of Pachena Point on January 1, 1854. Her captain and cook drowned. The rest of the crew, 14 in all, made the shore safely and were fed and housed by Indians, who later took them to Sooke by canoe.

The BREMEN – 1880

Collisions were generally due to heavy fog conditions and the desire of many skippers to maintain schedules even under such conditions. In 1880, the German ship BREMEN, feeling her way in toward San Francisco in the pea soup fog, struck Southeast Farallon Island. It was not a particularly outstanding wreck except for one thing: the schooner BREMEN had aboard a full cargo of whiskey valued even in those days at an astronomical figure. To the gang at North Beach and the Barbary Coast lads wailing at the waterfront, a ship full of whiskey vanished into the deep was indeed a wreckage to salvage. It was reported by many offshore skippers that sightings of fleets of small craft of all sorts were poking around close to Southeast Farallon Island. They all seemed to be fishing or looking for something.

During the era of 1929, in which this sort of cargo was not sold on the open market, a plan was made to salvage this vessel and its cargo. However, the salvage never materialized. Their failure saddened the waterfront gang all over again, but no doubt brought satisfaction to those who looked at alcoholic stimulants with a disapproving eye. And to this day, off the bleak Farallones, veteran captains still lick their lips while passing the grave of the schooner BREMEN. Perhaps they are visualizing the possibility of a cask of grog suddenly surfacing from the deep for all hands to lay hold.

The Whaleboats

The whaling vessels of America also play an important part in the history of the days of the sail. Whaling was done on both east and west coasts. When the lookout on the masthead sang out, "She Blooows," the captain would answer with "Where away" and from the voice overhead would come the sighting. "Four points off the lee bow." With a crew of six men the whaleboats were lowered from the davits to the water. There were usually four boats lowered and ready for action. Whaleboats were about 30 feet long,

and built of cedar. The boats were rowed, or if the winds were right, sailed until they were close to the whale. This type of craft was often lightly built and could be easily smashed by the whale's tail or crushed in his powerful jaws.

Once in range of the whale the harpooner threw the harpoon to which was attached 1,300 feet of rope. If the throw was successful, the tottle end of the harpoon would open to prevent it from pulling out. When the whale was struck, the "Nantucket" sleighride began. The beast would then sound (dive) and swim off towing the small boat at great speeds. When the whale would tire the boat would come alongside and make ready for the kill. The mate would thrust his lance into the whale for the final kill. When the whale was dead, it was towed to the mother ship where the cutting stage was lowered, and the cutting process would start.

A sperm whale could "run" for hours and sometimes tow a boat out of sight of its mother ship. The task of towing the dead whale back to the ship was laborious and monotonous. The whale was lashed to the starboard side of the vessel by heavy chains, the flukes to the bow and the head to the stem of the ship. When the kill was ready, the "cutting in" stage would start. Large slabs or "blanket-pieces" were cut and hauled aboard. The blubber was then cut into two-foot hunks called "horsepieces," which in turn would be sliced into smaller pieces called "bible leaves." The "bible leaves" were then boiled in the tryworks until reduced to oil. From the pots, the oil was put into cooling tanks and then funneled into large barrels.

On a good voyage the ship would bring home about 2,000 barrels of oil, equivalent to 64,000 gallons. When the casks in the hold were full and heavy with whalebone, the long voyage home was a welcome thought. You could always tell when a whaler was in port. Look out "Frisco" here they come, brace yourself, Ahab's sons are heading for wine, women, and song.

The Schooner CASCO

One of the most famous ships on the bay of San Francisco was the schooner CASCO. The CASCO was almost a miniature palace. Designed along the lines of the famous tea clippers, she was built for idle cruising and racing on the Bay. This 85-foot yacht captured virtually every speed laurel the Bay City yachting fraternity had to offer.

Built by Dr. Samuel Merritt, who was once mayor of Oakland, the yacht satisfied those who enjoyed sailing in style. Intricate panels of imported hardwoods carved by hand, bulkheads lined with pure silks, along with mirrors complete with tassels and velvet drapes were only a part of this luxury vessel. This beautiful yacht lived an adventurous

life for 41 years. Her infamous years were to see this respectable ship descend to the iniquity of smuggling, murder, and disaster. In 1888, Robert Louis Stevenson chartered this ship for a cruise to the South Seas. Trying to overcome tuberculosis, Stevenson and his wife believed the gentle climate of the islands would perhaps help his ravaged health.

Captain A. H. Otis informed his illustrious passenger and his guests that from the outset there would not be any discussion of Stevenson's literary works on board his ship. It seems having read TREASURE ISLAND the stern mariner found his "seamanship" to be a bit "faulty." When Stevenson died, his body was draped by CASCO's ensign. The years to come saw this prized schooner placed on the block.

Bought by a Victorian syndicate, she headed north for her new and grim role as a seal hunter. The CASCO had cost $40,000 to build and furnish. However, the new owners picked up the ship for a paltry $7,000. Much of the plush interior was razed to enlarge her hole for the requirements of a sealer. The romance of the ship became only a memory. From Victoria to the Arctic seas, she enjoyed the honor of being one of the fastest sealers out of Victoria, BC. In 1898, the CASCO was again sold and used as a passenger and freighter in the northern waters.

The freighting trade did not last too long for the CASCO. Her less honorable years were to cause the customs office of British Columbia and California many a restless night. The black years for this once handsome figure were no secret. The illegal commerce in opium and Chinese immigrants were her new trade. Many a midnight departure from Victoria's inner harbor were overlooked by customs. It was generally conceded that once the CASCO spread her sails, nothing on the high seas could catch her.

On several occasions, when the ship becalmed within reach of the law, her suspected cargo seemed to have vanished over the side before the authorities were able to reach her. On more than one voyage, Chinese immigrants were blackjacked unconscious, weighted with chains or scrap iron, and slipped over the rail just as a coast guard cutter ordered her to heave to for boarding.

The next 12 years from 1900 found the CASCO once again back in the sealer trade. This fine ship was later sold to a wealthy Kansas City businessman, J. Sidney Smith, who used the ship for halibut fishing. The vessel was converted and completely overhauled in Seattle. Most of the ornate cabin fittings were removed and installed in Smith's Prince Rupert home. Few records give details of the activities of the CASCO up to 1919. It was known that she found a place in the fishing trade before being laid up in Coal Harbor. A fund to preserve her as a museum ship failed to come about.

During the first World War, the CASCO's once-gleaming decks found a new owner. The ship was used as a training ship for sea cadets in and about Vancouver. The urgent demand for all types of shipping saw the ship employed along the coast. With the close of the war, she found her way home to San Francisco. The South Seas again beckoned this beautiful ship. The next few years she was used as a pleasure craft.

In 1919, new owners once again headed her north into the frigid waters of the North Pacific. The seal hunting days were over. This voyage was to take her to a new venture seeking a lost gold mine in Siberia. The CASCO, despite her 41 years, was still in perfect condition. However, disaster was soon to loom its spell over this proud ship.

The new captain, C. L. Oliver, had never been to sea before, though he was well trained as a navigator. The crew of 29 men were a motely bunch, of which only two were seamen. Fist fights became the order of the day and one incident after another kept life on the ship like a living hell. Heading for the ice-choked Bering Straits, the CASCO met her death. The ill-fated ship came to the end of her long career on the ice off King Island on September 9, 1919. The ship once hailed as the "silver bird" was slowly ground to pieces in the ice far from the water of the South Seas and the glorious days on the Bay and the days when Robert Lewis Stevenson chartered this queen of the sea. Her best year was in 1869 when yachting became a popular sport on the Bay, the same year the San Francisco Yacht Club was incorporated.

In summary, the storied life of the CASCO provides an apt representation for the storied life of once great sailing vessels and those who sailed them. In the next chapter, we will explore the evolution of wooden sailing ships to steal-hulled vessels.

CHAPTER VIII
FROM DEAD RECKONING TO THE DAYS OF STEEL:
The Evolution of Ship Anatomy and Navigation

Our review of rumrunners to the Barbary Coast followed the stories or interesting characters from another place in time. Only to a limited extent are we prisoners of the past. The future sets us free like an escape hatch for tomorrow. Yet the rumrunners of yesterday had a profound impact on early America. In this chapter, we will consider the innovations of seafarers that created new ships with a new look.

There have been many changes and improvements in design and materials of construction since the first days of the sail. Three important changes include modifications in the sail plan, the use of steel as opposed to wood, and rigging changes all along the way. Even today, marine plywood and fiberglass hulls have replaced mahogany and teak woods. In the history of sailing, every era has seen some new evolution in ship building and navigation.

The First Compass and "Dead Reckoning"

In the days when man first ventured at sea, he did not have the use of navigation as we know it today. The stars, winds, and currents were the main means by which sailors found their way. They studied the signs of the sea. Curtain fish, never found far from land, told them that a coastline was near. Signs of driftwood and birds at sea were all anxiously studied. Man learned to follow the stars at night; the North Star told him which way was North. The rising sun told him which way was East and the sunset gave him the West direction. These signs were fine under some conditions, but what did he do on a cloudy day or a foggy night, or an overcast sky, when any direction might be north?

The Chinese gave the world the first compass. They had discovered that it was possible to magnetize metal dug out of the ground. The magnetized needle was placed on a straw so that it would float on water. The needle would always turn until it pointed

North. No matter which way the bowl was turned the needle still remained pointing North. The Chinese did not know or understand exactly why this happened. Now we know that a compass needle points North due to large underground deposits of magnetic ores near the North Pole.

The Arabs were next to improve this primitive compass. They placed the magnetized needle on a pivot, balancing it precisely in the center so that it could swing freely in any direction. It was now possible to sail unafraid of fog or cloudy skies. With this compass they could sail without the sun or stars for direction.

A simple art of navigation began with primitive instruments. It had to do with direction, speed, and distance and it was called "Dead Reckoning." Here is how it worked. When a ship set sail due West from a given port, the skipper would carefully note the time he left port and check the speed of his ship. Let's say he clocks his ship as traveling five miles an hour, with a steady wind and fairly constant speed. He then could calculate that every hour would take him five more miles west of his starting point. This is the principle of dead reckoning. The trouble with dead reckoning was that it was not very dependable with the ever-changing wind. A bad guess could land a ship several hundred miles away from its destination.

It was interesting how the old-time sailors clocked the speed of their ship. They tossed a floating chip overboard at the stern. Tied to the chip was a long piece of line, with knots tied along the line at regular intervals. As the ship sailed on, the chip dragged the line out much like a kite on water. The seafarer counted the knots as they slipped past his fingers. Another man kept a careful eye on the hourglass or counted out the seconds. They reckoned their speed as so many "knots." To this day, nautical miles are called "knots." A nautical mile is equivalent to 6,080 feet (1,853 meters). The correct term is, therefore, "so many knots," never "so many knots per hour." The knots were tied every 47 feet 3 inches, and the speed was calculated while a 28-second sandglass emptied itself.

Even with the advantages of modern compasses to calculate direction, a sudden storm could throw all calculations into a meaningless jumble. Measuring speed during a squall was impossible. Sailors just furled their sails and rode the storm out. Ocean currents could not be counted on, for a ship may seem to be moving but could actually be barely managing to stay in the same place. What was needed desperately was a way of finding out location at any time, regardless of speed or storm or current. A captain had to be able to put his finger on the map and say, "That's where we are." If he had a map!

The amazing thing is that all the knowledge that was necessary to calculate one's precise location had been discovered many hundreds of years before the navigators of Columbus began to grapple with the problem. It was only by rediscovering the knowledge of the ancient Greeks, that seafaring men hit upon the right idea. Eratosthenes, born in 2768 BC, knew the answers. Through his study of shadows cast by the sun, the position of the stars in the sky, and the appearance of a ship sailing down over the horizon, Eratosthenes figured out that the earth was round as a globe. He was such a good mathematician and geometrist that he figured out the distance around the earth to within 400 miles. His knowledge helped us to discover a way to find out exactly at what spot on the globe's surface he was at any given time.

Gradually, navigation developed into the exact science that it is today. Many young men today have little idea of the challenge that was before their grandfathers and their fathers before them as they went down to the sea in ships to match wits against the waterways of the world. In the 15th and 16th centuries there were a great number of navigational instruments introduced as ships ventured out on long voyages to unknown destinations. The first of these instruments was used for measuring the altitude of the Pole star. This tool was the seaman's quadrant, used in the second half of the 15th century by the Portuguese navigators.

The greatest contribution to navigation during the 16th century was from Gerhard Kremer, a Flemish instrument-maker who in 1569 published his famous map of the world based on a system of projection still in use today. Kremer, better known as Mercator, took the equator as the zero line from which to reckon latitude in both directions towards the poles. By the end of the 19th century, the meridian of Greenwich gained universal acceptance as the zero line from which longitude should be measured.

The problem which faced navigators during the age of exploration was that of finding longitude. The lunar distance method, which was generally accepted prior to the invention of the chronometer, demanded a certain amount of mathematical expertise, which was at that time often beyond the capabilities of the average navigator. Several methods were attempted but were still far too complex for seafarers of the day. The British government offered a prize of $20,000 to the person who could find an accurate method to determining longitude.

In 1730, the octant was invented by John Hadley and improved in 1734. Hadley's octant was generally adopted among many navigators of that period. The octant measured angles up to 90 degrees using the reflection principle, which doubled the degree of altitude that could be measured by the simple quadrant. The octant could

bring the image of a celestial body in line with the horizon and enable a more accurate reading to be taken.

Because of its accuracy, the octant became a very popular navigational instrument and was still in use at the beginning of the 20th century as a means of measuring the altitude of heavenly bodies. The sextant, an instrument modeled on the octant but with a 120-degree scale was the next step along the way. However, this still demanded a degree of skill which most seamen of that period did not possess. The modern sextant is a precision instrument much improved from the 18th century prototype and is used in conjunction with a chronometer and the Nautical Almanac to determine both latitude and longitude with a high degree of accuracy.

The first Nautical Almanac was published in 1776 and it gave the distance of fixed stars from the moon at specific times for each day of the year. This made lunar observation a far more reliable method for calculating longitude.

Direct Routes

Ocean currents were not yet charted in the early days of the great sailing ships. Even the most skilled captains often failed to find favorable winds and the most direct routes to their destinations. It was Matthew Fontaine Maury, a lieutenant in the U.S. Navy, who proved that ships could follow tracks or paths in the sea. Maury was crippled in a stagecoach accident and could not return to active duty at sea. During his journeys as midshipman on a man-of-war ship, he had become convinced that there was a pattern that could be followed in shipping routes. Maury was appointed superintendent of the U.S. Naval Observatory and Hydrographic Office. Maury, young and ambitious, poured over old logs of past voyages with his staff. He even had bottles dropped into the sea containing messages asking the finders to send them to him, stating the date, time and place the bottles were found. It was this young American naval officer, Matthew Fontaine Maury, who began to open the eyes of the world to the science of oceanography. The actual start of oceanography as a precise science is generally held to be during the voyage of the CHALLENGER in 1872–76.

By the end of 1851, many ships were recording latitude, longitude, hourly rate of current, variation of compass, barometer, thermometer, force and direction of winds, rain, fog, and other sightings. From Maury's studies he became a figure of international repute. In 1855, Maury published his book, *The Physical Geography of the Sea*, the first great classic of oceanography. His book was immensely useful to ship captains all over the world.

Maury was a native of Virginia and reluctantly resigned his commission at the outbreak of the Civil War. From 1862 to 1865, he was an agent for the Confederacy in England. Before his return to the United States in 1868, he served briefly as Commissioner of Immigration for Emperor Maximilian, hoping to establish a colony of ex-Confederates in Mexico.

Today he is recognized as the true father of oceanography and his system of recording oceanographical information has been adopted by maritime countries the world over. In Columbus's day, there were no clocks as we know them today. The only clocks they had were hourglasses. It took half an hour for the sand to run from the top vial into the bottom one. A sailor on watch had to turn the hourglass upside down every half hour. Just to make sure that the man on watch did his job, he had to ring a bell every time he turned the glass. It was calamitous if he forgot, for all trace of time was then lost and it could never be made up. Even though hourglasses are long outdated, ship's clocks still ring a bell every half hour, and time on board ship is still counted by these bells. Eight bells means that four hours have passed and it is time for the new shift, or "watch," to go on duty.

Lighthouse Sentinel

About the year 280 BC, Egyptians built the Tower of Pharos to mark the harbor at Alexandria. It was one of the Seven Wonders of the Ancient World. It was said the tower was more than 450 feet high. On the top of the tower a wood fire burned like a light in the darkness. The Roman Empire had beacons along the coast. Early mariners knew very little about the coastlines and the fear of dangerous rocks was always a threat. Many ships were given false signals and lured ashore to be plundered. Sometimes a lantern was hung on an ox and walked along the beach near dangerous rocks to simulate a ship sailing safely through a channel. The use of lighthouses is known as long ago as 660 BC. Today there are still lighthouses to be found the world over.

The lighthouse typifies maritime safety. A portfolio of sail would not be complete with at least some words about the role of the great lights that played such an important and historical part in the coastal defense and military readiness of this nation. In the early days, their strategic locations along our coasts aided law enforcement by making it possible for cutters to judge their distance from the coast and so prevent smuggling operations within the 3-mile limit.

The Boston Lighthouse

The first lighthouse established in America was built on Little Brewster Island in Boston Harbor and was first lit on September 14, 1716. The maintaining of the light was done by a tonnage tax of one penny per ton on all vessels, except coasters, moving in or out of Boston Harbor. The first lightkeeper, George Worthylake, also acted as pilot for vessels entering the harbor for a salary of $50.00 a year. In 1718, Worthylake, his wife and daughter, along with two men, were drowned when the lighthouse boat capsized as they were returning to the island from Boston. Benjamin Franklin, then a printer in Boston, wrote a ballad about the incident entitled "Lighthouse Tragedy," and sold it on the streets of Boston.

In 1774, the British took over the island and blocked the harbor the next year, making the lighthouse unavailable. When the British left Boston on March 17, 1776, there were a number of their ships left in New England. American soldiers landed on Long Island, New York and Massachusetts' Boston Harbor on June 13, 1776, and opened fire on the ships in the harbor who were soon at their mercy. Before sailing away, the British sent a boat ashore at Boston Light and left a time charge which blew up the lighthouse. The metal from the top of the old lighthouse was melted into molten metal and used to create American ship cannons.

In 1783, a new lighthouse was erected on the site of the old one. This new lighthouse, which still stands, is 75 feet high with walls 71.5 feet thick at the base, and is tapered to 2 feet, 6 inches at the top. During World War II, the light was extinguished as a security measure, but was placed in operation on July 2, 1954, with a 110,000-candlepower second-order electric light, flashing white every 30 seconds, which can be seen for 16 miles out to sea.

The story of the first American lighthouse parallels the history of the American nation, as our country began to develop, the need for more safety at sea was the signal

to build more beacons. Scarcely a year had passed since 1716, when the Province of Massachusetts built Boston Light, a new light structure had been erected somewhere in America. Under the supervision of the United States Coast Guard, there were 368 active light stations by 1957; as a nation, and before that, as a British colony, hundreds of other lighthouses had been built along our waterways. To tell the story of all the light stations in America would be a book in itself. Today, most of our coastal lights are automatic; the old man at the light is history.

The Three "L's" of Sailing

In the days of the sail, sailors sailed the seas by way of three "L's": log, lead, and lookout; and with a fourth L – latitude – when necessary. From the earliest records of man and his ventures in ships on the high seas, there were many difficult problems to overcome. The ocean's immensity posed one of man's greatest problems. As long as a vessel did not venture out of sight of land, he was safe from the monstrous sea. If the Asians had been as good as navigators as they were shipbuilders and sailors, they might have discovered America centuries before the Europeans. The science of transoceanic navigation was a slow, cumulative process. Chinese ship pilots had the compass a thousand years ago. When they knew where they were going and had a good grasp of coastal topography, early sailors would strike out for short voyages across the open sea.

Navigation by sea was much more dangerous than travel over land. For example, the Arabs of the Middle East perfected the astrolabe, a complicated instrument for land surveying. However, this instrument was of little value at sea. In the desert, the navigator had the advantage of a stable element, at sea there was no such stability.

In 1731, John Hadley introduced his quadrant, an instrument employing mirrors that permitted observations by reflection. Avoiding the sun's glare, however, was critical for effective accuracy. In time the quadrant developed into the sextant, which is still in use today. With the use of a sextant, knowledge of latitude can be worked out by simple mathematics. It was not until late in the 18th century that the chronometer was developed by John Harrison.

Captain James Cook, the English explorer, was the first to make use of the chronometer. Many of the great voyages that took place before the use of the quadrant and the chronometer were made with no better means of navigation than reckoned distance, an approximate knowledge of latitude most of the time, and well-kept compass courses. Other methods used in the early days of sailing included frequently stopping

by night to take soundings by lead line when possible, keeping a sharp lookout, and praying for guidance. Those were the men of steel that sailed in ships of wood.

The basic tools of navigation, the names of all the rigging, and the knowledge of mastering an encyclopedia of knots and splices might be learned ashore, but sails can only be furled from one place— aloft. The reality of life at sea was far removed from the adventurous tales often printed in news of the day. A ship fighting a Cape Horn gale required instant action based on experience. With the words "all starbowlines ahoy!" a crew went into action. "Lay out there and furl the jib!" called for a sailor to spring out to the bowsprit on the weather side of the jib boom and place his feet on the footropes holding on by the spar. With the great jib flying off to leeward and slanting so as to almost throw him off the boom, there was no time for classroom theory. A sailor had to "Hold Fast" as huge seas soaked his bones through. "Hold Fast" had to be second nature for a sailor.

The Catamaran

The word *catamaran* comes from the Tamil language, which is spoken predominately in South India. The original catamaran consisted of little more than two logs tied together. The word catamaran is derived from the words KATTU (tie) and MARAM (tree). A catamaran is any vessel having twin, side-by-side hulls. A quarter of scientists believe the ancient Polynesian people migrated over thousands of years from Southeast Asia and Indonesia in catamarans. These pre-Polynesians had a system of navigation uniquely their own. They followed the trade winds and the sea birds from island to island, using the stars to chart their courses at night.

Building these vessels was not a simple task. The hull trees were selected often many years in advance. Once the tree was selected, the brush was cleared away and the bark on the weather side was peeled off in order for decay to set in on that side, making the eventual hollowing of the log easier. The unstripped areas would by the same token be strengthened over the years.

The building of "KATTUMARAMS" as they were called by the ancient Polynesians, was a time of great ceremony and feasting. The work was done with stone adzes and human bones as their tools. After the trees were felled, it was shaped and hauled from the forest to a huge shelter where men worked on them in huts big enough to place the twin hulls their planned distance apart.

These ancient double hulled crafts were a subject of amazement to the first Europeans who saw them. Captain James Cook was amazed and perhaps a little embarrassed by the way the Tongan chiefs were able to sail rings around his ship, even when she was at her best in good breeze. Captain Cook and other explorers of the mid-1700s brought back drawings and descriptions of the Polynesian boats which were largely ignored until after World War II. Captain Nathaniel Herreshoff, in the late 19th century, built a catamaran and entered it into the Centennial Regatta in New York. Herreshoff beat the entire fleet of 90 boats. Because of his unusual craft, the AMARYLLIS, he was discouraged from entering the race again. Although other twin-hull designs were built, the catamaran of the 1800s was still a curiosity.

The battles of the South Pacific during the war with Japan brought countless American and European soldiers to the islands of the Pacific and in contact with catamarans. The native outriggers, double hulls and canoes were a curiosity to the young men who were strangers to the islands. After the war, new concepts and variations of sailing vessels sprang up all over the world, from plywood, aluminum, canvas, and later a material called fiberglass, refined these vessels into one of the world's most popular pleasure crafts.

Wood For Wooden Ships

Native woods were used almost exclusively to build American ships. Southern pine was used for planking, white ash was used for oars, buttonwood for windlasses and blocks, elm for keels, ironwood for handspikes, juniper for knees, locust for treenails, maple for the cabin, white oak for the stem, and white pine for masts and large spars.

Man-O-War

The design of ships after Columbus's time was influenced by the increased use of gunpower and cannons. Gunpower spelled the doom of the slave-manned galleys. The

big guns needed room and the slaves took up that needed space. The use of cannons changed sea-fighting tactics. Instead of trying to ram and board enemy vessels, ships with cannons would remain apart and attempt to blast each other out of the water. Ships became floating batteries with each country trying to "out-cannon" the other. The "man-of-war" was here to stay.

When Holland built a two-decker ship carrying thirty guns, England countered by building an enormous three-decker vessel bristling like a porcupine with eighty guns. The Spanish in turn would answer the challenge by building a ship with ninety guns. This competition continued until warships became clumsy and too heavy to move. An example of this was the magnificent warship KRONAN. This Swedish Royal flagship was woefully top heavy.

While under full sail, the KRONAN made a sharp turn to face the enemy for battle when a gust of wind simply capsized her on her port beam. As the ships masts and sails touched the water, a violent explosion ripped her amidships and she sank within minutes. The vessel took some 800 men to their death.

In her day, KRONAN was the largest ship in all of Sweden. This vessel was 200 feet long overall, weighing 2,350 tons, and carried 126 guns. This ship took seven years to build, she was launched in 1668 and commissioned in 1672. The KRONAN's demise cost Sweden control of the southern Baltic.

An equally famous 17th century warship was the VASA (also spelled WASA). Like the KRONAN, this ship sank on her maiden voyage out of Stockholm in 1628. The sinking of the VASA was a blow to Swedish pride; the loss of the KRONAN was a national disaster.

The old broken-up pattern of the ship's decks disappeared. It was hard to place guns along a ship whose decks were on separate levels. The slant of the decks made it most difficult to keep large cannons in place. Heavy guns could not be shifted up and down stairs. Ships were designed with decks running flush along the length of the hull, one above

the other like stories of a house. The great Spanish galleons took many a licking from the lighter, but more nibble, ships of England. The key to this problem was not to cut down on guns or add more but to lay on more sail.

Round Shot

The early cannons were not much better than ancient Roman stone-throwing catapults and ballistas. But with the advent of gunpowder, iron ball-shaped projectiles were used. In due time, advancements were made with all forms of firearms. They developed tangent sights and elevated screws, and the science of ballistics. When gunsights were first suggested to England's famous Admiral Nelson, he said, "I trust, gentlemen, I shall always get near the enemy so as to make sights unnecessary."

From the Whipstaff to the Ship's Wheel

The whipstaff, a vertical extension to a tiller, is a horizontal lever attached to the rudder by which a vessel is steered. On large sailing ships, the tiller was below deck and thus made it impossible for anyone operating the tiller to see where he was going. The whipstaff extended up above the level of the deck and overcame this difficulty. As the size of ships increased and more decks were added, it was necessary to find a more convenient arrangement for the helmsmen. Large vessels could not be operated in foul weather with the use of the "whip," consequently, as it could only be operated for a few degrees, much of the handling and trim was done with the sails.

Steering was very difficult on the large ships that used the ancient whipstaff. In 1711, the 90-gun Second Rate OSSORY became the first ship to be built with a steering wheel. The steering wheel was the most important advance in ship engineering and began

to supersede the whipstaff early in the 18th century. The exact date of the ship's wheel is unknown.

American Shipwrights

The colonies of the first English settlers were built on the shores of bays and rivers. Shipbuilding became a leading industry of the coastal towns. Some of the early shipbuilding centers have long since faded away, not because of lack of ships to be built but because the white-oak timber has all been cleared away. American virgin forests were one of our greatest assets. The English had depleted their timber over the years and America became the new supply source for the Royal Navy.

The "BROAD ARROW" brand of the Crown found its mark on many oak and pine trees in the great forests of the Colonies of New England. A third of England's merchant ships were built on American shores. A century later the American yards were still building ships for the Empire trade. Many of the clipper ships of England were a product of American shipwrights.

Early shipwrights began work by making a complete scale model of the ship later to be built by the many trade crafts required to build such ships. A good ship's carpenter was a man of many talents. The lives of many people were dependent on his skills and knowledge of ships made of wood. In the 17th and 18th centuries, most vessels of all sizes were built to carry a maximum of cargo which slowed the speed of the vessel. Chesapeake Bay shipwrights began in the end of the 18th century to build small ships which were believed to be copies from French fishing boats.

This new type of vessel became known as schooners. From the schooner came the "Baltimore Clipper" and the famous clippers of the mid-1800s. The original clippers had narrow hulls, sharp bows, V-shaped bottoms and had little cargo space, but they could run away from any ship of the day. These Greyhounds of the Sea carried acres of sail, and because of their speed they carried three-fourths of American cargoes exported throughout the world in 1812.

The rap of the calker's mallet was a familiar sound in the shipyards of the days of wooden hulls. The seams were packed with oakum, a hemp fiber made from old ropes, which was untwisted and picked apart. After the calking was in place, a hot pitch was placed on to seal the seams. Every crevice where leaks might let water in had to be calked.

Rigging normally was done after the ship slid down into the water, and the hull was floated free from its cradle. The ship was brought in broadside to shore and with the use of giant windlass she was carrying over on her side for stepping the masts.

The masts were trunks of tall trees, usually pine, some as thick as two feet and as long as forty feet in length. After the masts were in place and guyed by the shrouds, they were used as derricks to hoist the topmasts and topgallants in place.

The rigging was a slow task and carefully done. The maze of stays, braces, halyards, and bowlines were a sight to behold as a ship became a reality. Next came the sails and the skilled hands of the sailmaker. His talent lay in cutting the hemp canvas or linen so that it would "belly" just enough under the pressure of the wind. The story of the sail is a chapter in itself.

Black Hulls and Green Bulwarks

The renewal of commercial relations between the United States and England demanded increased shipping facilities after the close of the War of 1812. About the year 1816, numerous lines of packet ships came into being. These ships ranged from 300 to 500 tons register and were flush-decked, full-bodied vessels. It was the fashion of the day at first to paint the hulls of these packet ships black above the water line with bright varnished upper works, while the inside of the bulwarks, galley, etc., were colored green. The size of the packet vessel gradually increased until by the time they were supplanted by the clipper ships many of these vessels were over 1,000 tons.

The Painting of Ships

By about 1800, the fashion in painting ships also changed. A broad white band, broken by black squares in imitation of the gun port of a warship was a common style, while the inside work was painted in some light color instead of green. Packet lines had their own distinctive emblems, many painted on the sails, another renewal of an old-time sea custom. The packet ships carried plenty of sail. Skysails for summer use were set on removable pole masts above the royals. Studding sails were carried on all the yardarms up to the topgallant, except on the mizzen.

Ships of the different navies began to be painted somewhat uniformly at about the beginning of the 19th century. During the 18th century, it was a matter of personal choice by the captains. Most English ships were painted black according to Nelson's wishes with yellow bands broken by the black hatches of the gunports during the Battle of Trafalgar. By about 1815, the bands generally began to be painted white. This fashion was to stay as long as warships were sail-propelled, and long afterwards many merchantmen were still painted "Nelson-style."

SAVANNAH – 1818

The SAVANNAH was built by Fickett and Crockett in New York; she was 100 feet long, rigged with sails and a 90-horsepower steam engine to drive the paddles that were stowed on board once the ship was out to sea. The SAVANNAH was the first vessel to cross the Atlantic with the aid of steam and sails. In 1819, this ship sailed from Savannah, Georgia, to Liverpool to make the first trans-Atlantic voyage in 29 days. The greater part of this trip was made under sail, for only 60 tons of coal was carried onboard, which was enough for little more than three-and-a-half days. The smoke funnel on deck was angled to keep sparks away from the rigging. In 1921, this ship was wrecked on Long Island.

The Glorious Age of the Windjammer

Time never stops the world nor does the world slow down while man moves on to new horizons. From the early clippers came a new and gigantic creation, the tall ships of steel. A ship to challenge the coming of steam. Vessels built to carry thousands of tons of coal, grain, guano, nitrates, and timber to the far corners of the earth. This new descendant of the graceful wooden clipper ships was unparalleled in size, power, and beauty.

The crews of the steamships were responsible for the name that would last forever in the history of sailing, they called these monsters, windjammers. They said they were too clumsy to sail into the wind and would jam into it. They will never sail in the teeth of a storm. However, these white-winged vessels did survive the gales and captured the hearts of sailors the world over. Windjammers were the climax of centuries of evolution in the great age of sail.

The living history of the windjammers was all too brief, only 60 years from the end of the 19th century to the first third of the 20th. The clipper ships were all but gone with the coming of the steam-driven passenger liners and cargo carriers ruling the sea-lanes and world trade routes. It was a sad day when the huge square-rigged vessels were no longer practical. It was said that the likes of such ships will never be seen again, and thus it is so, for the return of this great moment in time for sailing ships has never come to pass.

For many years, the windjammers proved to be better sailors than steamers. Windjammers could survive in most any sea and battle the roaring waves that would crumple smokestacks and douse steam boilers and shear propellers like so much tinfoil.

The wind was free and as steamers traveled farther from home, their cost to operate cut deep into their profits. There were thousands of windjammers plying the oceans of the world around the turn of the century, while steamers were still searching for their sea legs.

The great secret in the construction of windjammers over clippers was steel. The passing of clipper ships gave birth to new and awesome dimensions in ship building. The average clipper was 150 feet long while the windjammers were from 300 to 400 feet long in length. Their great masts were three feet thick at the base and towered as high 200 feet above the keel. Sails weighed a ton dry and far more when wet. Sailors on windjammers tried to observe the tradition of one hand for the ship and one hand for the sailor, but the stiffness of the great mainsail required the use of both hands and a strong back. Only the force of the wind held the sailor aloft firmly against the main yard. In heavy seas, sails often blew out, and ships that could afford them carried several suits, or sails as they were called. Even so, sailors were constantly mending canvas to get ready for another day. Some 14,000 yards of canvas and miles of seams and thousands of stitches went into a suit for a windjammer. As ships grew larger, three masts gave way to four and even five. Sail plans began to change, as well as the manning of these ships. Windjammers were designed to sail with increasingly smaller crews.

The most significant change from clippers to windjammers was the rigging. With steel masts and yards came wire cable and chain rigging. Winches eased the backbreaking work of hoisting and lowering the yards and sails. With the advance of steel rigging came a new phenomenon, the unusual sounds these ships of iron and steel made. It was once said, a steel ship at sea was like a great giant organ being played by the hands of the wind and sea.

Windjammers were floating warehouses on the move. The clippers of old were faster but much smaller in size. The greatest speed ever achieved under commercial sail was by the American clipper, JAMES BAINES, which reached 21 knots in 1856.

Steel Rigging

Steel rigging was almost revolutionary. Hempen cordage was quick to decay and stretch interminably. In the course of a long voyage, it was not uncommon for a ship's mainstay, a rope usually about nine inches in circumference, to stretch four feet or more. The security of the masts was a constant chore. The continued lengthening of the ropes necessitated frequent adjustment and was a constant menace. Steel wire standing

rigging used in later years of the sail required practically no attention and was almost unbreakable.

California Clippers And Downeasters

The years of 1850 to 1860 were the great years for the California clippers. However, the race to California began to slow down by 1855. The rumbling of the War between the States caused many people to hold fast and see what the future held. In the years to come, a new type of ship came to take the place of the "greyhounds."

They were the Downeasters, or grain ships built in the 1870s. The California Clippers were built by the shipbuilders of New York and Boston. The Downeasters were built by the shipbuilders of Maine. Bath, Maine built many fine ships of this period. Downeasters were square-rigged and had three masts. They were the finest ships afloat in their day. Because they were built "way down east" in Maine, they were called Downeasters.

The gold nuggets of California were not the only type of gold available to make money for those who came West. Golden wheat grew in the rich soil off California and the world was hungry. Wheat grain was a heavy cargo and if it became wet, it could swell until it burst the hull of a ship. On long voyages many times grain would rot in the holes, and there was always the fear of fire.

Falls of Clyde
Honolulu, Hawaii

San Francisco was the third most important sailing port in the world by 1890. Downeasters carried not only grain, but also fertilizer, and even ice to all parts of the world. The men of Maine knew their days were to draw to a close when the English and Scottish shipbuilders began building ships of iron. They were called "Lime Juicers" because of the custom of giving the crew a cup of lime juice and water every day. This practice kept the men from getting a terrible disease called scurvy. The hulls of these lime juicers were built of iron and later steel plates, making them less expensive to keep up and ideal for the grain market in California. One of the lime juicers to survive the years is the FALLS OF CLYDE, which is now docked in Honolulu, Hawaii at the new Maritime Museum.

The world's first iron ship ever built, the GREAT BRITAIN, has been fully restored and refitted and is open to visitors in Bristol in southwest England. The ship was launched in 1843 by Prince Albert. The GREAT BRITIAN had quite an adventurous life before she was wrecked in 1886 off the Falkland Islands in the south Atlantic. Her sturdy hull proved impervious to weather and in 1967 a campaign was launched to bring her back to Britain for a museum.

The SOVEREIGN OF THE SEA was the finest of Donald McKay's famous clipper ships; as far as beauty of lines, this vessel was number one. These white winged ships were known the world over for they carried America's flag and commerce to the far ends of the earth. McKay's clippers did more than this, they earned many of the early fortunes upon which the prosperity of this country was established.

MacKay's SOVEREIGN OF THE SEA must not be confused with two other ships with the same name, the line-of-battleship of 1637, or the medium clipper built in 1868. McKay's ship was launched in June 1852, her length was 258 feet, with 2,421 tons register. The SOVEREIGN OF THE SEA, built at Boston harbor, had the longest and sharpest ends of any vessel built at that time. She combined the grace and beauty of the smaller ships with immense

strength to carry the sails. The crew consisted of 105 men and boys. On board there were four mates, two boatswains, two carpenters, two sailmakers, three stewards, two cooks, 80 able seamen, and 10 boys before the mast. She was commanded by Captain Lauchlan McKay, the younger brother of Donald McKay. Young McKay, like his brother, was a shipwright and opened a shipyard in Boston. At one time in his life, he served four years as a carpenter on the U.S. frigate CONSTELLATION. Captain McKay was 41 years old when he took command of the SOVEREIGN OF THE SEA.

According to one story, the older McKay brother spent some time with his brother as a passenger on board the ship he had built to see first-hand what kind of sailor she was and observing the sails for strains on her spars and rigging. Donald proclaimed "Well, she appears to be a pretty good ship, but I think I can build one to beat her"; and so, it was, eventually he did. Nevertheless, the SOVEREIGN OF THE SEA set many records in her life and on one voyage was credited with a day's run of 436 miles, which equals the world's record set by the FLYING CLOUD.

In 1853, the SOVEREIGN OF THE SEA made a dangerous return from Melbourne to Liverpool with over four tons of gold-dust and mail. Because of the great value of the cargo, a group of men planned to take over the ship. The captain acted with great firmness and tact in suppressing the mutineers and was able to put them in irons without loss of life. Captain McKay received much credit for his courage. On August 6, 1859, the SOVEREIGN OF THE SEA met her fate on the Pyramid Shoal in the Straits of Malacca where she was wrecked and became a total loss.

The Challenge

This portfolio of sail must also cover the period from 1807 to 1858 which challenged the day of the tall masts. Steamships were in the picture but were not quite trusted as

yet. The CLERMONT was the first steamship built in 1807 that proved to be a reliable vessel with steam. Robert Fulton's CLERMONT began a regular run from New York to Albany on the Hudson River. The following year another vessel was built for the Delaware River, the PHOENIX. She was another first. The PHOENIX had to travel from New York to Philadelphia and thus became the first seagoing steamship.

The SAVANNAH was the first steamship to cross the Atlantic; however, she was in fact a full-rigged ship with an accessory engine and a collapsible paddle wheel. From the Savannah River to Liverpool in the summer of 1819, she very seldom used her machinery. In 1838, another ship crossed the Atlantic, but this time with the aid of an engine. The voyage was made by the SIRIUS, which made the trip at an average speed of 6.7 knots.

During the 18th century, there were many who believed that the propeller was a better and safer means of propulsion than the paddle wheeler. The middle of the 19th century saw some 30 or so different propelled types and patents from all over the world.

The GREAT BRITAIN

The first propeller-driven vessel to cross the Atlantic was the GREAT BRITAIN in 1843. The ship was built of iron without any outer keel, but to lessen rolling at sea she was fitted with two bilge keels. Her length was 322 feet, width was 50 feet, and her engines of four 88-inch cylinders developed 1,500 HP; a six-bladed propeller that was 15.5 feet in diameter and rotated at 53 rpms provided the power to move the ship. In her trial runs, the ship reached 9 knots. However, neither ship owners nor passengers were quite ready for a ship without sails. The GREAT BRITAIN, like other steamships of the day, were fitted with sails. The vessel carried a total of 15,000 square feet of sail on her six masts.

On May 1, 1854, construction started on a ship which was to be the largest yet seen by the world. The ship was launched as the GREAT EASTERN, with a length of 692 feet and width of 82.7 feet. She was the only ship in the world to have both paddle wheels and a propeller. The wheels were 56 feet in diameter and the diameter of the four-bladed propeller was 24 feet; the six masts could carry a total sail area of 58,000 square feet and reach a speed of about 15 knots. The GREAT EASTERN could accommodate 800 in the first class, 2,000 in the second class, and 1,200 in the third class, plus a crew of 400 and room for a cargo of about 6,000 tons.

Unfortunately, the ship's engines were not heavy enough to give her adequate speed and it was difficult to find ports to dock. In time, she became an enormous failure as a

passenger ship. In 1865, she was used for a cable layer between the United States and Europe. In 1888, the ship was sold for scrap.

The Golden Age

The golden age of the wooden ship will be remembered as the great fifties as trade conditions conspired to make it so for the American ship builders. Favorable treaties with various nations turned a large proportion of their commerce to American companies. The discovery of gold in California caused passengers and goods to be carried to the West Coast. In turn, the China trade with Pacific Coast lumber furnished a cargo westward, while silks, rice, hemp, and other riches of the Orient made the home-bound voyage profitable. The state of Maine surpassed all the other states in building ships. In Kennebec alone, 476 vessels were built during this period, a total of 324,888 tons (an average of 680 tons per vessel). This was a record not to be surpassed during the era of the wooden ship.

The NIGHTINGALE

One of the most beautiful of the clipper ships was the NIGHTINGALE. Named for Jenny Lind, whose likeness she carried beneath her prow as her figurehead, she represented all that was lovely and exciting on the high seas in the great years of the fifties. The day she was launched in June, 1851, until the day she disappeared beneath the waves 42 years later, the NIGHTINGALE had a life full of adventure. So proud and confident were her owners that they offered to match the NIGHTINGALE against any British or American ship for a race to China and back for a stake of $10,000. The challenge was never accepted.

The Capstan

The capstan was an upright cylindrical device found on deck along the centerline of a ship. It had a drum turning on a vertical axle of heavy construction, around which to wind rope or cable for moving heavy objects such as anchors and large sails. The capstan used to have another working part fitted on top of it called the drumhead, into which capstan bars were fitted so that the capstan could be turned by hand. The difference between a capstan and a windlass is that the capstan is always mounted vertically, while the windlass is always mounted horizontally.

HARRIET LANE

The HARRIET LANE, a sidewheeler built in 1857, was the first successful steam Coast Guard cutter and one of the most famous ships in the Civil War. This ship was credited with firing the first shot of the war in April, 1861, at Fort Sumter. The southern steamer NASHVILLE tried to run Charleston harbor without showing her colors, whereupon the HARRIET LANE fired a shot across her bow. This ship participated in the first Union victory, the capture of Fort Clark and Fort Hatteras. The HARRIET LANE fought under both the Union and Confederate flags. She was captured at Galveston and finished the war in the service of the Confederates.

M.M. HAMILTON

The M.M. HAMILTON was a sloop built at Herpswell in 1869 with 1,000 square yards in her mainsail. This tone sloop was the largest ever built. New England boatmen used scows for the transportation of ice and stone and other heavy bulky commodities. Rockport, Massachusetts, was the home of the Rockport Granite Company that quarried and shipped it to all ports along the eastern seaboard. This type of vessel was sometimes called a granite sloop.

Heaving Down

Heaving down was the ancient method of repairing the old sailing vessels without using a dry dock. The ship was strengthened to take the strain, her masts were shored up with timbers, and then horse-operated capstans on the wharf pulled her over with powerful tackle until the keel was exposed above the water. Once a ship was down, a crew of caulkers would scrape down and re-caulk the bottom of the hull. When the ship was in this position, the copper sheathing covering the bottom was removed. Then the hulls were checked for marine borers—a characteristic of the wooden hulls of the downeasters.

"Between the devil and the deep blue sea" is a saying most people believe means "between Satan and the bottom of the ocean." However, the word devil in this case has nothing to do with the ruler of the kingdom of evil. The "devil" was the seam in a wooden ship's hull next to the waterline, and it was called that because it was "the devil to get at" when caulking.

Paul Bunyan and Shipbuilders Came West

As the wheat fields spread over the Northwest, new shipping ports were developed. In 1876, the ST. CHARLES was the first ship to load wheat at Martinez, near San Francisco. The event was celebrated by the enthusiastic inhabitants with an elaborate banquet. Long before Paul Bunyan had turned from the white pine forests of Maine and commenced his long trek westward across the continent toward the mighty Oregon firs, shipmasters had recognized great possibilities in the development of the forests of the Northwest. The first commercial cargo of lumber to be carried out of Puget Sound in an American ship was in the brig ORBIT OF CALAIS. That was in the year 1850. Ten years later, the first cargo of yellow fir spars was shipped to Atlantic ports in the LAWSON of Bath, Maine.

The beginning of West Coast timber being used for ships came in 1877, when Captain Guy C. Goss of Bath visited the Pacific coast. He was so impressed with the timber on the banks of Puget Sound that he sent a cargo home to the yards in Boston, New York, Bath, and Philadelphia. The result proved that a new vast woodland was found for ship builders. One of the cargoes, carried out by the ship GUY C. GOSS, contained 250 pieces suitable for masts and spars; many measured 112 feet in length and 36 inches in diameter. Having neither knot nor blemish, they were worth $900 a piece. The building of the great vessels and smaller barks of the later period was made possible by the use of this heavy timber.

The ship ROANOKE, for instance, whose spars were massive sticks of Oregon fir, had a lower mast 38 inches in diameter. The fore, main, and mizzen masts were 92 feet long, while the spanker was 98 feet.

As early as 1896, there came ominous signs that American wood was losing the California grain trade to English iron. Owners and shipbuilders began to turn with more serious attention to the fore-and-aft rig and to the rapidly increasing coast trade, which was secure from foreign competition. The shadows of time began to lengthen. By 1889, the grain fleet of 213 ships contained only 30 American vessels. From 1885 to 1890, no square-rigger left the way anywhere on the coast of Maine. (The word "ways" refers to the track under a vessel down which she slid and launched into the water after having been built). The last of the American square-rigged vessels was built by 1893, when Charles Minot launched the ARYAN in his Phippsburg yard.

Topsail Schooner

The schooner rig is believed to have originated in Holland in the late 16th century and probably evolved from the Dutch JACHT, a small two masted craft used on the inland waters of that country. The English also employed small two-masted fore-and-aft rigged ships early in the 18th century.

The schooner is essentially American in its later development, and when this type of vessel became common in the British Isles and the Baltic, it was a copy of the American schooner. Just why this term, topsail schooner, should be applied to schooners carrying square yards and square topsails is not an accident. In America, a far greater number of schooners carry topsails than those which have none. Today nearly all of the topsails are of the gaff variety, the spar on which the upper edge of a fore-and-aft sail extends.

The schooners of the past were usually used within specific localities. The low cost of building a schooner and the low operating cost with small crews, and the fact that they could sail without the need of fuel or motor requirements, enabled these ships to compete in certain coastal trade with steam and motor vessels. The schooner generated profitable commerce in America on the Great Lakes and Atlantic and Pacific seaboards for nearly a hundred years.

All the American schooners were built of wood; three notable exceptions were the KINEO, a five-masted ship of 2,128 tons; the WILLIAM L. DOUGLAS, a six-masted ship; and the only seven-masted schooner ever built, the THOMAS W. LAWSON. Two of these ships met a perilous fate. The WILLIAM L. DOUGLAS was lost in a collision in 1917.

The THOMAS W. LAWSON, which was converted into an oil tanker, was chartered in 1907 for a voyage across the Atlantic. The seven masts on the LAWSON were known respectively as fore, main, mizzen, jigger, spanner, pusher, and driver (the last three sometimes were termed simple numbers four, five, and six). The ship encountered bad weather in the Scilly Islands and anchored, hoping to ride out the storm. During the night of December 13, 1907, the storm unleashed its wrath and the LAWSON capsized and went under. It broke up before Bishop's Rock Lighthouse. The crew went down with the ship.

Sails, Masts, Spars, and Ropes

There were hundreds of different kinds of sails, masts, spars, and ropes used in sailing vessels. As the ships grew in size, every rope and stay that could bear a rag of

canvas became a sail. On a three-masted ship from forward to aft, the masts were called "foremast," "mainmast," and "mizzenmast." The ropes that supported the masts were called "stays" or "shrouds."

As for sails, starting from bottom to top, there were the main course mains 1, the lower tops l, the upper tops l, the lower topgallant sail, the upper topgallant, the royal and the skysail. These were just part of the names of each sail, because in order to tell which mast a sail was on you had to add the name of the mast. A sailor might hear the sound ring out, "lower m'nt'fall'nts'1" (lower-main-top-gallant sail). At any moment, in sea dog style, a sailor might hear the bosun shout through a gale in the pitch-black night, "aloft there on the main T'gall'nt yards and be quick! Haul up the T'gall'nt claws and snug her down fast! Damn your hide, watch out for the main foreroyal brace, you blithering idiot! Trim down that windward leech!"

The American Schooners

The fore-and-aft rigged vessel with four or more masts were called the great schooners. Their day dovetailed with and extended beyond that of the downeasters, and the story of their use and decline provides the last chapter in the history of wooden sailing ships and the shipbuilding industry on the East Coast. The American schooner was known as the most weatherly and economical sailing vessel ever built.

Owing to foreign competition, the profits from long ocean voyages began to diminish. A demand for low-cost transportation was heard up and down the coast. Bulk cargoes like coal, ice, granite, lumber, and lime were needed in this growing country. The origin of the term "schooner" is obscure. Prior to 1850, the word "schooner" stood for a two-masted vessel earning in part square sails on the foremast, hence the phrase "tops-1 schooner." This type of two and three masted rig began its long career of popularity as a coastal carrier very early in American history. Schooners were the errand boys of the coast. They averaged around a hundred tons and were to be found in every river, bay, and inlet along the entire East Coast. The brigs and the topsail schooners were preferred for longer voyages to the Caribbean or to South America, but for short hauls, the small schooners were ideal for up to 500 miles.

In the early 1800s, almost every town had its wood landing. At one time Belfast, for example, had 50 or more wood schooners and in April 1844 there were piled on its wharves awaiting shipment over 10,000 cords of wood. Wood was a profitable cargo. Wood worth two dollars a cord in Maine was valued at four dollars a cord in

Massachusetts. With an average load of 50 cords, a skipper might clear $100 a trip besides what he received for freight on merchandise brought back on the homeward voyage.

The economic value of the great schooners lay in the extreme simplicity of their rig, which allowed the use of steam winches and other labor-saving gear. On a full-rigged ship, there were 204 running lines. The setting of the main topsail required the simultaneous handling of it. By contrast, the running gear on the principal sail of the fore-and-aft rig was reduced by three major lines, and in later years this task was handled by steam power. Fore-and-aft rigging demanded fewer skilled crewmen and thus were more profitable than other ships that required more manpower.

Wire rigging set up by turnbuckles were used in place of hemp. Steam winches handled the cargo, plus sails, and anchor. The schooners had electricity for lighting, steam heat, and telephones in all parts of the vessel. Much of the drudgery and peril of a sailor's life was changed by the latest equipment and shipboard machines. Instead of being housed in foul-smelling, dark forecastles, the crew now lived in a steam-heated deck house. They ate their meals from oilcloth covered tables, as good as those furnished ashore in the better boarding houses. Their comfort was superior to that enjoyed in the master's cabin in the days before the clipper ship.

In the variable wind conditions of the Atlantic coast, the schooner rig proved ideal. The Grand Banks fishing schooners were among the finest of all sailing, trading this type of rigging was unsuited. In strong winds and squalls, the booms were apt to lash across the deck, causing several dismastings. The large ocean-going schooners earned the nickname "mankillers."

At the beginning of the 20th century, the schooner became the vessel most used in the coal trade. More than 50 five-masted schooners were built for the profitable coal trade. Ten six-masted schooners were built in the 1900s. The THOMAS W. LAWSON, launched at Quincy, Massachusetts in 1902 was a steel-hulled giant. Her overall length

was 396 feet and she could haul 9,000 tons of coal. The THOMAS W. LAWSON became an oil tanker under sail, a rare status for such a vessel. This ship lasted only five years before she suffered an ignominious accident.

The Bluenose and The Thebaud

The two most famous fishing schooners to vie against each other were the BLUENOSE and the THEBAUD. The BLUENOSE won in 1923 and 1931. The THEBAUD won in 1930.

From Maine To California

In the maritime world of some two generations ago, "downeaster" was a term of fixed and no uncertain meaning. It conveyed a picture of a par excellence full-rigged wooden ship or bark with her sails spread in the wind, designed, built, and launched in a shipyard on the coast of Maine, and usually with a skipper from Maine.

It was the California gold which had heightened the demand for the clipper. Now it was the California wheat which called forth the downeaster. The downeaster and the clipper, besides their points of contrast, have much in common, however, the career of the clipper, like the gold rush, was short and romantic. The clipper ship era lasted but 13 years, from 1846 to 1859. The life of the downeaster extended the era of the wooden ship by at least a quarter century.

In appearance, the downeaster resembled the full clipper of the fifties. Their lines were neither as sharp nor as hollow as the clipper, while to increase their cargo capacity they had little dead rise. (The term "dead rise" connotes the angle at which the bottom rises outboard, from the keel, and specifically indicates the rise in inches for each foot from the keel.) The downeaster, hence, as compared with the clipper, had a flat bottom. Downeasters were as trim as the finest yachts of the day with little or no ornamentation and the flowing lines of her hull. From stem to stern they were holystoned, oiled, and in ship-shape to the letter.

LLEWELLYN J. MORSE

The LLEWELLYN J. MORSE, a downeaster engaged in the Cape Horn trade in 1890, was a ship of 1,393 tons, built at Brewer, Maine in 1877. The elliptical stem shown here was characteristic of this type, a compromise between the earlier transom stern

and the round stern, which was introduced on the clippers and persisted in Bostonian and Canadian shipyards.

In the years to come, the fore-and-aft rigged sailing ship with two or more masts came on the scene. The schooner was originally a two-masted vessel. Schooners with three, four, and five masts were also built. The five-masters were considered oddities in their day. During the 19th century, a host of schooners were created for a variety of duties.

THOMAS W. LAWSON

The THOMAS W. LAWSON was the only seven-masted American built ship. Launched July 10, 1902, at the Yore River, Massachusetts, she was designed to be the greatest cargo-carrying ship afloat. However, she seldom found enough cargo to make her voyages profitable for her owners. The ship had a crew of only 16 which was an economy measure for a vessel this size. In the variable wind conditions of the Atlantic coast, the schooner rig proved ideal. It was among the finest schooners ever to sail along with the fishing schooners of the Grand Banks.

The WYOMING

This American schooner was built in Bath, Maine, in 1909. The longest wooden ship ever built, she was 330 feet long and six-masted. This class of sailing vessel handled entirely differently from square-rigged ships. The six masts were the fore, main, mizzen, jigger, driver, and spanker. Schooners of this size carried steam wrenches to hoist the largest sails. The spanker boom was 90 feet long and was so thick that when a man sat astride it his feet did not show below the boom. In foul weather these great booms were apt to lash across the deck, giving them the nickname "mankillers." This type of vessel was clumsy and difficult to handle. Sailors who were used to the square-rigger were never at ease in a schooner.

EDWARD SEWALL

This four-masted ship was the last of the five steel ships built at Bath. Maine, at the turn of the century by Arthur S. Sewall. Richard Quick was the master of this ship for two decades and earned the reputation of being tough. The EDWARD SEWALL frequently had trouble getting a crew, even though her seamen received a good wage of $25 month. On her first homeward voyage from the Orient, Captain Quick's entire crew deserted to Honolulu. In 1913, a record was set for duration; it lasted 293 days

from Philadelphia to Seattle. Off the coast of South America, the ship's steel bowsprit dropped off at sea. The ship was put into port and half of the crew of the SEWALL deserted. Some forty days later she again set sail with a new bowsprit, only to have the second one break off. After another month in port, the second crew deserted. It took another 67 days to go round the Horn. The EDWARD SEWALL was 300 miles to the west of the Cape, only to be blown back in heavy weather to a point 40 miles east of the Horn.

The EDWARD SEWALL completed her last voyage in 1916 under the Sewall flag. She was sold to the Texas Company and changed over to carry oil in bulk. The Alaska Packers bought her in 1922 for use in the northern waters. Then in 1934, the ship was sold again, and made her last and final voyage to Japan to be scrapped and forgotten.

The U.S. RUSH

The U.S. Rush was a Revenue Service Cutter. Cutters such as this steam auxiliary vessel were similar to a sloop, except that the mast was set somewhat farther astern. This ship was used by Uncle Sam to prevent smuggling and enforce customs regulations.

U.S. cutters performed many functions of government. For the Department of Justice, they enforced the law, apprehended criminals, and served as "floating courts." For the Navy, they gathered military intelligence. For the Post Office Department, they carried the mail. For the Department of the Interior, they carried teachers to their posts and monitored sanitation, and guarded timber and game. For the Department of Commerce, they conducted surveys of the coast and of regional industries. Medical and dental care reached isolated villages brought by cutters carrying Public Health Service doctors and nurses. Marriages were even performed by the commanding officers of cutters. Many of these functions are still carried out by cutters of the Bering Sea Patrol. In addition, they discharged the normal duties that the Coast Guard performs everywhere.

The LINCOLN was the first American ship to reach Alaska, shortly after its purchase from Russia in 1867 for $7,200,000. One of the notable Alaskan cutters was the BEAR which served 41 years on the Bering Sea Patrol. In the winter of 1897, she volunteered to go to the aid of whaling ships frozen near Point Barrow. Sailing as far as she could, the BEAR sent a rescue team mushing nearly 2,000 miles across the ice, driving a herd of 400 reindeer before them for food. They set out December 17, 1897, and reached the whalers on March 29, 1898. For four months, they kept order and staved off starvation among 500 natives and 300 marooned sailors until the BEAR broke through the ice in July.

In the year 1877, the old schooner DOBBIN was refitted as a "school of instruction." Sailing from Baltimore with the first class of cadets, nine in all, it tacked at sea for four and a half months between the mainland and Bermuda, and visited Provincetown, Massachusetts, Portland, Maine, and the Azores. In 1878 the 250-ton bark CHASE was built as a cadet ship to replace the DOBBIN. When the CHASE was put into winter quarters at New Bedford, Massachusetts, the school was continued in a sail loft. In the winter of 1900, the CHASE was quartered at Arundel Cove, Curtis Bay, Maryland, and a two-story wooden school was built there in the service's repair yard. The school moved to Fort Trumbull, New London, Connecticut in 1910, and finally in 1932 into a new building of its own a little farther up the Thomas River. Thus evolved the famous institution now known as the Coast Guard Academy.

Summary

Now that we have discussed many of the important innovations in sailing ships that evolved during the late 19th and early 20th centuries, we will discuss the end of the era of the days of the sail in the final chapter.

The Humbolt

CHAPTER IX
THE LAST DAYS OF THE SAIL:
Landmarks of the Great Age

Modern construction and techniques have long ago made the great sailing vessels of another day only a memory. However, the old ships do seem to sail on, wholly forgotten. There are between 20 and 30 square-riggers and possibly another 40 or 50 ketches and schooners around the world. Many of these ships are used as training ships to instill confidence in youngsters preparing for a life at sea. Some of the sailing ships are the Danish DENMARK, the British SIR WINSTON CHURCHILL, The Soviet Union's CHRISTOFORO COLOMBO, Japan's NIPPON MARU, Norway's CHRISTIAN RADICH, and Chile's ESMERALDA.

Other notable ships of the day include the DAR POMORZA of Poland, the GAZELA PRIMEIRO, the last of the Portuguese Grand Bank schooners, the GORCH FORK and the HUMBOLT of Germany, the GLORIA of Colombia, the LIBERTAD of Argentina, and the MIRCEA of Romania. These ships as well as many others are seen and appreciated by sailing buffs the world over each year.

The CUTTY SARK

The CUTTY SARK is one of the last of the great clippers of old. This ship is now in permanent drydock on the west bank of the Thames, at Greenwich Naval Observatory where the world's standard of time is set. On November 23, 1869, at Dumbarton on

the Clyde, the 963-ton CUTTY SARK was launched. She was only 212 feet in length and 36 feet in beam, with a depth of 21 feet.

Incorporating the best features of other successful vessels of the day, the CUTTY SARK became one of the fastest clippers in history. She was ship-rigged, heavily sparred and carried a very large spread of canvas. It was said that at the time she was built, there was no ocean-going vessel afloat that could keep up with her in good, strong steady wind. Many of the records set by this ship have stood to this day. In 1880, the CUTTY SARK, while in the wool trade from Australia, set some of her fastest passages. She made the record-time of 71 days from Sydney to London in 1887–88. During the clipper era, the CUTTY SARK, and her greatest rival, the THEMOPYLAE, were the fastest ships that ever moved on the sea under the power of the sail alone. Her plain sail area was around 32,000 square feet; and when driving the CUTTY SARK at her maximum speed of a little over 17 knots, the power developed was equivalent to an engine of 3,000 HP.

The name of the ship came from the poem, "Tam O' Shanter," by Robert Burns. His verses tell how Tam, a Scottish farmer, rode for his life to elude the pursuit of a beautiful young witch named "Nannie," who followed him clad only in a "cutty sark." In English, that is a short shirt or chemise. Today "Nannie" is probably the first thing one notices on approaching the CUTTY SARK. The carved figure of "Nannie" was done by Robert Hellyer of Blackwall. Unfortunately, the original figurehead was lost at sea many years ago, and that which she now bears is a somewhat crude replacement.

The days of sailing ships in the tea trade were already numbered when the CUTTY SARK was launched. On November 16, 1869, the Suez Canal was opened, making available to steamers a shorter sea route to the Pacific via the Mediterranean, while the sailing ships still had to work the Trade Winds around the Cape of Good Hope.

In a light wind, the CUTTY SARK lacked the ability to ghost along, as some of the clippers could do, like the THERMOPYLAE in particular. But with a strong head wind on her quarter, or sailing windward, nothing under sail could touch the CUTTY SARK's speed. This ship was really suited for the Cape Horn Passage and the Roaring Forties. The Roaring Forties referred to the area between latitudes 40 degrees south and 50 degrees south in the Indian Ocean where the winds are a steady prevailing westerly. Today the term now includes that area in the North Atlantic between latitudes 40 degrees North and 50 degrees north frequented by continuous strong westerly winds.

When the Suez Canal opened, steamers began to take over the tea trade. Ships like the CUTTY SARK were forced to look for new cargoes. The wool trade was the

answer. The Australian wool trade differed from the tea trade because the object of the tea was to be the first ship home with the first of the new season's crop for London markets. The fastest ships were loaded first. With the wool, however, it was exactly the other way around. The object then was to get the last of the clippers or slowest ships loaded first in order to get all of the ships to London in time for the January and February wool sales. This meant the fastest ships were kept back to load last, this way no one missed the wool market.

In 1870, the CUTTY SARK gave its name to a popular whisky, although the famed clipper never once carried a cargo of Cutty Sark Scotch in her hull. Her sailing records were impressive: during an 1877 voyage she made 3,457 miles in 11 days carrying her cargo of tea. In 1880, after what may have been her only visit to America, she raced back to London from New York in 19 days.

In 1895, the CUTTY SARK was bought by the Portuguese, and renamed FERREIRA. After being dismasted, she was re-rigged as a three masted barquentine. In 1922, the CUTTY SARK was reconditioned and restored to her clipper rig by Captain Dowman. She remained at Falmouth until 1938, when she was presented to the Thames Nautical Training Collage. The CUTTY SARK today is preserved as a national monument.

The FALLS OF CLYDE

The merchant ship FALLS OF CLYDE was built in 1878 by Russell and Co. of Port Glasgow, Scotland. She was the first of nine vessels comprising the famous Falls Line of Glasgow. Today she is the world's only surviving full-rigged four-masted ship. This vessel was built for world trade and was designed to carry a large cargo with a small crew. The ships of the Falls Line were all named after waterfalls in Scotland. The FALLS OF CLYDE from 1879 to 1899 made 70 voyages to ports the world over, carrying such cargo as lumber, cement, wheat, and jute.

She was constructed of riveted wrought iron 11/16 inches thick. Her length is 266 feet, her breadth 30 feet, her gross tonnage is 1,807, and her net tonnage is 1,740. The total cost of the vessel was $18,609 in 1878. In San Francisco, the FALLS OF CLYDE was sold for $425,000 to an agent for William Matson, later to be known as the Matson Line. She arrived at Honolulu, Hawaii on January 20, 1899, the first four-masted iron ship to come into the harbor flying the Hawaiian flag.

The ship was converted by Matson Line from ship to bark rig, also adding a deck house and a chart house. At that time, the vessel was the largest in the sugar trade, later to be used for regular passenger and cargo service between these ports from

1899 to 1907. By Congressional action, her registry was changed from Hawaiian to American in 1900.

In 1907, she was to be a maritime rarity when she was converted to a sailing oil tanker. The Associated Oil Company bought the FALLS OF CLYDE and continued serving the Islands until 1920. She made two charter voyages carrying oil from Texas to Denmark, and a voyage to Buenos Aires and Panama during the years 1921–22.

Her life was changed again in San Pedro, California, where she was rigged down to a floating oil depot by the General Petroleum Company until 1958. Under a new owner, the ship was taken to Seattle, Washington. In 1963, the people of Hawaii raised over $425,000 in four weeks just in time to save the FALLS OF CLYDE from being sunk as a log breakwater in Vancouver, BC. The U.S. Navy's fleet tug MOCTOBI towed the ship from Seattle on her trip home to Honolulu in 1964.

Restoration of the FALLS OF CLYDE was assumed by the Bernice P. Bishop Museum in 1968. Today, this ship is considered to be one of the finest and best preserved in the world. It can be seen at the Hawaii Maritime Center in Honolulu, Hawaii. To the people of Hawaii, the world should indeed be grateful for their insight in saving this maritime treasure. In 1973, the FALLS OF CLYDE was entered into the National Register of Historic Places.

The JUAN SEBASTIAN DE ELCANO

The JUAN SEBASTIAN DE ELCANO is a Spanish training vessel named in honor of the man who completed the first circumnavigation of the world. Juan Sebastian concluded the expedition started by Magellan in 1519 to find a westward route to India. After Magellan was tragically killed in the Philippines, Juan Sebastian de Elcano sailed the one remaining galleon of the original five back home to Spain with only 17 survivors. The length of this ship is 352 feet, and her beam is 44 feet with a mainmast of 164 feet. This ship is one of the world's largest topsail pigged schooners sailing today. She carries 407 people: 24 officers, a crew of 173 and 210 trainees. Her four lower masts are all steel, but the topmasts and spars are of Oregon pine.

In 1969, this ship sailed into Monterey, California, where it dropped anchor and its crew "invaded the city with a parade." The 75-year-old four-masted ship's marine midshipmen and the crew marched up Alarado Street to Jules Simoneau Plaza. The JUAN SEBASTIAN DE ELCANO also took part in the Tall Ship's 76 Bicentennial Salute to America.

In 1960, the U.S. nuclear submarine TRITON sailed Juan Sebastian's route submerged, and upon completion of the underwater voyage around the world, surfaced for the first time in the Spanish port of Senlucar de Barremeda. The TRITON carried with her a bronze commemorative plaque with the date of both circumnavigations, carrying the inscription "Hail, Noble Captain, it has been done again."

The U.S. Coast Guard EAGLE

When the HORST WESSEL was taken over by the U.S. Coast Guard at Bremerhaven, Germany and renamed the EAGLE in 1946, by coincidence the figurehead was a handsomely carved eagle. The talons of the eagle held a wreath inside which was a swastika, the symbol of Nazi Germany. This ship first served in the German Navy for 10 years as a training ship. The log records that Hitler's birthday was once observed on board this ship. The pro-Nazi figurehead was replaced by the shield of the United States Coast Guard. The refitting of the ship took five months. The deterioration of the wood used in the figurehead was replaced by a smaller antique eagle, which once graced the bow of the ship CHASE.

Today, the EAGLE plays an important role in the development of young cadets in the U.S. Coast Guard. That moment of truth comes when a cadet, as part of his training, finds himself 150 feet above the rolling sea and hears the order "man the fore royal clewlines and buntlines, tend the sheets, halyard and lee brace ease the halyard dew down, round in the leg brace." Despite its modern equipment, the ship still must use manpower for most of the tasks aboard the EAGLE.

The square-rigged barque EAGLE, the pride of the U.S. Coast Guard, is the sixth vessel to bear that name. The first EAGLE was a brig of 187 tons, built at Philadelphia in 1798. She was 58 feet along her keel, 20 feet across her beam, with a nine-foot hold

and a crew of 70, including 14 marines. The first Captain of the EAGLE was Hugh George Campbell of South Carolina.

The second EAGLE, under the command of Captain Frederick Lee, was used as a convoy for American ships passing through Long Island Sound. The third and fourth cutter named EAGLE were used to carry out routine duties of revenue vessels and operated from 1816–24 and from 1824–29 respectfully. The fifth Coast Guard vessel named EAGLE was a 100-foot patrol boat commissioned on November 11, 1925. The boat was used for the next seven years for the enforcing of Prohibition. This ship was sold after ten years of duty.

The modern EAGLE is bark that displaces 1,894 tones, 295 feet in length and was built in Hamburg, Germany in 1936. Named the HORST WESSEL, she served the German Navy for ten years as a training ship. After World War II, she was acquired by the United States as part of Germany's war reparations after having served as a cargo ship during the war. The steel hull ship has three masts and carries more than 25,300 square feet of sail and more than 20 miles of rigging. Her normal complement was 180 trainees in addition to 19 officers, and a crew of 46, for a total of 245 on board. This ship also carries a 700 horsepower Diesel engine.

There are three sister ships of the U.S. Coast Guard EAGLE owned by other nations: the MIRCEA of Romania, the SAGRES II of Portugal, and the TOVARISCH II of the Soviet Union.

In 1938, the HORST WESSEL made her first and only Atlantic cruise to the Canary Islands. During World War II, her cruising was confined to the Baltic. In the last days of the war she was engaged, as were many German ships, in transporting East German refugees and soldiers west before the advancing Russian armies. Although she suffered some slight bomb damage, she miraculously escaped sinking when she failed to make Kiel Harbor the night an air raid by Allied forces sank every vessel in the harbor.

The Coast Guard, which had been looking for a replacement for the DENMARK, was delighted to take her over. She was renamed EAGLE in honor of the long line of famous U.S. Revenue Cutters dating back to 1798. The EAGLE's 700 HP Diesel engine gives a speed of 10.5 knots. Under sail, she can achieve up to 18 knots under favorable wind conditions. She carries 80 tons of fuel and 200 tons of fresh water. The men learn to work aloft and caulk the two miles of deck seam and manhandle the 25,300 square feet of sail. Cadets in the lower classes learn to serve as ship's crew, while upper classmen and women in the Coast Guard Academy learn to serve as officers. The crew sleeps in

the traditional hammocks below the decks. In rough weather, six men are required to handle the three linked wheels that compose the main steering wheel.

The EAGLE's home port is now New London, Connecticut, where she resumes her old career as a sail training ship. When at home, the EAGLE rests alongside a pier at the Coast Guard Academy in New London. During the warm months, the EAGLE goes on one to five-week cruises.

The Academy was originally founded in 1876 with a class of nine students on board the Revenue Cutter DOBBIN. A series of cutters replaced the DOBBIN, and in 1932 a permanent shore facility was built for the Academy on land donated by the New London community. The enrollment at the Coast Guard Academy consists of men and women who all sail at one time or another on America's only active commissioned Square rigger.

KRUZENSHTERN

The KRUZENSHTERN was built in 1926 for Hamburg shipowner L. Leeisic as the last cargo-carrying four-masted barque ever constructed. She originally was intended to be a training ship and cargo carrier at the same time. Initially, this ship was commissioned the PADUA and worked the nitrate trade and later the grain runs from Australia. Her sailing days under the German flag were off and on until 1939. During World War I, she lay in Flensburg, Germany until 1946, when PADUA was handed over to the USSR.

The ship was recommissioned under the name of the famous Russian seaman and explorer, Adam Johann von Kruzenshtern (1776–1846), who in 1803 to 1806 led the first Russian round-the-world scientific expedition. The name

Ivan F. Kruzenshtern is credited with this distinction. Unlike most other national sail-training ships, this vessel is attached to the Ministry of Fisheries, rather than to the Navy or Coast Guard.

The Soviet Union's KRUZENSHTERN has a length of 378-feet, rig height of 162 feet, a beam of 46 feet, her draft is 25 feet, and her sail area is more than 36,000 square feet. This ship accommodates 236 persons, including 26 officers, 160 trainees and 50 crew members.

This ship was the largest vessel in the 1976 International Sail Training Races sponsored by Cutty Sark Whisky. The races are organized every two years by the Sail Training Association and are supported by sponsors seeking to promote an interest in sailing. The race began in Plymouth, England, and ended in Newport, Rhode Island. A fleet of about 100 ships completed the voyage to America. A major goal of the organizers of the race was to foster international relations. The 1976 races ended in the United States at the invitation of Governor Noel of Rhode Island, the Bicentennial Commission, Mayor Donnelly of Newport, and the American Sail Training Association.

From Newport, the ships sailed in company to New York to take part in Operation Sail and the July 4th Bicentennial salute to America. This 12-mile-long parade of ships, the likes of which was not previously seen in the history of the United States, was the highlight of the Bicentennial. The world's last survivors of the age of the tall ships will long be remembered as they lined up to make their grand flotilla.

The U.S.'s EAGLE was the host ship of Operation Sail '76 and led the parade. The cost for Operation Sail '76, which took nearly five years to plan, was $70 million. The money came from foreign governments throughout the world. The list of Tall Ships from around the globe would be endless; however, there are several ships worthy of noting during these last days of the sail.

ESMERALDA

In 1952, at Cadiz, Spain, a ship was built as a sister ship to that country's JUAN SEBASTIAN DE ELCANO. The name of that ship was DON JUAN DE AUSTRIA, but before she was completely finished, she was destroyed by fire. The remains were sold in 1953 to Chile, where the vessel was rebuilt and re-christened the ESMERALDA. With her overall length at 353 feet, the ESMERALDA is the largest four-masted barkentine in the Western Hemisphere. This steel-hulled sailing ship carries 332 officers, crew, and cadets. Her beam is 44 feet, her draft 23 feet and her mast height

are 165 feet. This ship has a range of 8,000 miles under power at her cruising speed of eight knots. She can attain up to 12 knots with her 1,400 HP diesel.

This ship was named for a Chilean warship used in 1879. In June of 1974, she was greeted by some 300 angry picketers protesting the Chilean military junta government. Protesters claimed the ship was used as a floating prison and torture chamber to overthrow the government of President Salvador Allende. While berthed at Alameda, California, even the head of a prostitution union called Coyote joined the protest, refusing their services.

Klondike Gold Rush 1869–1899

The almost insane drive of humanity to reach the gold in the frozen area of the Klondike River set off one of the greatest chapters in the history of North America. The gold rush of 1869 had a lasting influence on the land that might have taken years to be settled had it not been for the mass exodus to the Yukon Territory of Canada. Gold had been found in the Juneau area and along the Yukon River as early as 1887, possibly even much earlier. One of the richest deposits of placer gold ever discovered was found on Rabbit Creek. It took almost a year for the word to reach the outside world, and by then stakes were made all along the tributaries of the Klondike River which flowed westward meeting the Yukon River at Dawson.

The first news of the gold strike came on July 16, 1897, when the ship EXCELSIOR docked in San Francisco. The following day the ship PORTLAND docked at Seattle with 68 miners and gold reportedly worth more than $700,000. The cities all up and down the West Coast were cashing in on the excitement. In 1898, 112 ships were built to carry miners and cargo north to the "Promised Land." Ships of every shape and size were used; anything that would stay afloat was available for a price.

The fastest route from the West Coast was up the Inside Passage of Canada and Alaska to the head of the Lynn Canal at Skagway. It was a journey of over 1,000 miles. Port cities along the way became rich as their merchants' supplied tons of gear connected with the stampede. The government of Canada required each miner to bring enough supplies with him to last one year.

PACIFIC SWIFT

The PACIFIC SWIFT is a topsail schooner and specially constructed for both coastal and offshore sailing. It was built by the Sail and Life Training Society (S.A.L.T.S.)

as a working exhibit at the EXPO 86 in Vancouver, B.C. The PACIFIC SWIFT was launched before a crowd of over 30,000 well-wishers. She was towed to Victoria, B.C. where the vessel was fitted out and rigged. This square topsail schooner has a sparred length of 20 feet 6 inches, displacement 96 tons, and accommodations for a crew of 5 and 30 trainees.

On her maiden voyage, the PACIFIC SWIFT sailed to EXPO 88 in Brisbane, Australia. Eleven months later she returned home to Victory, B.C. on a voyage that took the PACIFIC SWIFT to 30 ports of call and 20,000 miles. The first two sailing vessels built in what is now British Columbia were very similar to the SWIFT. They were built to search for the Northwest Passage and to trade for sea otter pelts, which were sold in China. On September 20, 1788, almost 200 years prior to the launching of the PACIFIC SWIFT, the NORTHWEST AMERICA, a 60-ton schooner was launched. This vessel was built for British interests by 90 Chinese tradesmen in just seven months from the felling of the first timber at Friendly Cove in Nootka Sound on the west coast of Vancouver Island. The ADVENTURE, the second vessel launched a few months later, was shipped out in disassembled form from Boston, much as the frame of the PACIFIC SWIFT was prefabricated on Galiano Island and shipped to Vancouver for finishing as the EXPO 86. The original SWIFT was a clipper mail packet brig of nine feet, nine inches. Her mainmast stood 92 feet. Her sails added to an area of 7,000 square feet.

This clipper ship was used to promote tourism in Baltimore but met with disaster in a squall 240 miles north of Puerto Rico in May of 1986. The survivors spent nearly five days on the Caribbean Sea on a life raft before being plucked from the sea by a Norwegian freighter. The ship sank in less than a minute with high seas and winds of 30 to 90 knots. The clipper was due back in Baltimore on June 14 and was scheduled to sail to New York for the July 4 rededication of the Statue of Liberty.

SAGRES II

The SAGRES II was built in 1938 in Germany and is now used by the Portuguese Navy. She is the sister ship to the U.S. EAGLE and is 295 feet long with a sail area of about 20,000 square feet. The SAGRES II, under full sail, is an unforgettable sight; on her square sails she wears the Maltese Cross. The figurehead on the bow of the ship is the bust of Henry the Navigator. This vessel from Portugal carries 243 persons aboard: 10 officers, a crew of 153, and 80 cadets. Her main mast is 142 feet aloft.

The SAGRES II received her name from the Promontory near Cape St. Vincent in southwestern Portugal. It was from this point that many explorers departed in the 15th century. Prince Henry, who died there in 1460, was one of the earliest backers of oceanic exploration.

The SAGRES II carries 52 tons of oil for her two Diesel engines of 750 HP, her top speed is 9.4 knots.

AMERIGO VESPUCCI

This ship is one of the largest of the full-rigged vessels used for sail training today. She resembles a 19th century frigate. This 330-foot ship was named for the Italian navigator and explorer who lived from 1451 to 1512 and for whom America was named. This Italian ship was built in 1930; she is built of steel, and her rig is 160 feet high. She carries 7 officers, 30 crew members, and 100 trainees. In 1960, the AMERIGO VESPUCCI made a very notable voyage: she carried the Olympic flame from Athens to Italy.

DANMARK

The DANMARK was launched in 1932; she is a 252-foot fully rigged ship. Her hull is of steel, her beam is 33 feet and has a draft of 17 feet. This ship carries 26 sails with a total area of 17,600 square feet; the height of her rig is 130 feet. She is powered by a 486 horsepower Diesel engine.

Denmark has used sail-training for at least 300 years. The Danish government gives training to young boys 15 to 20 years old, for careers as officers in the Danish Merchant

Marine. Trainees are given intensive education in mathematics, physics, mechanical engineering, hygiene, as well as navigation, radio, and weather. The young men are trained in every task aboard ship from washing dishes to assisting the surgeon. The DANMARK and her crew are famous for the salute they give in port, by "manning the yards." The crew in their white uniforms stand on the yards, high above the deck, with hands outstretched to the next crew member. The trainees are sent on cruises that normally take six months and usually voyage around the globe.

In 1940, the German Army occupied Denmark. At the time the DANMARK was in the United States. The ship was offered to the U.S. government and was used as a Coast Guard training ship with Danish officers in charge. The vessel was returned to Denmark in 1945.

CHRISTIAN RADICH

The Norwegian CHRISTIAN RADICH is a 575-ton, full-rigged ship which appeared in the film *Windjammer* in 1958. This ship has a steel hull, her sails have a total area of 14,525 square feet, and her rig is 128 feet high. This vessel was commissioned in 1937.

For three months, boys from ages 15 to 19 are given training in all aspects of life aboard ship. By the time the trainees go ashore at the end of the cruise, they know if the life of a sailor is for them. The training is rigidly structured to make men out of boys. If a boy decides that sea life is not his cup of tea, he will have had an experience that will never be forgotten.

SEA CLOUD

The largest and most luxurious square-rigger in the world is the SEA CLOUD. She is a four-masted bark built in Germany in 1931 at a cost of $1.2 million dollars. She has four 9-cylinder Diesel engines that have an output of 6,000 HP and can move the ship at 15 knots. The SEA CLOUD is manned by a crew of 60.

Maritime Museums

Throughout the world, there are many sailing ships that have been preserved as historic vessels from the past. In the United States, there are many fine museums devoted to the days of the sail. Contributions for maintenance and restoration are

needed to keep many of our old ships afloat. Slim budgets based on admission fees and contributions make it hard to keep some of these waterfront museums alive and well.

Mystic Seaport Museum

One of the best-known maritime museums in the United States is the Mystic Seaport Museum in Connecticut. Founded in 1929 as a small museum for maritime-related artifacts, this living museum now encompasses 17 acres of historic homes and waterfront buildings. The re-created New England seaport and shipbuilding community includes scores of smaller boats ranging from sloops to steam launches.

The oldest whaleship in America, the CHARLES W. MORGAN, can be seen here along with the square-rigged ship JOSEPH CONRAD, built in 1882 as a training ship for cadets. The village contains a general store, a one-room schoolhouse, ship chandlery, and daily demonstrations from life in the 19th century.

Mystic's early colonists were shipwrights. During the 19th century, Mystic was an important port. Whaling ships were built here along with 22 clipper ships. Some of the buildings are on the original sites, whereas others have been meticulously re-created from pictures of early buildings no longer standing.

MOSHULU

Tied up at the Philadelphia waterfront at Penn's Landing can be found one of the greatest gems in the world to a sailing ship buff. The largest tall ship in the world can be found there. The four-masted bark MOSHULU, 393 feet in length, is a few feet longer than the Soviet Union's KRUZENSHTERN, the largest of the sail training ships in the world. This 1904 square-rigger is an outstanding museum ship. The museum aboard the MOSHULU has a collection of photographs of the ship's history along paintings and prints and a model of the ship in her heyday.

This ship was built in Scotland and originally named KURT. This vessel can boast of having many careers, from a nitrate carrier to waterfront restaurant. When World War I began, the MOSHULU was in Oregon loading grain and was ordered to stay there until further orders. When the United States entered the war with Germany, the KURT was confiscated and renamed DREADNOUGHT. The ship was renamed the MOSHULU, an American Indian word meaning fearless. In 1935, she was sold to a Finnish owner who used her as a grain hauler from Australia to Europe. The MOSHULU won the last grain race in 1939. During World War II, this ship was confiscated by Germany

and became a floating warehouse. In 1968, a U.S. Specialty Restaurant Corporation bought the ship and spent more than $2 million dollars restoring the bark for her new and final career, that of a restaurant and museum.

National Maritime Museum

The National Maritime Museum in San Francisco, California, is one of the greatest sea history museums in the nation. There are nine ships of historical interest tied up at several piers along the waterfront. The BALCLUTHA, built in England in 1886 is a full-rigged ship, 301 feet long, and worthy of a visit any time you're in the city by the Bay. Other vessels in the museum's flotilla of ships include the C.A. THAYER, a three-masted schooner that was the last commercial sailing ship operating from the West Coast until she retired in 1950; the ALMA, one of the last scow schooners on the San Francisco Bay and a Liberty Ship from World War II; a sidewheel ferry; an ocean-going tug; a paddlewheel tug; a steam-engine schooner; and even a submarine.

This museum, including the ships, is administered by the National Park Service. The waterfront flavor is to some degree a sharp contrast to the concrete and glass towers of the city by the Bay. Many of the old waterfront buildings have been refurbished to draw visitors to this amazing city.

Mariners' Museum

The world's largest collection of figureheads from old sailing ships can be found at the Mariner's Museum in Newport News, Virginia. Though many of the figureheads are from ships long gone, they present an interesting history and are some of the best

examples of the woodcarver's art that was used to ornament the bows of some of the world's proud ships from the past.

Solo Sailing

Along with landmark vessels preserved in harbors throughout the world, stand landmark sailing records. The stories of the great days of sailing have thus far covered large ships, tall ships if you will, and the crews that manned them. However, from libraries and newspapers come the stories of solo adventurers that have thrilled readers for years. Here are a few of the men and women who singlehandedly sailed their small crafts into history.

The earliest transatlantic solo sailing on record was that by Alfred Johnson of Denmark in the 20-foot CENTENNIAL, which sailed from Nova Scotia to Wales in 46 days in the year 1876. The story of Joshua Slocum, a retired sea captain who challenged the world in 1895, was the start of many firsts in the history of solo sailing.

Captain Joshua Slocum, at age 51, set out alone from Boston in a 37-foot sloop, the SPRAY, on April 24, 1895 and landed at Newport Harbor, Newport, Rhode Island in 1898. The voyage took him 46,000 solo miles. His voyage of three years and two months is sprinkled with adventure. After escaping a pirate felucca off Norocco, Slocum repelled Fuegian natives by using tacks scattered on the deck of his ship. He narrowly missed destruction by a whale in the Pacific and lived on potatoes and salt cod for the duration of his voyage. His only companion was a book of stories by Robert Louis Stevenson. Slocum's account of his voyage has become a classic of the sea.

Others to sail around the world were Francis Chichester in nine months in 1966, making one stop, and Alex Rose made the voyage in 345 days, making two stops, in 1968; both men were knighted for their achievements. The fastest solo sail ever, 167 days, was made by Frenchman Alain Colas in 1974 aboard a 70-foot trimaran—a three-hulled vessel that sailing authorities placed in the unconventional category.

The Nonstop Voyage Around the World

One of the greatest sea adventures of our time is the story of Robin Knox-Johnston, the first man to sail nonstop around the world in a tiny ketch, SUHAILI, from Falmouth, England. His solo voyage took him 313 days and covered over 30,120 nautical miles.

Robin Knox-Johnston, a 29-year-old Merchant Navy officer, sailed his ketch for ten and a half months on an incredible adventure. He sailed under rules requiring that

the circumnavigation be completed without outside assistance. No food, water, fuel, or equipment could be taken on board after he started, and it was required that the departure and return voyage be recorded at the port from where he started.

This young Englishman overcame astounding hazards: his water tanks were polluted, a storm put his radio out of action, his self-steering gear was jettisoned, his main boom collapsed, his tiller sheared off, his cabin top was smashed, his once white sails were weathered and brown, and his tiller arm jury-rigged to the rudder head. At the end of his incredible voyage he said, "A jolly good holiday."

First Woman to Solo Around the World

Naomi James, a 29-year-old housewife, who had a few years of sailing, took her 53-foot sloop, THE EXPRESS CRUSADER, on a voyage that lasted 272 days at sea and covered nearly 30,000 miles. Mrs. James left the south coast of England on September 9, 1977 in a 10-ton, fiberglass sloop, which normally takes a crew of 10. Her solo circumnavigation clipped off two days from the record set by the late Sir Francis Chichester, in the GYPSY MOTH, 1966–67.

THE SOLO VOYAGE OF THE DOVE

At the age of 16, Robin Lee Graham of Santa Ana, California, set sail from California in a 24-foot sloop called the DOVE and sailed solo around the world from 1965–70. His odyssey took him 33,000 miles. Graham became the first teenager to make such a contribution to the world of solo sailing by his notable voyage.

The Close of the Great Days of Sail

Sailing ships became marvelous vessels indeed. There was no sea upon the face of the earth that man could not sail his ships of wood and steel. However, there came a threat to the whole world of sailing. Steam power began to be applied to the problem of moving ships. As steam became more efficient and dependable, the builders of sailing ships began to realize that this new competitor was here to stay and would someday push them off the seas. They decided to put up a fight, and if they lost, they were going down in glory. Going down in glory they did!

The last days of the sailing ships were the most colorful, romantic, and thrilling days of their whole history. During the 19th century, the makers of sailing vessels tried to outwit and outrace builders. For a long time, the clippers held the market over

steamships on trade and speed. The gold rush in California gave the clippers the edge over steam because under a brisk wind the clipper could log 18 to 20 knots. But the sails were doomed.

A steamship did not have to "tack," but could drive ahead in a straight line, ignoring the wind. Cargo steamers might have been slower than clippers side by side, but because they could plow a straight line, they usually beat the "greyhounds" from port to port. Sailing men fought back bitterly with their clipper ships. They built super clippers, great "windjammers" with iron hulls and a fantastic spread of sail on four and even five masts.

The opening of the Suez Canal connecting the Mediterranean sea with the Red Sea, via the Gulf of Suez helped to seal the end. This 103-mile canal was constructed in 1859–69. The final nail in the coffin for wind ships came with the building of the Panama Canal. This 51-mile-long canal joining the Caribbean Sea and the Pacific was begun in 1881 by the French but was abandoned in 1889. In 1903, the United States backed a successful Panamanian revolt against Colombian rule and gained construction rights for the canal, which opened in 1914. Steamers no longer had to sail around the Horn or Cape of Good Hope, and wind ships could not tack through the canals.

One of the last mightiest of these square-rigger ships was the German Clipper PREUSSEN, a 408-foot vessel, built in 1902. She weighed 5,081 gross tons and it took a crew of 45 men to handle her five masts of sail, all square rigged. She carried a tremendous burden of cargo in her iron hull and could average 16 knots on most voyages. In 1910, a collision damaged her headsail and she drifted under the Dover cliffs and was helplessly smashed to pieces by the waves on the rocks.

Once steam power was mastered, steamships were limited in size only by the amount of steel available. They were built much larger than sailing vessels could ever be built. Their great size enabled them to carry three and four times as much as sailing ships, therefore they could charge less for freight than their competitors.

The Age of Sail is Over!

As the 20th century progressed, the age of sailing across the great oceans ended. Hats off to the men and women of the past, sailors of today, and even greater sailors of tomorrow. *Hold Fast* is your remarkable story and I have been honored to have told it in the pages of this book.

About the Author

James H. Campbell (Jim Campbell) is a Marine artist and author specializing in marine art and history. He is widely known as one of the most talented artists for capturing the detail and life in the subjects that he chooses to do in pen-and-ink. Involvement with his subject is an important part of his success. His studio in the coastal mountains of northern California, like a museum, is filled with books, pictures, and artifacts from the days of the sail. Pen-and-ink provides a way for Campbell to communicate his knowledge of historic sailing ships from the days of the sail. Gathering sailing information and trivia from many sources has been his life-long interest. The artist has spent more than 60 years researching material for many of the marine art subjects found in *Hold Fast*, including the many scores of original drawings elegantly reproduced in this book.

Campbell is a member of the International Society of Marine Painters as well as a member of the Santa Clara Art Association in California. Through both his drawings and writings, he has captured the remarkable history of an era of the golden age of sailing. Many of the drawings in *Hold Fast* are also in print. The description of each vessel in *Hold Fast* features colorful accounts of seafaring adventures and nautical trivia.

Jim Campbell's life as an artist and author began during the 1950s. He was born in Detroit, Michigan in 1928. After his family moved to Ansonia, Ohio in 1945, Jim worked for his father in a small-town newspaper and printing business. He did everything from writing short articles for the paper, to setting type, printing the paper, and even delivering it. In 1948,

he married Joanne Dohse. From rural Ohio, they traveled west on their honeymoon and spontaneously decided to settle in San Jose, California, where they raised three beautiful girls.

Campbell's experience in the newspaper field helped him obtain a job working for the *San Jose Mercury News* and the *San Francisco Examiner*. While working in San Francisco for the *Examiner*, he became enchanted with the ships of the bay. At this point, Campbell's interest in marine art began. Campbell was often seen on the San Francisco Bay waterfront during his lunch breaks sketching the fisherman, dock workers, their vessels, and old wharf buildings.

After selling his artwork for many years, he formed his own company in 1975 with a business partner called Cam-Mac Originals. The company reproduces Campbell's original works of art which are marketed in some of the finest and most prestigious galleries and shops from San Diego, California to Vancouver, British Columbia, and from the East Coast to Hawaii. Jim Campbell's pen-and-ink drawings now hang in private collections throughout the world in Japan, Hong Kong, New Zealand, Germany, England, Canada, and the United States. Many of his drawings have won awards in competitive art shows throughout Northern California.

Cliffco, Inc., producer of Stamp Exhibitions in San Jose and San Francisco, commissioned Campbell to use his marine art as official Post Office cancellation subjects and for cachet designs. This included the first day covers of the "First Civil Settlement Stamp" issued on September 9, 1977, celebrating San Jose's participation in the 200th birthday of the United States.

One of Jim's favorite quotes is: "If I can bring some of the nostalgia of the days of the sail and that bygone era to new generations through my artwork and writing, this will be my legacy." His advice to other artists and authors is: "The more you study and know your subject, the more your personal identity will take shape. Artists live in a maze of color and techniques until they find a style which best identifies them from others. The key to being a successful artist with identity is to gradually build up your own collection of studies for future reference—creative capital in an art bank. Never feel as if you have created your great work of art. That gem is still locked in your mind. As a self-taught artist, I believe enthusiasm is the best teacher anyone can have."

GLOSSARY

Glossary of Sailing Ships

BARK – This ship was a three-masted sailing vessel, square-rigged on all but the aftermost mast, which is fore-and-aft rigged. There were also four and five masted barks.

BARKENTINE – Much like the bark but square-rigged only on the foremost and fore-and-aft rigged on the remaining masts. Barkentines were built with three, four, five and six masts.

BRIG – A sailing ship with two masts, square-rigged on both masts.

BRIGANTINE – A two-masted square-rigged ship. However, towards the end of the 17th century it became square-rigged on the foremast with a gaff sail on the mainmast and square sails on the main topmast and main topgallant.

CARAVEL – A vessel from the 14th to the 17th centuries. This type of ship was used by the Portuguese and Spanish for voyages of discovery in the 15th century. This vessel lacked the high forecastles and the sterncastles of the contemporary carrack and was lateen-rigged on two or three masts. However, it was subsequently found to sail better across long distances with square sails on the fore and mainmast and a lateen on the mizzen mast only.

CARRACK – This type of vessel was a typical large trading ship of the 14th and 17th centuries.

CAT BOAT – A sailboat with one mast, at the bow.

CLIPPER – Developed from the Baltimore clipper. Built for speed on the high seas. These ships were sleek, fast square-rigged vessels of the 19th century. They were used in the tea trade and the California and Australia gold rush. The clipper was three masted, all square-rigged, with an additional gaff on the mizzen and a raking

stem and overhanging stern. The clipper ship GREAT REPUBLIC was, however, four-masted.

CORVETTE – A sloop of war. Armed with guns along one deck only.

CUTTER – This vessel was a single-masted sailing ship with two or more sails before the mast. A fast ship used in the 18th century by revenue officials and pilots; a very seaworthy patrol vessel also used by the Coast Guard.

FRIGATE – This type of vessel was square-rigged with three masts, and smaller than a ship-of-the-line. Usually having only a single gun deck with between 24 and 38 guns. Frigates were classed as fifth or sixth rate man-of-war and were used as privateers and escort ships. In America, frigates were built at the turn of the 19th century that could carry more than 50 guns. They were warships of the 18th and early 19th centuries.

GALLEASS – Warships used in the Mediterranean from the 15th to the 18th centuries, lateen-rigged of three masts.

GALLEON – Galleons were built by all nations, however, the tall ships that the Spanish used for bringing home gold and spice from the new world have come to be called galleons. In fact, most people call any ship with a high poop a galleon, but the original type had three decks and a rather low bow and was moderate size. They were a modification of the early carrack. The galleon was square-rigged on its fore and mainmast, lateen-rigged on the mizzen. They were used through the 15th to the 17th centuries as commerce and war ships.

KETCH – a two-masted vessel with foremast the taller and mizzen toward of the rudderpost.

PINNACE – A 17th century three-masted square-rigger.

SCHOONER – A fore-and-aft rigged vessel, two or more masts. The 19th century saw this type of ship with everything from two to six masts. The THOMAS W. LAWSON was the only seven-masted schooner ever built.

SHIP – The ship in the 18th and 19th centuries was a vessel with at least three masts, all of them square-rigged, with a gaff on the aftermost mast and a bowsprit.

SLOOP – A single-masted sailing vessel with one headsail. This vessel was also known as a corvette, the class of ship just below a frigate.

Nautical Terms

Ships and sailors have a language all their own. This list provides a basic vocabulary of maritime terminology that will help you converse and better understand the language of an "old salt."

AFT – The rear or stern of the vessel. Also means direction, near or toward as in "going aft."

ALOFT – Above the deck.

AMIDSHIP (or midship) – The middle portion of a ship, between the bow and stem. The widest part of the ship also called "midship."

ANCHOR'S AWEIGH – The anchor is off the bottom.

BEAM – The width of the vessel at its widest part.

BECALMED – Unable to move due to the lack of wind (calm).

BELAYING PIN – A rod of wood or metal used for securing the running rigging.

BILGE – The lowest part of a ship where water collects.

BINNACLE – The housing of the vessel's compass.

BITTER END – The end of a cable or chain which holds the anchor that lies behind the large posts called the bitts to which it is secured.

BLACKBIRDING – Transporting slaves across the Atlantic in the African slave trade.

BLACKJACK – A Jack is the word for a flag flown on board ship. The blackjack was supposedly the pirate's flag.

BLOCK AND TACKLE – A combination of line and two or more large pulleys used for lifting heavy objects.

BULKHEAD – Any of the partition walls used to separate various areas of the ship such as rooms, etc.

CLEW – Lower corners of a square sail. There are two clews, one at either corner of the bottom of the sail.

COD'S HEAD AND MACKEREL TAIL – The shape of a ship which is broader in the bow than the stem.

COLORS – The name given to the national flag when flown on board ship.

COMBERS – Waves with a foamy crest. Breakers are waves which collapse on the shore and are usually very foamy.

COMMANDER – Officer next in line below the captain.

COMMODORE – A captain with special responsibilities, but he is not yet a rear admiral, the next rank after captain. Also, a chief officer of a yacht club or senior captain of a merchant line.

CONTINENTAL NAVY – This name was given to the American Navy after the Declaration of Independence in 1776, and before the official founding of the United States Navy in 1794.

CORBIE'S AUNT – An interesting corruption of the word corposant, another term for the electrical phenomenon often seen at sea, also known as St. Elmo's fire, which takes the form of balls of fine and sparks at the masthead and yardarms when the air is charged with electricity.

COURSE – The path or direction a vessel travels as expressed by the angle subtended between the centerline of the ship and true north. Example: if a ship is sailing due east, her course is said to be 90 degrees; due south is 180 degrees; due west 270 degrees. Also, the term means sails hung from the lowest yards on all masts.

CRIMP – A supplier of men to waiting ships, by means not too ethical; these people were paid blood money for their deeds. Practiced all over the world from the 17th century on and very much in use in San Francisco during the gold rush.

CROW'S NEST – A vantage point high up on the main mast used as a lookout.

CUTLASS – A short sword issued to boarding parties on warships.

DOCK – In the strict sense, a dock is the water space alongside a pier, wharf, or quay in which a ship floats while being loaded or unloaded. In general usage, however, dock, pier, wharf, and quay synonymously mean the structure at which a ship ties up when at or in port.

DRAFT – The depth of the water a ship draws.

ENBARK – means to go aboard ship to make ready for sailing.

FATHOM – A measure of length, six feet, used chiefly in measuring cordage, cables, and depth of water.

FO'C'SLE – The foremost part of the ship, originally the quarters for the crew.

GALLEY – The ship's kitchen.

GROSS REGISTER TON – This is a measure, not of weight, but of cubic content of the enclosed space on a ship and is the measurement used in giving the size of passenger vessels. 100 cubic feet is equal to one gross register ton.

HELM – A generic term for a ship's steering apparatus.

HEAVE TO – A maneuver by which a vessel is brought to a halt.

HOLD – Interior of a ship below decks where cargo is stored.

JURY RIG – A temporary contrivance designed to replace a missing or damaged piece of essential gear, which could be anything on board ship from stem to stem.

KEEL – The ship's backbone. The keel is a horizontal thick steel plate running the full length of the ship's bottom, on the top of which a vertical center frame is fitted and to which the main framing of the ship is attached.

KNOT – A unit of speed, equivalent to one nautical mile per hour. The length of a nautical mile is 6,080 feet.

LEAGUE – An old measurement of distance with various equivalents. A sea league equaled 4 Roman miles or 3.18 nautical miles.

LEEWARD – The side of a vessel away from the direction of the wind.

LOG – A daily record of a ship's speed and progress.

MARTINGALE – A short spar pointing down beneath the bowsprit. Also called a dolphin striker.

POOP DECK – A raised deck at the stem. The aftermost deck.

PIN RAIL – Wooden rail with belaying pins to which running rigging is secured.

PORT – To your left, facing forward. Indicated by a red navigational light.

RIGGINGS – All the lines and their fittings. Standard rigging supports the masts. Running rigging raises, lowers, or controls the sails.

SCUPPERS – The narrow drains below the ship's rail.

SHIP – A vessel of three or more masts. A fully rigged ship.

SHROUDS – Lines on wires from the masthead to the sides of the ship used to support the mast as part of the standing rigging.

SOUNDING – Depth of the water, "to take a sounding."

STABILIZER – A retractable "fin" extended from either side of the vessel for smoother sailing.

STARBOARD – To your right, facing forward, indicated by a green navigational light.

TRY WORKS – The equipment for cooking and rendering blubber on a whaling ship.

WEATHER SIDE – The side of the ship toward which the wind is blowing. Also called the windward side.

WEIGH ANCHOR – To raise the anchor.

WHEEL BOX – Houses the worm-gear connecting the wheel and the rudder.

WINDLASS – A winch operated by hand or by power, for raising the anchor.

YARD – A long horizontal spar set at right angles to the mast and keel used for supporting sails.

YARDARM – The end of a yard. It was from these points that some offenders were once hanged.

YAW – To swing from side to side, to go off the true course.

YELLOW JACKET – This is the familiar name by which the flag for Q in the International Code of Signals is known. Q is the yellow flag flown when a ship is in quarantine.

SELECT BIBLIOGRAPHY

The following selections of books were sources of reference for the present book and might be found interesting as background reading and further reference.

Archibald, E. H. H. (1968). *The wooden fighting ships in the Royal Navy*. New York: Area Publishing Company.

Block, I. (1953). *Ships*. New York: Garden City Books.

Carse. R. (1965). *Sailing ships*. New York: Galahad Books.

Carter, J. S. (1928). *American traders in European ports*. Salem, Ma: Peabody Museum.

Chapelle, H. (1935). *The history of sailing ships*. New York, NY: Bonanza.

Chatterton, E. K. (1923). *Sailing ships and their story*. London: Sidgwick & Jackson.

Croix, R. (1957). *Mysteries of the Pacific*. New York, NY: John Day Company.

Cucari, A. (1978). *Sailing ships*. New York: Rand McNally & Co.

Dana, R. H. (1875). *Two years before the mast*. London: Random House.

Havinghurst, W. (1957). *The long ships passing*. New York: MacMillan Publishing Co.

Hudson, J. P. (1957). *The voyage and search for a settlement site*. J. Paul Hudson.

Kemble, J. H. (1957). *San Francisco bay*. New York, NY: Cornell Maritime Press.

Lobley, D. (1972). *Ships through the ages*. London: Octopus Books.

Landstrom, B. (1969). *Sailing ships*. London: Alien & Unwin.

Lubbock, B. (1933). *The best of sailing*. New York: Gosset & Dunlap.

McNairn, J. (1945). *Ships of the redwood coast.* Stanford, CA: Stanford University Press.

Maddocks, M. (1981). *The Atlantic crossing.* New York: Time Life Books.

Morison. S. (1971). *The European discovery of America.* New York: Oxford University Press.

Mullen. E. (1963). *The end of Blackbeard the pirate.* Pleasantville, New York: Readers Digest Inc.

Newell, G., & Williamson, J. (1957). *Pacific lumber ships.* New York: Crown Publishers, Inc.

Pastry, J. H. (1981). *Romance of the sea.* Washington, DC: National Geographic Society.

Reinstedt, R. A. (1975). *Shipwrecks and sea monsters of California's central coast.* Carmel, CA: Ghost Town Publications.

Roche, T. W. E. (1973). *The golden hind.* New York: Praeger Publisher.

Scott, R. B. (1970). *"Breakers ahead!" A history of shipwrecks on the graveyard of the Pacific.* British Columbia: Review Publishing House.

Svenssons, S. (1965). *Sailing through the centuries.* New York. MacMillian Publishing Co.

Shadbolt, M. (August 1967). New Zealand's Cook Islands. *National Geographic,* 132, (2), 203–232.

Tunis, E. (1951). *Oars, sails and steam.* New York: World Publishing Co.

Von Power, N. (1974). *American Navies of the Revolutionary War.* New York: G. P. Putman's and Sons.

Whipple, A. B. C. (1980). *The clipper ships.* New York: Time Life Books.

Whipple, A. B. C. (1980). *The whalers.* New York: Time Life Books.

SHORT AUTHOR BIOGRAPHY

James Howard Cambell (aka Jim Cambell) is an internationally known pen-and-ink artist whose exquisite drawings have captured many of the historic ships of the world. Campell's originals have graced well-known art galleries, including the Jack London Museum of Oakland, the San Francisco Maritime Museum, and Virginia's Mariners' Museum. His work is also found in private collections throughout the world, including Japan, Hong Kong, Germany, England, Canada, and the Netherlands. Campbell also has illustrated a number of books and authored hundreds of short stories. His previous books are Down Memory Lane: Illustrations of San Jose and Surrounding Points of Interest, and From Cinnabar to Quicksilver, Jim still resides in San Jose, California, with his wife of 77 years, Joanne Campbell.

ALSO BY J. HOWARD CAMPBELL

Down Memory Lane: Illustrations of San Jose and Surrounding Points of Interest
From Cinnabar to Quicksilver

Made in the USA
Columbia, SC
20 January 2025

0de4ec69-dcff-486a-95a4-9371ba8aa6e1R01